THE RUMRUNNERS

THE RUMRUNNERS
A PROHIBITION SCRAPBOOK

MARTY GERVAIS

30TH ANNIVERSARY EDITION
REVISED & EXPANDED

BIBLIOASIS

SECOND EDITION / REVISED & EXPANDED
Fourth printing, January 2015.

Library and Archives Canada Cataloguing in Publication

Gervais, C. H. (Charles Henry), 1946-
 The rumrunners : a prohibition scrapbook / Marty Gervais. — 30th anniversary ed.

Includes index.
ISBN 978-1-897231-62-3

 1. Smuggling—Ontario—Windsor Region—History—20th century.
2. Smuggling—Michigan—Detroit—History—20th century.
3. Prohibition—Ontario—Windsor Region—History—20th century.
4. Prohibition—Michigan—Detroit—History—20th century. I. Title.

HV5088.G47 2009 364.1'33 C2009-904131-6

Edited by Daniel Wells.
Cover design by Karl Parakenings.
Front cover image courtesy *Walkerville Times*.
Back cover image courtesy Bill Marentette.

We gratefully acknowledge the support of the Canada Council for the Arts, Canadian Heritage, and the Ontario Arts Council for our publishing program.

PRINTED AND BOUND IN CANADA

For Donna, Elise, Andre, Stephane and Gabriel

Contents

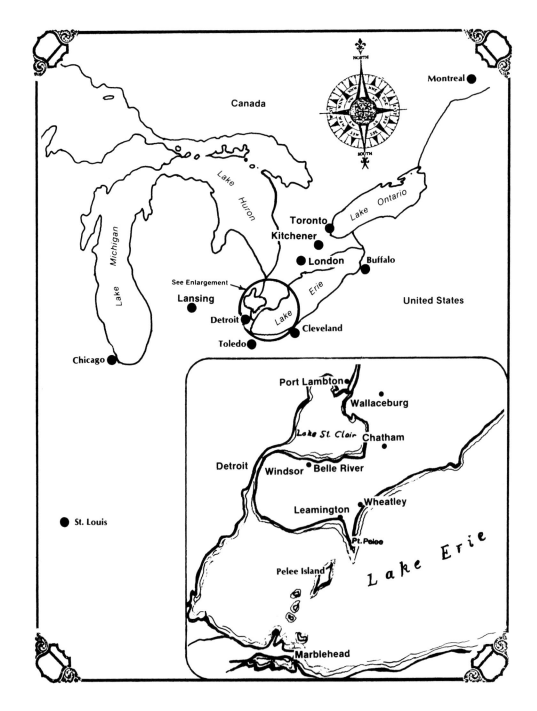

Liquor went out across the Great
Lakes region to the hot spots of
Chicago, Buffalo, and Cleveland.
The towns of Leamington, Belle
River, Wheatley, Port Lambton all
funneled liquor across to the U.S.

(Drawing by Peter Frank of Gale Research)

Foreword

The peaceful Detroit River. A great centre fielder might just be able to throw a baseball across, Windsor and Detroit are that close. Roy Haynes, U.S. Prohibition Commissioner, said there was no better spot than the Detroit River for smuggling liquor. "The Lord probably could have built a better river for rum smuggling. But the Lord probably never did!"

The Detroit River became the primary transfer point for Canadian liquor and beer into Michigan, Ohio and points further afield. And Windsorites took almost immediate advantage of the opportunities Prohibition presented. In the first days of Prohibition, Canada Customs noticed a huge increase in the demand for motorboat licences, and issued a warning that contraband liquor might soon find its way across the rivers and lakes into the U.S. In the first seven months of 1920 – the start of Prohibition – more than 900,000 cases of liquor were shipped to the Windsor area for what was termed "private consumption." Sure enough, in one week alone in May 1920 the police court collected more than $10,000 in fines from rumrunners.

It became evident that a new age had been born, and as Larry Englemann writes in *Intemperance*, the Prohibition dream had become "an American nightmare." It was also a wild and hysterical period, that ushered in its own language – speakeasies, flappers, rumrunners – and introduced a colour and excitement difficult to match at any other point in recent memory. It left its mark on the memories of everyone who lived through it. If you weren't involved in the actual traffic of liquor, you were buying and drinking it. If you weren't drinking, you were campaigning against it. If you weren't parading and carrying placards, you were privately sipping ale with cherished delight.

Some recall it with a smile and a wink. You can almost hear knees being slapped at the telling of these stories, brimming with exaggeration, a blend of gossip and fact, blessed with an affinity for the spectacular.

These are the reminiscences of people who guided jalopies across the ice, carting wooden crates of bourbon and good Canadian whiskey to blind pigs and warehouses on the American side; of those wide-eyed bystanders who unobtrusively stood at a counter drinking shots, trying to catch the eye of some giggling gal with kiss curls who kicked and waved on the glistening ballroom floor of a border roadhouse; of the people who paid dearly for the occasional bottle from someone who was reputed to be associated with the masterminds behind the liquor trade; of the innocent participants from that era

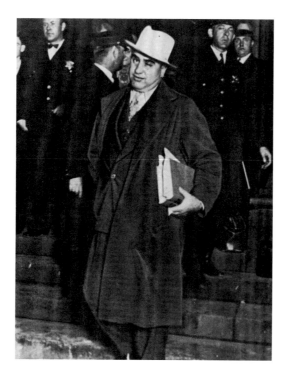

Al Capone developed most of the rumrunning activities in the United States, and is said to have accumulated up to $100 million per year from contraband beer sales alone. He is said to have engineered countless killings, but when finally sent to prison in 1931, it was for tax evasion.

who had an Uncle Jake and Aunt Gertie who kept a healthy supply of booze under the floorboards of the back shed.

All of these characters have an exclusive flag over the territory in their memory they call the Prohibition Era.

The liquor being sold in the U.S. was for the most part smuggled across the border from Canadian ports. The majority of this passed through Windsor, or the Border Cities, as the ports surrounding Windsor were then called. Police estimated that nearly four-fifths of all the liquor smuggled into the U.S. passed across the Detroit River. The traffic was so heavy and frenetic that this route came to be known as "The Windsor-Detroit Funnel."

One would have thought Prohibition would have put an end to liquor consumption, but it had just the opposite effect. Less than a year after its introduction, the per-capita consumption jumped from a pre-war level of 9 gallons to 102 gallons. This liquor, of course, wasn't for private use, but was shipped across the river to blind pigs and warehouses.

One Windsor widow, who lived on Pitt Street, just one street up from the Detroit River, was suspected by the police of selling liquor to smugglers. She had purchased forty cases of whiskey and nine barrels of liquor over a six-month period. Upon being brought to court, the protesting woman said she had taken up serious drinking since the war and now downed at least five quarts of whiskey daily. The magistrate proved unsympathetic and ordered police to confiscate the remainder of her "household supply."

Though Prohibition "failed", for the owners of the blind pigs, for the bootleggers, the rumrunners, the gangsters, the roadhouse proprietors, the police, the magistrates, the spotters, the boaters and armies of others, it was a roaring success. It meant work. Employment. Easy money. Cash in the pocket. Good times. Shiny new cars. New suits.

But these bootlegger tales by no means eclipse the recollections of the hard-driving temperance soldiers who worked tirelessly to win the battle against strong drink, who actively campaigned to bring in the laws that put liquor under lock and key and hoped to eradicate Demon Rum's ugly effects, which they claimed destroyed not only minds but families. For them

– those in The Dominion Alliance, the Woman's Christian Temperance Union (WCTU), the Women's Legion for True Temperance, the staunch and pompous Methodists, the saloon busters and the angry evangelists – Prohibition represents lost years, fatal years. Little did the enemies of moonshine and the saloons realize that by putting liquor out of the reach of the general population, they had in effect created a monster. For instead of society turning reflectively upon itself to ponder the common good, as they had hoped it would, it plunged itself headlong into one of the wildest, most violent and colourful of times – the Roaring Twenties.

It was during this era that North America gave birth to some of the largest crime syndicates and most vicious criminals. It was a time when Al Capone, Bugs Moran, Johnny Torrio, the Purple Gang, Pete Licavoli, and the Little Jewish Navy (sometimes called "Jew Navy") became household names.

Unemployment during this period became a myth as legions joined the forces of both the temperance groups and the bootlegging industry. As an example, Detroit boasted that during those years, sales related to liquor – profits from smuggling and in blind pigs – made booze the second largest industry in that city, exceeded only by the manufacture of automobiles. The Detroit Board of Commerce speculated that more than 50,000 people were involved in the booze business. Actual sales of over the counter liquor in Detroit amounted to more than $219 million, while wine sales surpassed $30 million.

The number of people working in the liquor trade in Canada is much harder to estimate, but

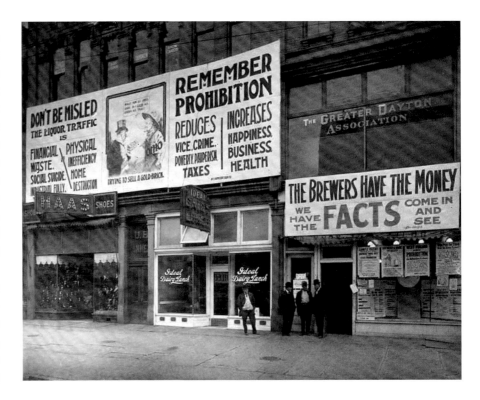

in the early days of Prohibition, it was said that 25% of the population near the Detroit River was involved in booze smuggling. Nearly a quarter of a million dollars was collected in fines by Windsor courts from boaters illegally possessing liquor during the first seven months of 1920.

When the Methodists and Anti-Saloon Leaguers preached about the evils of strong drink, they could never have envisioned the bizarre and terrible wars among bootleggers, gangsters and roadhouse owners, or the squabbles and tragedies among their own overzealous clerics and temperance leaders. There was no way they could have predicted either the St. Valentine's Day Massacre in Chicago or the

Prohibition campaigners set up offices in the downtown areas of cities across North America to pass out information on the evils of drink, arguing that Prohibition would reduce crime, vice and poverty.

The Woman's Christian Temperance Union was strong in its campaigning to bring Prohibition into effect in both Canada and the U.S. The Union became powerful during the First World War when men were away fighting in Europe.

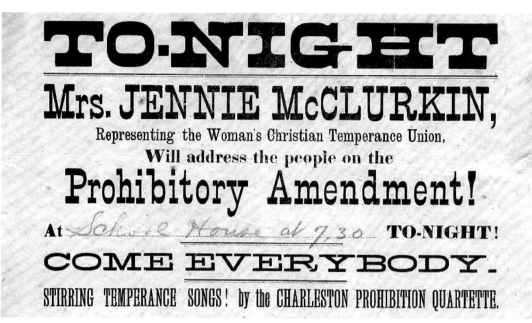

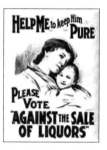

Posters were circulated in public places calling for the vote to ensure that Prohibition forces would win the day.

shooting of a roadhouse owner in Sandwich, Ontario by a Methodist minister packing pistols and accompanied by gun-toting hoodlums.

It was indeed an irony that the Canadian White Ribbon Tidings in 1919 sang;

Then storm the citadel of Wrong
With votes as ammunition
And usher in the welcome dawn
Of Total Prohibition!

Those glad voices didn't perceive the follies before them. They couldn't have foreseen how legislation against the consumption and sale of liquor would in fact *bolster* the trade, something very much removed from an era of "Total Prohibition." These same enthusiastic campaigners who declared in editorials that a failure to vote for Prohibition would be "the thing that turns homes into hovels," couldn't have anticipated how Demon Rum would be responsible for transforming these hovels into castles, as evidenced by the proliferation of grand homes built in old Walkerville.

At the time, these advocates of temperance, who declared strong drink the cause of "feeble-mindedness, idiocy, epilepsy and . . . all kinds of moral weaknesses," won the day. In their editorials, slogans, relentless campaigning, meetings and parades, they won the support of the Protestant churches and of government, and eventually the general population. Or at least they succeeded in convincing the majority to vote for Prohibition.

But after triumphing, a new battle was thrust upon them: enforcement. Keeping Demon Rum out of the hands of the weak. This is what

Women were important players in organizing the vote for Prohibition.

spawned an era of deviousness, great ingenuity and colour. From it emerged the rumrunners, the bootleggers, mobsters, tipsters, gamblers, protection rackets – and a never-ending source of booze spilling out casually and uncontrollably across North American towns at exorbitant prices in shot glasses, quarts, gallons, kegs and boatloads.

If anything, this is the quality of Prohibition as we have come to recognize it. We recall the scraps of stories, the bits of history picked up from sketchy newspaper flashbacks, but we have long forgotten the overwrought and somewhat absurd efforts of the church leaders who warned society that strong drink led not just to the obvious drunkenness, but to wife-beating, broken homes, bad health and vile talk as well.

But the battle waged, however, by these passionate Methodists and anti-saloon, hatchet-carrying women is not something to be ignored by historians. After all, these fierce temperance armies scored an important victory at the polls and raised the flag over a new era. But once the ballots were counted, and the victory announced, the new war had begun. It was an underground battle that defeated the Prohibitionists and won the day.

But the nagging questions always arise. How did Prohibition take hold? Why did it fail?

First of all, Prohibition was something shared by both the U.S. and Canada, in terms of legislation. But there is a marked confusion over this, because how could Canadians send shipments of booze across the border to the U.S. if legislation was in effect in Canada prohibiting liquor?

13

To put it simply, the laws were enacted at different times and with loopholes.

In the U.S., the Volstead Act went into effect in January 1920 and placed a ban on the manufacture, sale and transportation of all intoxicating beverages.

In Canada, the federal government introduced legislation in March 1918 ending legal importation of liquor into the country, its manufacture in Canada, and transportation of it to any part of the country where its sale was illegal. All the provinces of Canada, the Yukon and the Dominion of Newfoundland passed prohibitory laws on liquor in the wartime spirit. Quebec was the only one to renege, and after a referendum returned to the sale of light beers, cider and wines.

When the U.S. had passed its Volstead Act, the temperance forces could actually claim that the entire continent north of the Rio Grande was dry – except for the province of Quebec.

Where the confusion reigns, however, is in the ensuing events. The Canadian federal government repealed its wartime measures at the end of the war, so in December 1919, strong drink could again flow along the recognized trade routes across provincial boundaries. It could also be exported to countries that did not have laws prohibiting liquor. Of course, the U.S. had such laws, but sure-footed suitcase smugglers, fast boatmen and, later, crafty air pilots took their chances and sent the booze across the river. Most carried false export papers.

To hamper this liquor activity, the provinces drafted new legislation to fill in the gaps created by the federal government's decision to opt out of Prohibition.

Essentially, the situation in Canada was that some provinces had prohibition on the sale of liquor, its consumption and its transportation within the province. But no ban existed on the manufacture and export of liquor – and that's how Canadians thwarted the Prohibitionists.

How all this came about can be boiled down to about five causes:

1) The First World War.
2) The new authority of women.
3) A half-century of campaigning by church leaders, politicians, evangelists and women's groups.
4) The existing moral climate of the time.
5) Rural paranoia about urban intrusion.

Most blame the First World War, which had a tremendous influence upon the eventual passage of legislation that took away a person's freedom to drink. During the war, both the U.S. and Canada, as already stated, enacted laws that set the groundwork for full bans on liquor and beer. It was believed that money should be diverted from liquor to "war fitness."

All of the provinces and territories of Canada brought new sanctions into effect. The Ontario Government, for example, passed the Ontario Temperance Act (OTA) in 1916, which closed down all bars, clubs and liquor shops for the duration of the war. The federal government's legislation was not passed until March 1918, near the end of the war. It put a stop to the legal importation of liquor into the country, the manufacture of it in Canada and its transportation to any part of Canada where it was illegal.

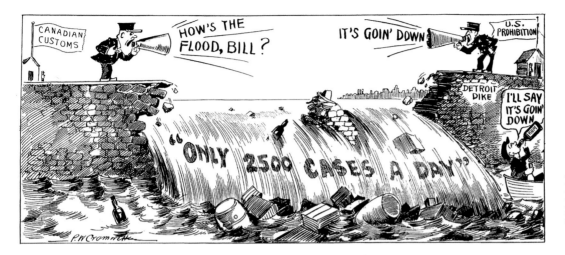

Political cartoons of the day lampooned the laws and the fact that liquor was making its way across the border at an alarming rate.

The moral climate in the U.S. brought on by the war permitted the easy passage of the Volstead Act. The 18th Amendment to the Constitution banning the manufacture, sale and transportation of all intoxicating beverages breezed through Congress in December 1917. By January 1919, the required thirty-six of forty-eight states had backed the Amendment, and by October of that same year, despite the veto of President Woodrow Wilson, Congress approved the Volstead Act. On January 16, 1920, the new law went into effect. It was named after Congressman Andrew J. Volstead, a Minnesota Republican, who believed that, "The law does regulate morality and has regulated morality since the Ten Commandments." He was utterly confident the new rules of order would be obeyed.

Another wartime condition that aided Prohibitionists in both the U.S. and Canada was the new authority of women. Before and during the

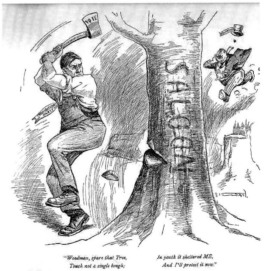

"Woodman, spare that Tree,
 Touch not a single bough,
In youth it sheltered ME,
 And I'll protect it now."

war, women found voice in numbers. They banded together in exclusive groups. In many cases, these were temperance-oriented organizations, such as the Woman's Christian Temperance Union and The Dominion Alliance.

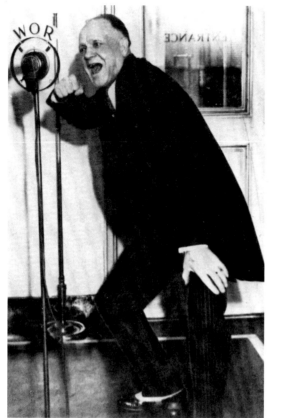

(*Left*) Billy Sunday. More than eighty million people attended the dramatic evangelical services organized by the baseball player turned preacher who would pull off his coat and vest during a heated sermon to harangue a crowd in a booze sermon, damning "crooks, corkscrews, and whiskey politicians." Sunday left major league baseball to hit the sawdust trail of preaching and was a great force for the temperance cause.

(*Right*) *Proceedings 19th National Convention of the Anti-Saloon League of America*, Washington D.C.

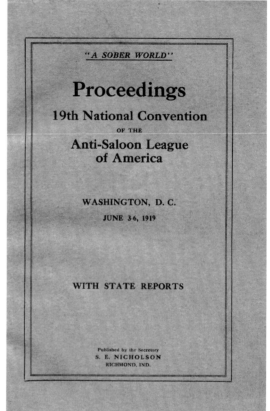

Women had also acquired far more responsibility during this time, as they were forced to fend for themselves during the war, to find work and feed their families while their husbands were fighting in the trenches overseas. This granted them more leverage and independence, thereby influencing the man of the house to vote for laws to prohibit the use of liquor.

More importantly, during this period women won the right to vote in elections. In Ontario, William Hearst's government enfranchised women in 1917. This proved crucial to the passing of Prohibition in the 1919 referendum in that province. Where women had not yet earned the right to vote, as in Quebec, stiff temperance laws failed to gain approval.

The half-century of campaigning by groups like the WCTU, The Dominion Alliance, and the Anti-Saloon League (U.S.) contributed perhaps more than any other factor in generating support for Prohibition. By the early 1900s in the U.S., the great temperance leaders, ordered their forces to use any means necessary to shut down the saloons – even hatchets if necessary.

The Bible and hatchet-carrying Carry Nation and her male counterpart, the iron-fisted Dr. Howard Russell, were the most popular of the U.S. temperance leaders. Reverend Ben Spence, the dogged and determined leader of The Dominion Alliance, and N. W. Rowell, a zealous Methodist and leader of the Ontario Liberal Party, crusaded vigorously through the difficulties of "wet" times in Canada.

Occasionally, the American and Canadian temperance groups joined forces to bombard their common enemy. One of the most dramatic examples occurred when evangelist Billy Sunday castigated and cursed the evils of drink at the Toronto Arena in front of more than 10,000 frantic supporters. In a barbed, stirring speech, the dynamic purveyor of Prohibition demanded that people march in support of the forthcoming referendum that would ensure Prohibition. Staggering across the stage like a man possessed, he argued that if they did not kindle in their hearts the spirit of Prohibition, then "whiskey people could . . . make the old world a puking, spewing, vomiting, maudlin, staggering, bleary-eyed, tottery wreck. . . ."

This Prohibitionary craze may seem unfathomable out of context but, on closer examination, the period up until 1920 was dominated by prohibitions – on clothing, behaviour and even food. In Ontario, especially, the straight-laced Protestant ethic dictated an exclusive code of conduct. It was strictly forbidden in 1919, for example, to purchase a cigar, an ice cream cone, a newspaper or anything vaguely frivolous on a Sunday. And playing sports of any kind was absolutely banned on

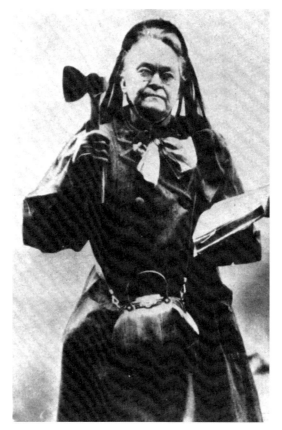

Hatchet carrying Carry Nation, who literally busted open rumshops as early as the turn of the century, symbolized early Prohibition movements. She was famous for leading groups of raiders who wrecked saloons with rocks and hatchets.

the Lord's Day. In Michigan, as an extreme example, it was considered a crime for women to wear high-heeled shoes. In such a world a ban on intoxicating beverages did not seem so out of place.

In addition to all of these factors, one cannot ignore the impact of the farmer on the polls. The farmer was regarded as the silent partner of the Prohibition movement. The Prohibitionists relied upon the farmer to cast his ballot against the evils of drunkenness and sloth, which he viewed from the safety of his front veranda in

(*Left*) William E. Raney. When the United Farmers of Ontario swept into power in 1919, the new Attorney-General, Raney, was determined to enforce Prohibition. Much of his previous public career had been devoted to combatting racetrack gambling.

(*Right*) The Honorable Ernest Charles Drury. The Drury administration had an ignominious ending, with matters reaching the courts of the land and winding up with the jailing of important figures and grave changes against others. (*Windsor Star*)

the remote and serene countryside, as something distinctly urban.

In Ontario, the farmer had an ally when the temperance forces were gearing up for the referendum. *The Farmer's Sun*, the official organ of the United Farmers of Ontario (the UFO Party) told farmers what they already knew – that their rural sanctuary could only be ensured if they voted to bring cities and towns under the umbrella of Prohibition.

The Farmers' Magazine advocated a similar prescription for good living. During the 1919 campaign, when the referendum was being hotly debated, the magazine declared, "We as farmers can't afford the risk of reckless auto driving, and wild county midnight depredations if liquor people get 'yes' written on the ballot."

In Ontario, the politicians cleared the path for Prohibition. The leaders of the three largest political parties – Premier William Hearst of the Conservatives, N. W. Rowell of the Liberals and Ernest C. Drury of the UFOs – were all Methodists, and all solidly behind Prohibition.

The extremes to which the Prohibition movement went weren't overlooked by everyone and weren't universally accepted or regarded as being "normal" for that time. Stephen Leacock, writing for *The Living Age*, described a prohibitionist as a drunkard who could always be

relied on to poll a vote in favour of Prohibition while "in a mood of sentimental remorse."

The famous humorist was deadly serious in his campaign to fight Prohibition. In an address delivered in 1921 at a Toronto meeting of the Citizens' Liberty League, Leacock said, "The attempt to make the consumption of beer criminal is as silly and as futile as if you passed a law to send a man to jail for eating cucumber salad. . . ."

Leacock wasn't alone. Organizations, groups and newspapers formed a solid front to fight the temperance movement. In Windsor, a new newspaper called *The Plain Dealer* became the official organ of the Border Cities Branch of the Citizens' Liberty League for Moderation, and its sole purpose was to print the facts about fierce, sloganeering Prohibitionists.

Like their Prohibitionist brethren, the anti-Prohibitionists could also count on church support. Whereas the temperance movement had the unwavering backing of the Methodists, the anti-Prohibitionists had the backing of Catholics and Anglicans. In 1920 the eccentric and iron-willed Bishop M. F. Fallon of the London Diocese of the Roman Catholic Church furiously argued that Prohibition opposed all the best Catholic traditions of personal conscience. He was supported by Reverend T. C. Street Macklem, Provost of Trinity University in Toronto, who considered the new legislation a detriment to health because it forced people to drink contraband and homemade concoctions, which might be contaminated or poisonous.

Not enough heeded the sentiments of the anti-Prohibitionists. Prohibition swept in like a tidal wave. Ontario went "dry forever," in the estimation of some. Other provinces followed suit, including Manitoba, Saskatchewan and the Northwest Territories.

But the centre of attention remained Ontario, and more specifically the Border Cities, because these isolated communities became the focal point for shipping illicit booze into the U.S.

Why Prohibition failed can be answered by a chronology of events and the background behind them.

On October 20, 1919, Ontario went dry by an overwhelming majority of more than 400,000. The Government sale of liquor was also soundly defeated by 240,000 votes. Ontario had also voted in a new leader, Ernest C. Drury, a Methodist Sunday school teacher and avid temperance man. He was leader of the new UFO party in Ontario, a political force dedicated to enforcement of the OTA. Drury appointed William E. Raney, an active Dominion Alliance member, as his Attorney-General.

The victory both in the referendum and the election was viewed as momentous, especially by the Methodists who openly boasted in their *Christian Guardian*, that "the liquor traffic's damnable trail (which) has besmirched every aspect of our political and social life," had finally come to an end. The editorial claimed that liquor had "bred crime and harboured criminals . . . mocked at decency and wallowed in violence," and now, it had "run its lurid course. . . ."

What irony! What ensued was specifically what the Prohibitionists believed would be eradicated. Prohibition created an age of mobsters and raised crime to new heights – all

(*Left*) Walkerville Brewery. (*Right*) Riverside Brewery. Inside, men were busily turning out as much beer as they could to meet the heavy demand.

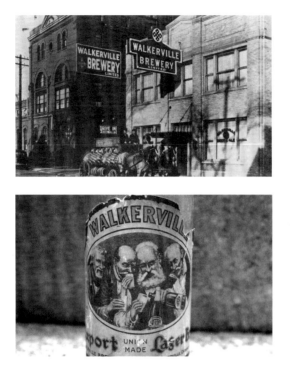

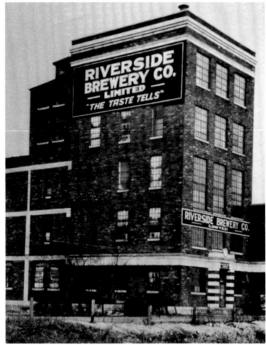

Breweries sprung up in the midst of Prohibition. Walkerville Brewery did a roaring business. Its facilities weren't far from the riverfront.

because of overlooked loopholes and the very insult of taking away a man's beer.

In any case, the new laws were short-lived.

In December 1919, the Federal Government repealed its wartime ban on the manufacture of intoxicating beverages, the importation of liquor into Canada and the transportation of it to any part of the country where the sale was illegal.

This took the wind from the sails of the dry advocates, because once again booze could be manufactured in Canada, and once more Ontario residents or residents of any other province or territory in Canada could import all the liquor and beer they wanted.

People were never prohibited from having a "cellar supply," for personal use, and they could now stock up on legal supplies from outside the province. Much of this supply came from Quebec.

The Ontario Government very quickly realized they had been fooled by the federal authorities.

Under pressure from temperance groups and provincial authorities, the Dominion Parliament approved Bill 26 before scrapping its wartime Prohibition measures. This bill decreed that the provinces could prevent the importation of liquor by holding a referendum.

In response to this, British Columbia, Alberta, Saskatchewan, Manitoba, and Nova Scotia all voted "dry" in their importation referenda, leaving isolated Ontario to debate the

question further. The province wanted to turn off the tap, but temperance leaders were divided over how this should be achieved.

The Dominion Alliance hoped for more than just an end to imported booze – its leaders wanted a ban on the sale of native wines, which were still permitted under the law. There were also heated arguments about the transportation of liquor *within* the province, which eventually led to the passage of the Sandy Bill, which disallowed the movement of liquor within Ontario except by and under the order of the Board of License Commissioners.

The bill, however, could not go into effect until Ontario had voted in favour of Bill 26, which would stop importation.

Ontario voters went to the polls April 18, 1921 and passed both pieces of legislation in a referendum, and on July 19, 1921, Ontario no longer allowed residents to order whiskey and beer from Quebec or any other province in Canada. At the same time, it was no longer permitted for anyone to transport intoxicating beverages from one place to another except under order of licensing officials.

The loophole in this latter law was uncovered by the watchful, amiable giant of the illicit liquor trade – Jim Cooper.

Cooper, who built the fashionable Cooper Court, first in Belle River, and then in Walkerville, made millions from his clever insight. He set up shop in Detroit and under a bizarre technicality supplied liquor legally to residents in Windsor. Canadians merely had to telephone a Detroit number and order liquor from Cooper. The goods purchased were not brought into the

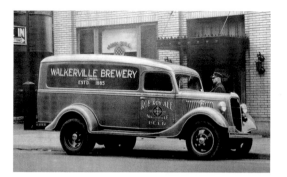

Walkerville Brewery supplied beer to customers as far away as Chicago and St. Louis, but also to thirsty Canadians.

province of Ontario. They already were in warehouses. But because the booze was purchased out of the country, it was perfectly legal to have it delivered from a Windsor warehouse to Windsorites.

There were other means of acquiring liquor. One was through a permissive doctor's prescription plan, a plan so abused that the Board of License Commissioners refused to honour the prescriptions if they believed physicians were not writing them honestly. Some doctors had taken advantage of the law to the extent that people were lining up in the streets outside their offices.

In one month, one doctor on Gladstone Avenue in Windsor, had issued 1,244 liquor orders

Wrong impression – Postcards that went into circulation depicting Canada as the barroom of the United States were vehemently opposed by temperance organizations.

and on one particular day had written out more than 244 prescriptions. This spectacle led Stephen Leacock to remark that if you wanted a drink in Ontario, "it is necessary to go to the drugstore, and lean up against the counter and make a gurgling sigh like apoplexy... one often sees these apoplexy cases lined up four deep...."

By May 1921, a limit was placed on the family doctor so that he couldn't issue more than fifty prescriptions for one quart of liquor each month.

Another means of buying liquor was from the manufacturer. But this had to be for *export* purposes. With clearance papers from Canada Customs showing you were exporting liquor to Cuba, South America, or virtually anywhere where Prohibition wasn't in force, you were permitted to take all the booze you could carry and pay for. The only stipulation was that a B-13 clearance document had to be issued from federal customs officials with the destination stamped on it.

The liquor was collected at the export docks that were strung out along the Detroit River shoreline from Amherstburg to Belle River. And the exporter, or rumrunner, as he came to be called, loaded up at night. Armed with his papers, or what Elliot Ness called, "The Canadian Print Job," the rumrunner stole away with his shipments across the lakes and rivers,

Windsor export docks kept Canadian Customs officials busy with rumrunners filling out B-13 Export papers to take liquor to places that did not have Prohibition, when, in fact, the cargo was headed straight across the river to Detroit.

unseen by the watchful Yankee patrol boats. The runners weren't lugging crates of whiskey to South America or Cuba, as was indicated on their clearance documents: they headed for Detroit or Cleveland. So ludicrous was the situation, that the *Border Cities Star* ran the headline: "SAME BOAT GOES TO CUBA FOUR TIMES DAILY."

These bold and brash runners – some of them taking photographs of themselves sitting upon crates of booze on a wind-swept, frozen river – were a special breed. They carried their cargo on rafts, rowboats, canoes, sailboats, speedboats, anything that could float and facilitate travel to Cuba or South America or Detroit.

Of course, some of the liquor remained right here in Canada. The boats would pull out of the export docks headed for some faraway port across the world, but instead would zoom straight to slips behind the roadhouses, such as the Rendezvous, the Sunnyside Tavern, or the Edgewater Thomas Inn. The liquor also ended up in private homes, or in secret caches where it was later hauled by automobile and truck to blind pigs.

Even the laws at the time made it impossible to stop the flow of liquor across the Detroit River. On August 11, 1921, the legality of exporting liquor into the U.S. was challenged in a Windsor court. Police Magistrate W. E.

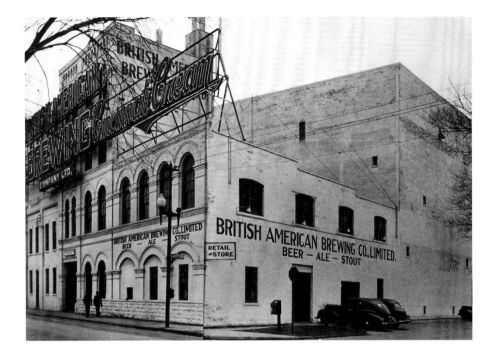

The British American
Brewing Company.

privileged to fill orders for shipments of beer to the U.S. even if it is illegal for the citizens of the U.S. to have beer."

This was followed by a statement from the Walkerville Brewery: "If Sam Smith of Flint orders a carload of beer, the order will go through the usual way. We will obtain clearance for the beer at the Customs and deliver it to Sam Smith in any boat he sends."

Gerald Hallowell in *Prohibition in Ontario* makes it clear that export was a matter of federal jurisdiction. He said, "Smuggling broke no Canadian law and the Dominion Government showed no signs of remedying the situation. There were no provisions in the Customs laws or regulations to warrant refusal of clearance." He quotes one official as saying: "To anyone interested in assuaging the sudden thirst of 100 million Americans, Canada was the promised land, a smuggler's paradise – an Andorra with a border 4,000 miles long, and an undefended border at that."

During Prohibition, six distilleries and twenty-nine breweries operated within the province of Ontario, all licensed by the federal government.

Drury and Raney did everything they could to stop the illicit activity, but to no avail. When they contested shipments of beer and liquor going into the U.S., a Windsor magistrate said that unless Canadian authorities changed the laws, customs authorities were obliged to provide clearance papers.

Raney moved swiftly and harshly to put an end to such illicit liquor traffic. He enlisted the fanatical Reverend J. O. L. Spracklin, whose

Gundy ruled that shipping beer and liquor from Canada into the U.S. was actually lawful, even though Prohibition existed on both sides of the border. He pronounced that the Canadian Government had no power to prevent such supplies from reaching thirsty Americans. This test case resulted from a protest by James Haverson, the lawyer for The British American Brewing Company, when Sandwich Police confiscated a shipment of beer intended for five individuals in Wyandotte, Michigan. The lawyer argued that under Dominion law, there was no legal right on the part of the police to stop this export across the river. E. R. Bond, then vice-president of the brewery, stated at the time: "We have no knowledge of or interest in the laws of the U.S. and believe that we are

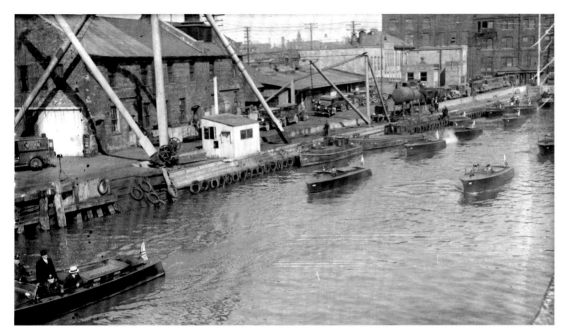

The Export Docks were clogged with rumrunners eager to make a fast buck. The riverfront was open 24 hours a day as these so-called exporters conducted business.

Loading up a speedboat from an export dock on the Canadian side of the river.

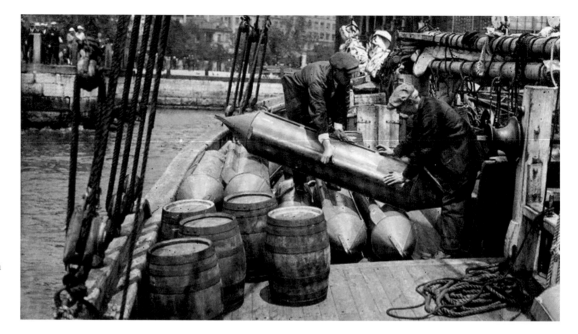

Bizarre stories circulated during this era, including tales of liquor encased in torpedoes shot beneath the river's surface to secret terminals.

story is included in this book, but this effort backfired when Spracklin shot and killed a tavern owner in a zealous campaign to eradicate bootlegging in what was termed "The Essex Scandal."

Forty million dollars in booze crossed the Detroit Funnel yearly. Booze was going across with skaters on sunny afternoons and tourists crossing on the ferry. Bottles were strapped to underclothing, inside brassieres, in stockings, in boots, up coat sleeves, in car tires. But this was small-time suitcase smuggling. Liquor found its biggest profits in boats and old jalopies.

Liquor traffic also led to more ingenious forms of delivery. Air rumrunning was perhaps the most dynamic of them all. Aerial smuggling was a novelty, and at first it was something that

went unhampered by authorities, who already had their hands full trying to combat the convoys of boats that snuck across the river at all hours of the day and night.

The aerial rumrunners were big-time and gang-organized, under contract to the likes of Al Capone and the Purple Gang, who needed swift supplies on a daily basis. It was estimated that as much as $100,000 worth of booze left Windsor and neighbouring parts via the air each month for American landing strips.

In Ontario, the landing strips were often farmers' fields, given over to the rumrunners at a flat rate fee. Sometimes they were paid as much in one day as what they would have earned if they had put in a crop. Sometimes the farmers aided the runners by assisting the pilots in landing at night. They would drive their cars

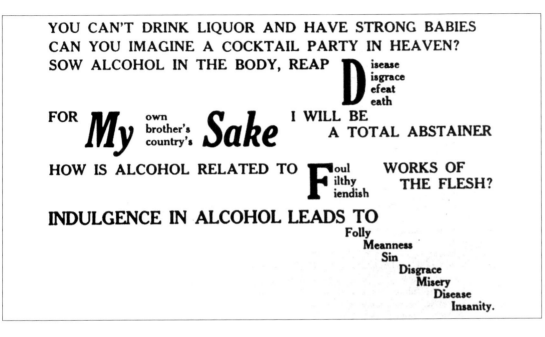

YOU CAN'T DRINK LIQUOR AND HAVE STRONG BABIES
CAN YOU IMAGINE A COCKTAIL PARTY IN HEAVEN?
SOW ALCOHOL IN THE BODY, REAP **D**isease
isgrace
efeat
eath

FOR **My** own
brother's
country's **Sake** I WILL BE
A TOTAL ABSTAINER

HOW IS ALCOHOL RELATED TO **F**oul
ilthy
iendish WORKS OF
THE FLESH?

INDULGENCE IN ALCOHOL LEADS TO
Folly
Meanness
Sin
Disgrace
Misery
Disease
Insanity.

The curses of strong drink.

to the field and keep their lights on, and often would set up lanterns and build small fires. For this assistance, they were paid as much as five dollars a case.

Large cargoes of liquor also made their way to Detroit through the railway tunnel under the Detroit River. Railway cars labelled for Mexico by way of the U.S. were shunted off the main track and unloaded on the outskirts of Detroit. In a 1923 exposé, the *New York Times* claimed that more than 800 cases of beer were delivered daily by mislabelled boxcar to Detroit. *The Detroit News* claimed in a 1928 story that more than half the shipments of illegal liquor to Detroit came by rail.

The typical scam was that carloads of just about any legal product were shipped across the border from Buffalo through Ontario to Wind-sor, where upon arrival, the Customs seals of these cars were broken and liquor substituted for the contents. Fraudulent seals were then affixed, and the boxcars rumbled right on through into the U.S. where they never underwent inspection.

Bizarre stories circulated during this era, including tales of liquor encased in torpedoes shot beneath the river's surface to secret terminals. And there were those who claimed there was a pipeline in the riverbed that flowed with whiskey. There are some old-timers who insisted they'd seen it.

One true story recounts how a contraption built to haul up to twenty cases of liquor along the river's bottom by means of a 500-foot cable was uncovered by customs border patrol inspectors in the fall of 1929.

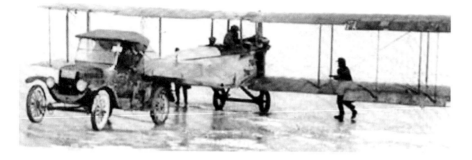

Plane smuggling became the fastest way to get liquor to thirsty Americans. Here these rumrunners are unloading liquor from a plane on the ice. (Courtesy of the Dossin Great Lakes Museum)

Nothing could stop the flow of booze into the U.S., not even the American patrol boats.

At the start of Prohibition, the American forces combatting rumrunning were sadly impotent. Both the Michigan State Police and the Detroit Police had in their shared possession a single antiquated boat that could barely catch the slowest rumrunner's vessel. In time, however, they built up their force and by 1922 had a 200-horsepower boat – with a top speed of thirty-eight miles per hour – crewed by a formidable collection of brutes, carrying with them handguns, machine guns, tear gas and rifles.

But in the beginning of Prohibition, the rumrunners nearly drove the police off the waterfront. The runners often fixed a cannon to the bows of their vessels and gave chase to the police. Gangs such as the "Jew Navy" openly attacked the police's cleanup operations on the lakes and rivers.

Drury and Raney knew by 1923 that the rumrunners and bootleggers would continue to flourish as long as Prohibition remained in force. All the propaganda about crime and drunkenness being wiped out was pure puffery. Blind pigs and illicit stills had sprung up every-

where, even within walking distance of Queen's Park, the Parliamentary offices of the Ontario Government. Speakeasies, gambling casinos and bootlegging joints across the province, and especially in the Border Cities, were thriving.

The Canadian Government even received handsome benefits from Prohibition. The Canadian taxation system funnelled money from smuggled liquor transactions into government coffers like never before. The Dominion Government levied a nine dollar tax per gallon on all intoxicating beverages. This was refunded upon presentation of a customs receipt from the country to which it was destined, providing that country was not in the throes of Prohibition. Since most, if not all, of the liquor landed on the American shores, these receipts were never handed in. As a result, the tax dollars piled up in Ottawa, and by 1928 the Canadian government was gathering up to $30 million a year from illegal exports to the U.S.

Officials in the employ of both provincial and federal authorities garnered tidy sums from rumrunning activities as well. Newspapers revealed, for example, unhampered delivery of beer to Detroit, Cleveland, St. Louis and Chicago. One U.S. Border Patrol officer, Daniel Shimel, who was one of the most notoriously hard-nosed policemen, was offered more than $50,000 to resign. He eventually resigned, not for the money, but because his colleagues *who were* taking bribes had threatened his life.

At one point it was discovered that the entire Yankee Border Patrol was on the take, and they were all either fired or forced to resign. One bootlegger, George Remus, who was called the

"King of the Bootleggers," estimated that he spent more than $20 million on payoffs during his lifetime.

In Canada, the situation was similar. People like Cecil Smith and Harry Low paid big bucks to avoid trouble from the police and warehouse owners. The extent of the graft, about as commonplace as smoking in public, shocked some officials, most notably the Canadian Minister of National Revenue, William D. Euler, when he visited Windsor in 1928. He stood on the riverbank and saw the boats leaving the Canadian side and heading straight to Detroit, and nowhere to be seen were the American patrol boats. Euler decided to ask a man at the export dock who was in the business why these runners didn't get caught, and the reply was simply that the police had conveniently taken the day off.

By the end of 1923, Drury's government counted amongst its successes that it had ended the importation of liquor from other provinces, and that it had set controls over prescriptions given by doctors. But in reality, it had failed both to halt the massive export of liquor across the border, and board up the blind pigs, bootlegging joints, casinos and roadhouses.

In the election of 1923, the UFO party was defeated by a new Conservative Government led by Howard G. Ferguson, who promised during his campaign to advance measures to please everyone concerned with the OTA.

Ferguson moved cautiously, not wanting to immediately dismantle the framework set up by Drury, and in 1924 held a referendum to determine whether voters still wanted Prohibition.

Well remembered by those most interested was the day in 1925 when the Ontario Government's 4.4 or "scantling beer" first went on sale. It was legalized beer, but most old-timers said it couldn't compare with the real stuff.

The huge majority of 400,000 of 1919 dwindled to a mere 33,000, but it passed again.

In 1925, Ferguson's government introduced legislation permitting the sale of 4.4% beer, soon to be called, "Fergie's Foam."

In 1926, Premier Ferguson returned to the polls, this time campaigning on the reintroduction of liquor through government control. His party was returned without losses.

In June 1927, the Conservative government introduced the Ontario Liquor Control Act, thereby ending Prohibition in Ontario. Liquor could now be bought through government outlets.

In the U.S., Prohibition was still in full swing. It wasn't to be repealed until 1933. Thus, the rumrunners, undaunted by the fall of Drury and

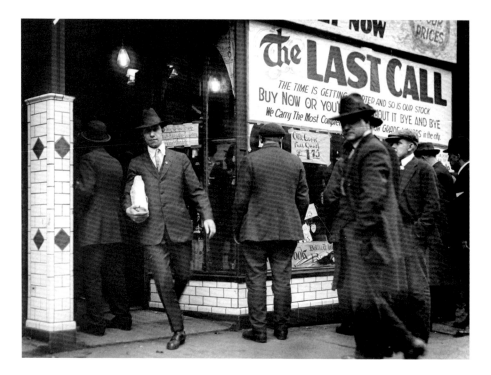

Last Call: People rushed to outlets to buy what was supposedly going to be their last opportunity to buy liquor.

unconcerned by the scrapping of the OTA by Ferguson, continued running booze across the border.

But all of this came to an end in 1930 when the MacKenzie King Government, heeding the pressure of the U.S., shut down the export docks and made the shipment of booze illegal from Canadian ports. It was too late to be of any use to the Prohibitionists, but it did put an abrupt end to the boom years of Prohibition in Canada, and especially to those in the Border Cities.

The stories of many the giants of Prohibition – Harry Low, Jim Cooper, Cecil Smith, Vital Benoit – are included in this book, but so are vignettes of those curious and lesser known

rumrunners who manned the boats and stole across the midnight waters. Most of them have passed away by now; some took their secrets to the grave. Others, quoted anonymously here, were still afraid the tax department or police would break down their doors and catch them fifty years later.

This book takes the form of a "scrapbook," which simply means that it is a collection of interviews, recordings, newspaper clippings, drama and miscellaneous bits about the turbulent era of Prohibition. The colourful lives of King Canada, who used to ship liquor daily to Al Capone in Chicago; of Walter Goodchild, who fought for his life in the Battle of Old Crow; the stories of the girls who engaged in the liquor trade at the age of five, or people who lugged boxes across the river bottom; of Jake Renaud, who aided his father in operating a speakeasy; of Noel Wild, who witnessed the kidnapping of his father (a newspaper photographer) by rumrunners; the stories of policemen, customs officials, newsmen; accounts of the incredible escapades of the gun-toting Methodist Minister Spracklin; yarns about blind pigs, speakeasies and the crazy, gone-mad era that roared on in the riverfront roadhouses; detailed narratives about Detroit's notorious Purple Gang and crime syndicate bosses like Pete Licavoli; their stories are told here, those of the people who fashioned the Roaring Twenties. Contraband liquor was what they all had in common. It made their careers, kept them at work, and gave them fame and wealth, no matter how short-lived.

Fireman feeding a pig beer.

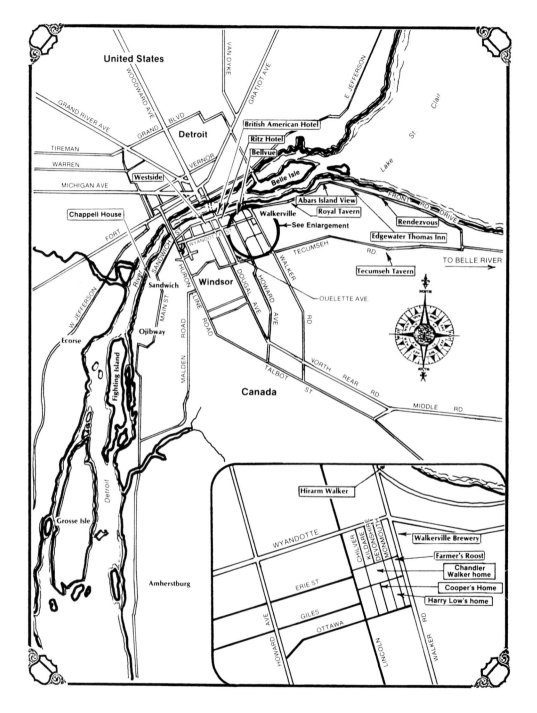

Four-fifths of all the liquor that went from Canada to the U.S. originated in the Windsor-Essex region.

(Drawing by Peter Frank of Gale Research)

The Windsor-Walkerville Connection

Art Jahns, archivist for Hiram Walker & Sons, writes about the connection between the two communities of Windsor and Walkerville. Walkerville was built on booze. It was a town developed and shaped by Hiram Walker. This piece by Jahns appeared in the Walkerville Times.

Because of a strengthening U.S. temperance movement in the 1850s, American distiller Hiram Walker came to Canada and established operations just outside Windsor. By the turn of the century, his Canadian Club Whiskey and his model town Walkerville were world-famous.

In the early 1800s, the consumption per capita of alcoholic beverages was at levels that would shock us today. It was a time before colas and other soft drinks, before fruit juices, even coffee and tea were often hard to obtain in frontier areas. Without refrigeration, even milk was at a premium.

Whiskey filled the bill and became the main beverage of pioneers. It was made locally in the mills and cost only twenty-five cents a gallon to produce. "Coffee breaks" for labourers were actually "whiskey breaks." Most people of the period also believed in the medicinal value of whiskey. The negative side of excessive whiskey consumption was downplayed, but with the

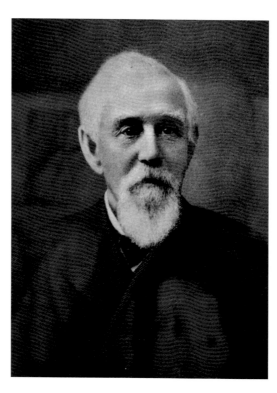

Hiram Walker.

passing of time, the problems became more and more evident.

Temperance movements had been in existence during this time, but now they gained in momentum, preaching the evils of drink. These leagues for the most part did not promote the complete elimination of alcoholic drinks but rather conservative and intelligent consumption.

Products of Hiram
Walker's Distillery.
(Courtesy of Bill Marentette)

In Canada and especially the U.S., saloons became a social mecca without equal. In an effort to draw more patrons, saloons created the "free lunch." Free only after the patron had laid down his money for drinks. The best free lunches were in Chicago.

From an 1890s survey, the following amount was consumed per day in a Chicago saloon: "150 to 200 pounds of meat, two bushels of potatoes, fifty loaves of bread, thirty-five pounds of beans, forty-five dozen eggs, and ten dozen ears of corn plus a variety of vegetables." We can only imagine the amount of alcoholic drink that was served to cover the cost of food and provide a profit for the saloon-keeper.

A woman at the head of a San Francisco temperance league declared that when her sons began their business life, they found themselves practically compelled to resort to the saloons for their midday lunches. No doubt the free food was an enticement, and they would have paid for a few glasses of whiskey to wash it down.

All of this activity brought with it heavier whiskey consumption and more social problems. Public drunkenness was all too common. Unfortunately this was, in many cases, the least offensive result of too much drink. Federal governments passed few laws to stem the problem and the temperance movements evolved to become the main "dry" force.

One temperance law that did have some impact was the "Maine Law" of 1854. This law managed to close some saloons and retail liquor outlets. The problem was that the law was enforced at the local level and some police were easily bribed. In spite of the shortcomings of the

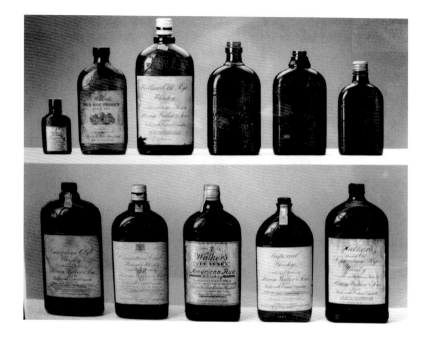

law, it had moderate success and several U.S. states adopted it, including Michigan.

Distillers and liquor merchants became genuinely concerned, including Hiram Walker of Detroit. In 1856, Hiram decided to come to Canada and set up operations outside Windsor in what was to become Walkerville. Temperance leagues were also in Canada but they seemed to have less of a presence than their counterparts in the U.S.

This move was to have profound consequences for Hiram Walker. A mere three years after he began The Windsor Distillery and Flouring Mill (later Hiram Walker & Sons), Prohibition hit hard in the U.S. This proved to be a windfall for Walker.

Then the Civil War began and U.S. distilleries were closed as non-essential industry and the border was closed to Canadian Whiskey imports.

The Americans had acquired a taste for our whiskey, however, and what followed would be only a preview of things to come.

According to Francis Chauvin in *The Life and Times of Hiram Walker*, written in 1927, "The demand for alcoholic beverages was so great that smuggling of Canadian-made whiskies became as profitable an occupation as it is now (1927) ... every day Walker's distillery was busy loading jugs and casks and barrels into American boats heading for American shores."

The Civil War had not changed drinking habits and the temperance leagues continued to grow in number and strength. In Canada, the temperance movement also continued to grow.

By 1898 the government was pressured to have a national plebiscite on the issue of Prohibition. Although 52% of the vote was in favour, a very low voter turn out and issues with Quebec and British Columbia resulted in the government's refraining from action.

During Prohibition, Walkerville's Hiram Walker & Sons continued to bottle large quantities of whiskey.

The issues of "wet" versus "dry" remained unchanged for another twenty years. Then a war fought halfway around the world forced change. In 1914 World War I began – the war that was to end by Christmas – dragged on for years.

From a Prohibition standpoint, things moved quickly. In 1917, the U.S. entered the war, and again their distilleries were closed and the importation of whiskey was outlawed. American drinkers had anticipated this might happen and U.S. sales of Canadian Club had doubled in 1917.

This was another windfall for Hiram Walker, but the financial gain was to be short-lived. In 1918, the Canadian government closed all distilleries and breweries as a non-essential industry for the war effort. By the end of the year all distilleries, breweries, and wineries in both countries had closed. Complete Prohibition had been achieved as a direct result of World War I.

It was after the war that all the problems with Prohibition really began. Canada, a much smaller country population-wise, was more vulnerable to the effect that Prohibition had on the liquor industries, which provided local employment and substantial revenue for the government. As a result, Canadian distillers were allowed to reopen shortly after the end of the war.

The U.S. took a different approach: distilleries, breweries and wineries remained closed. The U.S. government had struggles with this issue for years and now decided to take a stand in favour of the "drys." The Volstead Act passed in 1920 to enforce this stance. Since the American public still wanted to drink, they turned to the Canadians distillers, now in legal operation, for their supply. When the U.S. authorities cracked down on the Detroit/Windsor border in the late 1920s most of the smuggling efforts moved to the East Coast.

The shiploads of contraband liquor that left the coast proved much more lucrative than the jalopy-and-rowboats methods of the Detroit River smuggling business. This change in logistics pushed the industry to new heights.

A royal commission was set up in the mid-twenties to investigate the issue of bootlegging. The commission went to every city in Canada, coast to coast, ordering people to testify about their activities or involvement in this phenomenon. No sentences were handed out; it was merely a fact-finding mission.

Hiram Walker's descendents, who still owned and ran the distillery at the time, admitted to the production of alcohol. However, they did not own the docks and thus were not responsible for any illegal activities that occurred there. The Walker family's involvement was deemed above board and there were no repercussions.

Interestingly, there is very little concrete

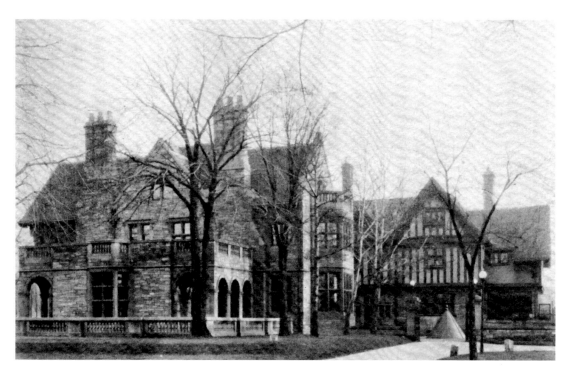

Willistead, the beautiful home of the Walker family in Walkerville, was donated to the town by the heirs to the estate and has since remained one of the landmarks of civic pride. With it went the beautiful grounds, now Willistead Park.

information available about Hiram Walker & Sons involvement in Prohibition, either during the nineteenth or the twentieth century. This is likely due to the fact that the Walker family wished to downplay the role they played. It is also believed that Prohibition was the reason why the Walker sons and grandsons sold the company in 1927 and moved to the U.S.

Tunnel Vision

Thanks to the Civil War, a Canadian dollar was worth a whopping $2.50 U.S. Being a visionary, Hiram Walker purchased as many U.S. dollars as he could.

At the same time, demand for alcohol was so great that his distillery was busy loading whiskey into boats headed for thirsty Americans. By the time the war ended and the U.S. dollar returned to par, Walker was a rich man.

Walker's success made competitors jealous; from a place called "Swill Point" in Detroit, a concocted story emerged that in order to avoid Customs, he had constructed a whiskey pipeline under the river from his distillery in Walkerville to his Detroit property at 35 Atwater St. Variations of this legend persist to this day.

Walker did use pipelines to move mash from his distillery to his livestock barns at Tecumseh & Walker.

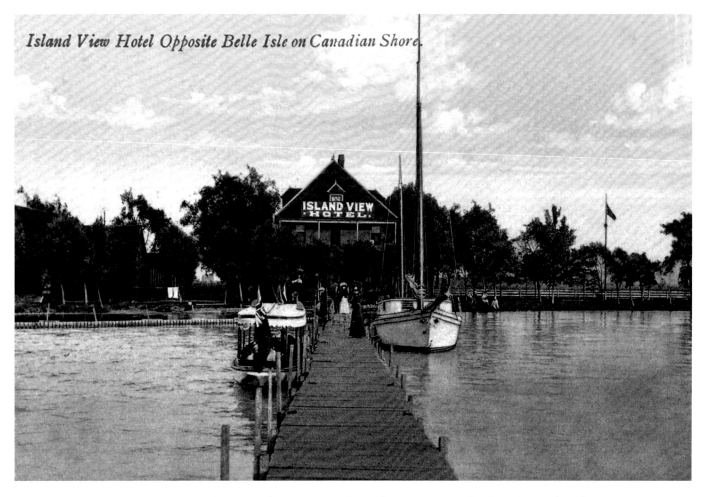

Island View Hotel Opposite Belle Isle on Canadian Shore.

Island View, commonly known as "Abars," was a roadhouse that sat opposite Belle Isle on the Canadian shore.
It was a favourite haunt of Babe Ruth, the Detroit Tigers and movie stars.

The Roadhouses

The shoreline of the Detroit River was like a diamond-studded bracelet with each glittering jewel a roadhouse. Michiganders nightly traversed the mile-wide river to moor their yachts until the first glimpses of dawn and then putt safely home to the American docks. They were on the Canadian side to feast upon the hearty seafood and chicken dinners, soak up the lush, elaborate speakeasies and toss away easy-come, easy-go money in long, bustling, upstairs rooms crammed with gambling tables and flappers.

This was the Twenties in the Border Cities. It was the age when men wore floppy tweed caps, slicked their hair back like Valentino, wore spats, smoked Omar cigarettes or Player's Navy Cut and carried revolvers. It was the age of kiss-curl ladies, chiffons, printed art crepes and hats with vagabond crowns. It was the age when parents washed their children with Lifebuoy soap and their clothes with Rinso, "the cold water washer" – then sped to the roadhouses for a night out to take in a little Bye Bye Blackbird, the Charleston, jazz bands – and of course, to roll the dice and drink.

On those nights, the music filtered out from the wide verandas and gingerbread barrooms of these fabulous roadhouses, and everyone within was lost in the mad whirl of music and

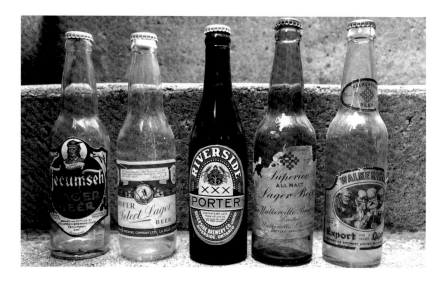

dancing – safe in the knowledge that although it was illegal to guzzle and gamble, trusty beady-eyed "spotters" stationed in second-storey windows or makeshift towers were ready to sound the alarm, warning of a police raid. And if the law successfully got wind of the illicit gambling and liquor, it was only a matter of minutes before the booze was rolled away behind false walls or into hideaway cupboards along with the gambling paraphernalia. All that remained in view for the police were the huge steaming platters of perch, frog legs, and chicken, hastily carried out to bored customers accustomed to such interruptions.

Beers of Windsor: A number of breweries sprung up during Prohibition, and these beers were served in roadhouses all along the Detroit River and nearby lakes.

(Courtesy of Bill Marentette)

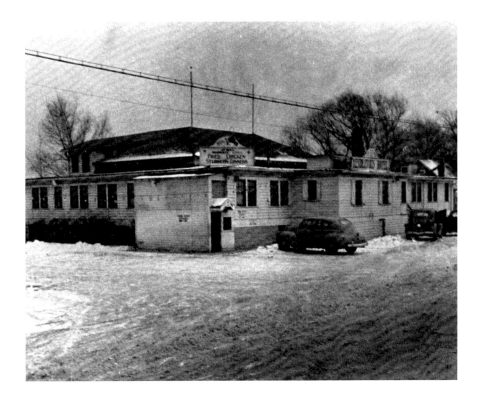

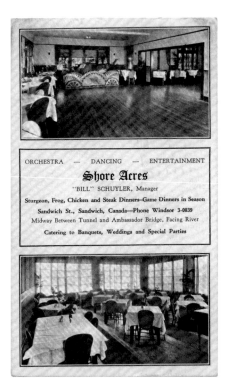

(*Above*) The Rendezvous' windows face east and west and were manned by spotters watching for police. Gambling and drinking were relegated upstairs, while one could indulge in heaping platters of chicken and seafood on the main floor.

(*Right*) Shore Acres promotion.

When I spoke with the Vuicics, back in 1980, Alice Vuicic, then owner of the Rendezvous Tavern in Tecumseh, Ontario, pushed open a storeroom wall panel on the second floor of the restaurant to display where gambling equipment had been stashed when the warning sounded. The entire second floor during the Twenties consisted of two large rooms for customers specifically wanting to drink and gamble.

Though Mrs. Vuicic wasn't the owner at the time, she discovered the false walls after she and her husband, George, left Kirkland Lake to buy the hotel. The Rendezvous had been one of several roadhouses in Essex County built close to

the water to provide easy access for illegal shipments of liquor. It was a typical Canadian establishment with a relatively relaxed speakeasy atmosphere.

Few of these roadhouses exist today. Among the survivors from the Twenties are the Chateau LaSalle in LaSalle at the western extremity of the riverfront. (There is also the Sunnyside, a mile from the Chateau LaSalle, but it was completely rebuilt after a fire destroyed it in 1972.) But gone are the Westwood in Ojibway, Shore Acres, and the old Chappell House, that in more recent years went under the name of The Lido, then Rumrunner Bar, situated at the border of the old town of Sandwich. It was here that the fanatical

Reverend J. O. L. Spracklin shot and killed Babe Trumble. To the east, there is the Bellvue (more recently called Danny's) and Abars Island View.

The Rendezvous was eventually torn down to make way for a housing development, but in 1980 when I spoke with Michael Vuicic, then general manager, it remained a going concern. He told me then that the food was probably quite good in the Twenties – large helpings of perch, pickerel, frog legs, chicken – but the meals were really a front for the gambling and drinking.

"You could eat all the perch you wanted downstairs for fifty cents – and upstairs there was the gambling and the booze."

When the old bar was removed and replaced thirty years ago, the simple but reliable old buzzer system was torn out. "This place was wired in with four other roadhouses – the Edgewater Thomas Inn, Abars Island View, the Golden House and Tecumseh Tavern.

"They would buzz that the police were on the way and all the stuff would be stashed."

Bottles were flung from the second-storey windows into a moat fronting the building. It was also from these second-floor windows that spotters were situated to watch for police and they'd hit the buzzer to warn the other hotels that a raid was imminent.

The Rendezvous was built in 1926 by Wilf and Harold Drouillard, who leased it to Danny Bell Sr., who in turn leased it to the Vuicics in 1943. The roadhouse was finally bought by the Vuicics in 1946. At the time of that purchase, the roadhouse was dilapidated. It had been neglected for several years by Bell, who was also

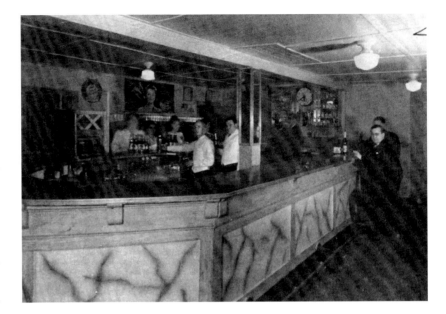

operating two other places – the Bellvue and the Royal Tavern. These were far more popular than the Rendezvous after Prohibition. Bell only kept the Rendezvous in order to secure a larger beer quota from the Ontario Government. Vuicic said Bell's routine was to send his men over in a pickup truck to load up the beer and haul it downtown.

"I know this because when my father bought it, Bell's men arrived to pick up a load of beer. My father told them they couldn't have it because he now ran the hotel."

The two large second floor rooms of the Rendezvous were altered after Prohibition because the new laws in Ontario stipulated that an establishment had to have at least six rooms to have a licence to serve beer. Bell built the six bedrooms but they were never used, according to Mrs. Vuicic.

The Buzzer Bar. The bar at the Rendezvous was called "the buzzer bar" because it was rigged with an alarm system which warned of impending raids by the police. When the Vuicics replaced the old bar, they had to tear out all of the wires from the antiquated buzzer system.

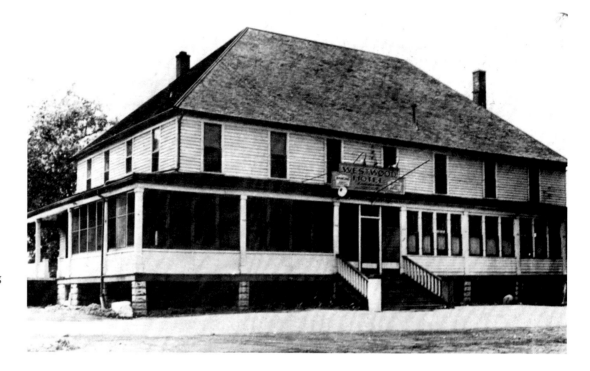

Westwood Hotel, a typical roadhouse with secret sliding shelves concealing bootleg liquor, was a haunt for rumrunners.

"In those days, you'd do just about anything to stay in business," she said.

The only surviving hotel that was wired in with the Rendezvous is Abars Island View, a towering three-storey building, with a name derived from the Hebert family, the original owners. A fisherman, Henri Hebert, registered the trade name "Abars" in 1893, because he found the French pronunciation of his name was more familiar in its anglicized spelling. The hotel remained in the family for three generations, and the name became a symbol of fine cuisine. Built to serve the stagecoach lines, the hitching rail at the front entrance remained long after automobiles made their appearance. At the turn of the century, the roadhouse became a leading nightspot on the waterfront and lured high society visitors from Detroit. Formal dress was required and local patrons were sometimes discouraged from dining there.

The flamboyant Mrs. Hebert, dressed in jewels and furs, sat at the entrance to greet her guests – the Fishers, the Dodges, the Fords, Jack Dempsey, Al Capone – or the Detroit Tigers and New York Yankees who often crossed the river to come to Abars because regulations forbade them to be seen in Detroit speakeasies. They directed their launches into the slips and docks provided behind the roadhouse, which sat right at the mouth of the Detroit River.

The Golden House in Tecumseh, which shared the buzzer system with Abars and Ren-

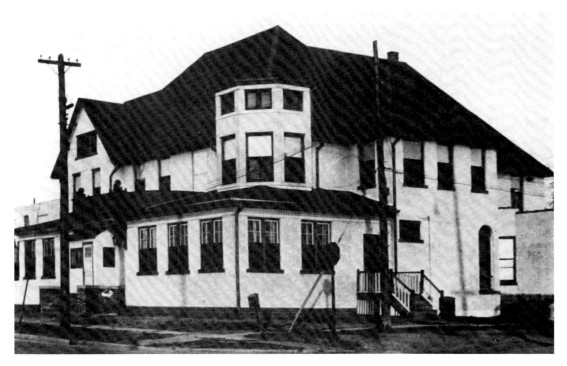

The Chappell House had a large ballroom and was a popular gambling and cockfighting spot. It was here that Reverend Spracklin shot the owner, "Babe" Trumble.

dezvous, burned down in 1976. It was ninety years old and originally known as the Bedell Hotel. One of the four original inns in the community, the Golden had a livery stable for its customers and large open facilities for eating and drinking.

Alphonse Pitre and his wife purchased the hotel from the Town of Tecumseh during Prohibition and operated it for fourteen years. His inn, along with the Tecumseh Tavern, was a good "stopping off" spot for travellers. The Tecumseh Tavern, built in 1903, was destroyed by fire in February 1977.

Westward along the riverfront, two other roadhouses that operated during Prohibition were the Bellvue (Danny's) and the Westside.

Both places stayed open all night long. Cars with Michigan and Ohio plates were a common sight, and pickups with shipments of illegal booze arrived boldly and regularly.

Sometimes roadhouse owners themselves delved enthusiastically into the gambling. One hotel owner, who had been losing all night, challenged another hotel owner to put up his establishment against his. With a throw of the dice it was decided – and the challenger lost. The next day, he made arrangements to transfer the ownership of his roadhouse to the winner.

Besides the roadhouses, there were regular hotels in Windsor, including the British American, the Ritz (not the present one) and the Windsor Hotel. These were not in the same class as

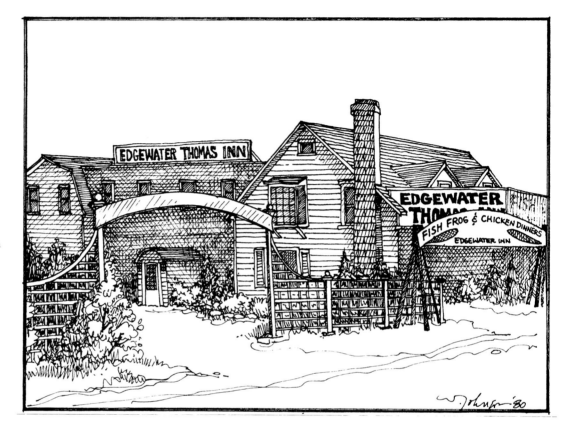

The Edgewater Thomas Inn was run by the lovable Bertha Thomas, who paid off police officers and gave away money generously to orphans and the poor. Bertha built the Edgewater from a small-time restaurant into a fashionable hotel.

(Drawing by Bill Johnson)

the roadhouses, which had an easier and classier atmosphere.

Further to the west of Windsor, the Chappell House was the dominating roadhouse. Built within a few feet of Sandwich Street, it had a sign over the entrance that read: "At All Hours." There were accompanying signs on the railings advertising frog legs, chicken and fish dinners.

This roadhouse with its prominent veranda was actually the second Chappell House. It was built by two brothers – Henry and Harley Chappell. They opened their first in 1865 on the Canadian Steel Corporation property in Ojibway nearby. They sold this and bought the Mineral Springs Hotel in Sandwich, then in 1897 opened up the second Chappell House on the present site.

The Chappells ran the roadhouse until it was taken over by the Trumble family. But even before the Trumbles bought it, the roadhouse had gained a wide reputation for its sumptuous meals. The Trumbles ran the hotel until 1949.

In those heady days of Prohibition, the Chappell House shared the atmosphere of other

roadhouses with its extravagant parties and gambling, but it also offered the sport of game-cocks in the deep recesses of the rambling old building.

Near the Chappell House, the Westwood had its share of parties and customers. Victor Bourdeau, its owner, used to show customers a wooden shelf that slid out to reveal a small cache where liquor was once hidden away. The roadhouse, once owned by the Reaume family that gave Windsor one of its most colourful mayors (Art Reaume), at one time was closer to the Detroit River, but was moved to its present site.

Further along the Seven Mile Road, as it is known in Windsor, there are two roadhouses that gained international reputations – the Chateau LaSalle and the Sunnyside. Old-timers recalled that some of the frequent visitors to the latter included Jean Harlow and members of the Purple Gang. Those were the days when slot machines lined the walls and 21-tables and crap tables dominated the large rooms. Liquor flowed easily and without end.

The Chateau LaSalle gained its reputation under the ownership of Vital Benoit who was regarded in the LaSalle area as the giant among rumrunners. The owner of the Hofer Brewery next door and the man who paid for the street-car tracks to bring customers from Windsor, Benoit's efforts in no time transformed the hotel into a popular haunt.

Chateau LaSalle is one of those hotspots of the Twenties that has survived and become as *Maclean's* declared "merely respectable . . . refined." The "giddy" decade, as the magazine

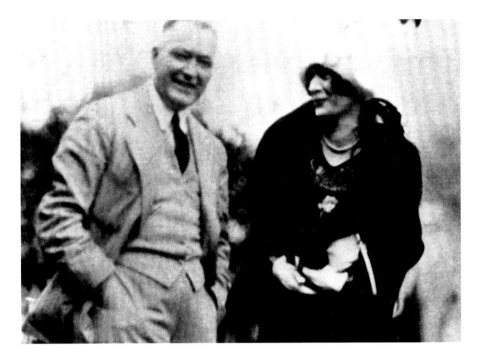

Bertha Thomas, in early years, with an unidentified companion.

described it, was reflected in their roadhouse style – the Venetian glass globes, the ginger-bread and the flappers. Evidence of that era has all but disappeared, except for the false walls, shelves and hidden rooms. These stand as reminders of the hectic pace and tone of Prohibition.

But of all the inns and roadhouses, the Edge-water Thomas Inn was the most unique and remained the most fashionable eating and drinking spot in the Windsor area. With its gin-gerbread flourishes, the inn was owned by the eccentric and wealthy Bertha Thomas. Later known as Martini's, it burned down in 1970.

The property where the Inn once stood is now the site of another eatery – Lilly Kazzilly's Crab Shack.

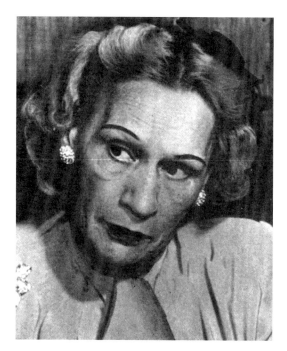
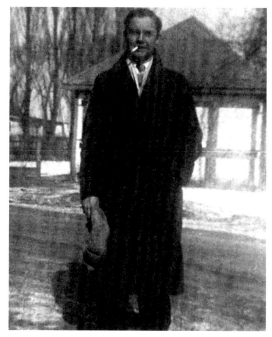

(*Left*) Bertha Thomas in later years. (*Right*) Louis Baillargeon, "Spotter" for Bertha Thomas.

Maclean's in an August 1953 article described the old Edgewater and Bertha: "Of all the inns around Windsor, Bertha Thomas's place was the most popular. Bertha was buxom, beautiful, full of personality, a Canadian counterpart of Manhattan's Texas Guinan. Her meals were good, her drinks were good, her band was lively."

Bertha was legendary. People recall her with fondness and admiration. She was a pioneer in the restaurant and roadhouse business in the Detroit-Windsor area. As the former Bertha Haf of Detroit, she came to Windsor as a widow to purchase a small three-room riverside restaurant. She cooked meals and served customers herself until she could afford both additional space and waiters. In the Twenties, her Edgewater Thomas Inn with its gingerbread entrances, mahogany panelled walls, its fabulous "shore dinners," the hideaway gambling and plush interior, became a favourite of Detroiters. As business improved, Bertha added more and more space. By her death in 1955, Bertha operated one of the most widely-known and patronized dining and partying establishments in the area.

But it was during the Twenties that Bertha made her reputation. Thomas's inn was equipped with secret passageways and hidden wine cellars. During Prohibition it took only the "tip of a stick" and the liquor shelves slid down a chute. Moments later, bottles of soda and soft drinks appeared in their place. Musicians had duties, too. When Thomas's inn was the target

of a raid the musicians would quit playing and rush to customers' tables and dump liquor from the glasses onto the well-padded carpets. On one occasion, when a band member missed the rug and some of the booze splashed upon the dance floor, it was mopped up by the raiding party – resulting in charges being laid against Bertha. But the clever roadhouse owner wasn't to be outdone. She proved that the dance floor had been recently varnished and that the varnish used had contained, curiously enough, alcohol.

Bertha's parking attendants also had extra duties. Louis Baillargeon, for example, was officially employed as a valet, but in fact was used as a "spotter." Hired as a young boy by Bertha who felt Louis lacked the proper home life and advantages of other children, she paid for his schooling and gave him work. Before directing him to park cars, she sequestered Louis in a strategic window location of the hotel where he was duty bound to do his homework and keep his eye on the movements of the police.

Bertha was among the few roadhouse owners who didn't have to worry about the police. Often it meant that she had to place ten-dollar bills on the floor in a trail leading from the entrance of the hotel to the back door exit. The police simply followed the path of money – and left the inn without charging her under the liquor laws.

Dorothy Lavellee, who was hired as a waitress by Bertha, never forgot those moments: "She'd see them coming, and she'd try first to ply them with beer and whiskey and she'd snap her fingers, and we'd come running, and she'd say to get the steaks on and frog legs."

But if things were serious – as sometimes they were when there were some young eager cops – the staff knew what to do.

"We'd dump the liquor into the carpeting, and if there were beer bottles on the tables, these would be tossed into buckets left under each table, and there were those long draping table clothes to conceal them from view, if there wasn't time to cart them out."

Besides Louis in the upstairs window, there was also a fellow stationed in the parking lot shack. Lavellee said, "If he saw the police coming, he'd press a button and the lights inside the roadhouse would flash on and off, and we knew we had to dump the trays."

Bertha was known for being very generous. She often helped struggling friends by paying their mortgages. In later years, she gave fabulous Halloween parties for the children in Riverside, Ontario.

"But if she didn't like you, you were in trouble," remembered a former Riverside Police officer. He added, "If she fancied you, then you were in good stead."

He said although many believed Thomas' Inn to be a fashionable nightspot, it was really "a high-class blind pig," and when it burned, many of the hidden rooms people often talked about were uncovered.

"She had all kinds of places to hide the booze – and there were buzzers all over the place – outside under the windowsills or in the little shack they had for the parking boys – there were buzzers inside near the bar and in various other

rooms – and there were false walls that would open up – she had it all figured out."

No matter how many times Thomas's inn was raided by the police during the Twenties, it was always back in business in less than ten minutes. "A fine was nothing to her," another policeman said. "It was just part of her operating expenses."

Lavellee recalled how as waitresses they had to line up outside the kitchen like soldiers each morning before work. Bertha would pace up and down in front of them, checking nails, and making sure their stockings were straight and their uniforms pressed. She didn't tolerate negligence of personal hygiene.

"She would check our shoes, what we were wearing, our hair, everything. If something wasn't right, she'd tell you. You had to be on the ball. You did what you were told. She didn't miss a thing."

Lavellee eventually left the roadhouse and went to Arizona where she ran her own place, but returned to manage the inn once Bertha had left.

"Bertha was a mystery. She lived on the second floor of the roadhouse and her place was lavishly decorated. She also had some private rooms up there, and into these, the police the bigwigs, the politicians, anybody who was anybody, could have those rooms for their own use, and they used them, played cards, drank, whatever they wanted. I know this because I had to bring the whiskey up there.

"I think some of them may have been connected with those running the liquor operations in Detroit and Chicago. Some say that Al Capone might've come there – I can believe that, but I never saw him personally myself."

Mary Maguire, a niece of the legendary Bertha, recalls Thomas' Inn well. She said there was a secret narrow passageway down to an underground dock below an old rumrunner haunt. She also remembers a rotted-out Chris Craft motorboat from the 1920s that had once been used during the rumrunning days to spirit liquor to this old roadhouse.

"I couldn't believe it," she said.

Maguire said the boat well was situated directly below the inn itself.

"Nobody knew about it," she said. "My aunt was so secretive. She had to be. There weren't too many she trusted." And if she learned that someone from her staff revealed something that ought to have remained quiet, she fired the person on the spot.

Maguire discovered the old dock long after her aunt's 1955 death. She had coaxed her cousin, Bertha's only son Russell, to show her the hidden entrance to the dock that lay below the rambling old roadhouse.

Maguire's mom and dad lived on the second floor of the roadhouse when her father, Pat Norton, was its manager.

Maguire said, "Bertha didn't like people to know about the private gambling quarters. She was very closed-mouth about a lot of things. She wouldn't tell you anything.

"This is a woman who just cries out to have a book written about her," says Maguire, who years ago started to research the life of her mother's sister.

In many ways, it was a family business.

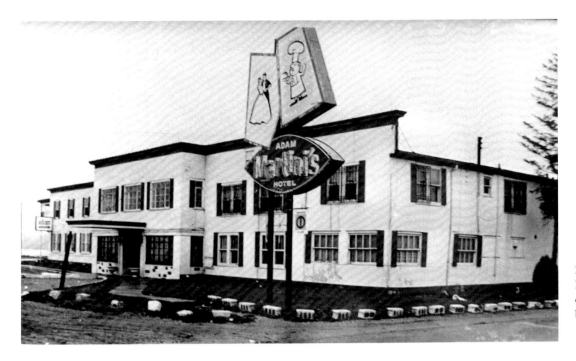

Martini's. The former Edgewater Thomas Inn owned by Bertha Thomas burned down in 1970.

Besides her brother-in-law as the manager, her sister Minnie was the bartender.

"These were the ones she could trust," said Maguire.

Bertha's maiden name was Haf, and her family hailed from Germany, but during the First World War, she changed her name to Thomas because of the adverse sentiment toward those of German origin. The name "Thomas" belonged to an old lover, said Maguire. "He had been an alcoholic, and Bertha finally kicked him out. But she kept his name." She had already long before divorced her husband.

It was the concealed boat well where the boats would coast in and unload illicit liquor and beer that caught the imagination of Maguire.

"I can still remember that stairway and how it was only wide enough to get a case (of booze) through. It was very steep."

She recalls seeing the Chris Craft "hoisted up and still hanging there."

Bertha also had an export licence, and legally could ship liquor across the border.

"There are so many myths and legends about her, and about that place."

But one that is true involved the secret rooms she kept in the roadhouse. The place was laced with false walls and from time to time, Bertha would move them around. She was always one step ahead of everybody.

"My aunt had a carpenter on staff, and he worked only for her. He was entirely faithful to her, and she trusted him implicitly."

Blaise Diesbourg.

King Canada: Blaise Diesbourg's Tales

Diesbourg's involvement in the liquor traffic soon brought him into contact with the kingpin of the underworld – Al Capone. He met Capone in a cellar in Belle River and struck a deal to supply him with regular weekly shipments of booze by plane. It was then that he adopted the name "King Canada." He soon became a supplier to the Purple Gang in Detroit and to other big dealers in the U.S. Instead of carrying a weapon, he carried a tough-minded attitude, which seemed to guide him to success. Diesbourg made bundles of money, but spent it as fast as he made it.

Diesbourg's story begins in the early years of Prohibition in Ontario when he was bootlegging and serving bar at his brother Charlie's hotel, the Wellington, on the main street of Belle River. He is remembered as a tireless worker when it came to loading liquor and beer into old cars and airplanes.

When I spoke to him, this man was a spry eighty-three-year-old. Blaise was a French-Canadian born in the farming area near Belle River, a small town west of Windsor. He lived with his dog in a two-room house that he had built himself. In his closet, he kept the choicest of his home brew – an endless supply of cherry and tomato wines. And in his kitchen, he always kept a bottle of whiskey at hand for any lull in conversation – though he loved to talk, argue, rib, and laugh.

Early Bootlegging

My brother was paying me only twenty dollars a week, you know. He said the business was all shot at the hotel – that's the Wellington Hotel and it's still in operation – but he said he'd give me a room and said I could eat here. And I helped him around the place, serving beer and cleaning up. It was during Prohibition. Oh, the police would raid the place. Why sure! But my brother didn't do nothing – he just paid the fine and opened up as soon as the liquor licence inspectors left. Nothing to it.

But that twenty dollars – I'd go to the dock (the export dock in Belle River that Art Diesbourg, his brother, owned), buy a case of whiskey and peddle it around, you know. I used to pay, oh about $1.25 a bottle, and I'd sell it for $3.00, I started up that way. I wasn't selling it across the river (in the U.S.). No, I was getting rid of it around here. Bootlegging it. That's what I was doing. But then I went on my own in about 1925 or 1926. I went to Stoney Point (east of Belle River on Lake St. Clair) and I kept my own hotel there. I called it Omar Hotel after Omar cigarettes from the other side. I had a partner, and he didn't want to buy my half of the business when I wanted to get out. He was no good – he'd drink everything.

Charlie Diesbourg (*at centre*), King Canada's brother.

We were bootlegging the stuff right from the hotel, selling it to anyone, but we also had rooms upstairs. My customers usually had lots of money; they were fellows from Chatham who came here with their girlfriends for a good time, and they'd drink in the rooms. We'd hide the booze at the neighbour's or wherever we could.

But we'd get raided. All the time. Jesus Christ, the police were in my place every day, until I put a stop to it. I sent a fellow I knew in government to Toronto, and he fixed it for me. I couldn't put up with that shit, no goddamn way.

I said to my friend, "I want that son of a bitch fired off the force." He said to me, "Don't worry, Blaise, he will be."

Well, he was, you know. I met my friend at a church affair in Stoney Point – it was in June. He said, "That guy (the constable) won't be bothering you anymore, Blaise."

Yep, he was gone – they say he was fired. I think he got a job in London. But you know, before that man got fired, I tried to reason with him. I mean, he was raiding my place every day. I got tired of that, so I decided I had better have a talk with him to fix this up. I decided to go see this constable – this is before I talked to my government friend.

So anyway, I went to Leamington (about thirty-five miles east of Windsor) where the police had their office. I saw him there. I went in, and said, "I don't want you to raid me no more," but he said, "Who the hell are you?"

I said, "Well, I'm just a little guy trying to get along, but I see I can't get along with you."

I had a bottle of whiskey with me. I took it out of my pocket and I put it on his desk.

"Now," I said, "lock me up!"

He said, "I will!" Oh, he was mad.

I said, "Have a drink with me, like a man." He wouldn't take a drink.

He said, "I'm going to call my partner and we're going to put you in jail." But I told him there was no goddamn way he was going to put me in jail. I took the bottle of whiskey and put it in my pocket and said, "I'll see you later." And when I went out the door, I said one more thing: "You know, you won't be here for very long." And he wasn't. He got fired. And you know, I never got raided again.

The Export Business

Them fancy people up there at Walkerville and them other places called this rumrunning "the

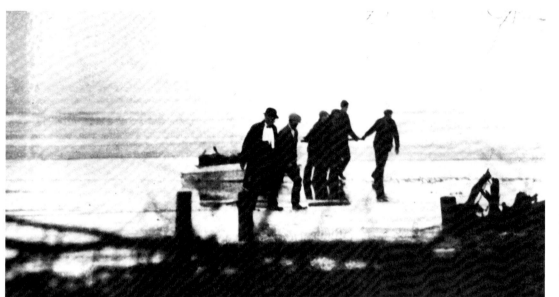

Rumrunners reaching shore. A well dressed man, possibly a tavern owner, helps rumrunners haul a boatload of liquor up to the shore.

export business." But you know and I know what that meant. It meant you took liquor across the border and sold it. Why sure, it was exporting the stuff, but there's no goddamn way it was legal. No way. But I'll tell you, everybody was doing it. Everybody took the stuff across, because it was the best way to make some good, fast money. Take it under your coat on the ferry, a couple of cases in a rowboat, any way you want. But me, I went into it in a big way. I took it across the ice, 800 cases of whiskey and beer, and it was like a highway out there – the cars going back and forth – and no one to stop you. Well, they had the law – but in the winter, it was hard to catch you.

The export docks were the places where you got the stuff. They were open day and night, twenty-four hours. Some guys would buy the stuff, load up the boat and leave it in the slips until night, and then they'd take it across.

I bought the stuff from all different kinds of places. They had export docks all along the river, but I never bought it from just one place – different ones all the time. And you paid cash for the stuff, maybe $10,000 sometimes. I'd get what I wanted and load it up.

The biggest outfit at the time was the Mexico Export Company. My brother Charlie was the watchman for them when he gave up at the hotel. But anyway, they were the biggest. There were also five docks at LaSalle. I couldn't tell you the names of all of them.

But there was also a dock in Amherstburg and in old Sandwich where the boats used to tie in. Coming this way (west), there were others. There was one where the CPR used to pull in on Sandwich Street near the railway bridge. They

Whiskey shipment on ice. At any time of day, the whiskey dealers and rumrunners would pile up shipments. Sometimes they were left like this in the middle of the lake for American rumrunners to retrieve.

also had docks at Riverside, Little River and one nearby at Lauzon Road – and then at Belle River. A big dock here. My brother Art was in that one with another fellow.

Well, a guy could come into these docks and get his whiskey and take it where he wanted. He had to have the papers of course. [B-13 papers were export permit papers from Canada Customs.]

Well, some of the bigger outfits from the other side wanted to make sure they got their stuff across. You may have heard of the Jew Navy. Well, they were a gang over there. They had a fleet of boats, more than the police, and they came over here and they docked and if the law on the other side was on the river, well, they

chased them away so they could get their stuff across.

It was a big outfit, this Jew Navy. They had about fifteen boats, and when the law on the other side saw them coming, well, they didn't wait around. When they seen the fleet coming, they just get to the hole, just like a rat. Oh yeah, they were scared. Well, later the law got themselves some big boats and they weren't so afraid.

In those days, you didn't use the banks. What good is a bank? They're never open when you need them. When I buy a load of whiskey at two o'clock in the morning, I need $12,000 in cash. So I'd get the money, but I'd keep it somewhere. Not at a bank. Who's going to open the bank at that time in the morning?

The bank manager here in Belle River asked me one time why I didn't put my money in his bank. I said to him, "Why should I put my money there? Suppose I want $20,000 at two o'clock in the morning, what would you say? You'd say to me, 'Go to hell!'"

You couldn't write a cheque in those days, except maybe at Walker's. I used to go to Hiram Walker's and buy a fifty-case load of whiskey. I think at that time a fifty-case load was $1,500. I gave them a cheque. They knew me.

I never was stopped at any of the other places. I always paid cash, and I could get $10,000 worth of whiskey just like that if I wanted. I was never stuck.

But one thing, I never did double-cross anybody. If you double-cross, you're a dead goose. That's what you are with them fellows. They'll get you. And that's what happened with some people. The law got them.

The law only stopped me once here. We had one provincial policeman here in town, and he knew me, and he knew what I was doing. But he didn't bother me. He was all right, a nice fellow, but this Mountie police guy – he was the one.

He came around one day asking about me. He said to the provincial, "Do you know this guy?" And of course, the provincial said he did.

Well, the Mountie policeman said, "Well, you know, he's taking stuff to the other side there." But the provincial – he knew I was doing this – said, "Oh no, he'd never do a thing like that. You'll never find a thing going to the other side from him."

"Well," the Mountie said, "look at this plane going up in the air there. He'll be here in fifteen minutes. I'll stop him. He'll be here on the Main Street."

Sure enough, I was. I come up the Main Street, and the provincial said, "Hey, put your car over there, the Mountie wants to search it."

I said, "Okay." But you know, I didn't have a damn thing, only my money. He took all the cushions out of the car. He looked under it, and when he got through, he had all the cushions out and hadn't put them back. I said to the provincial, "You tell that Mountie police to put them cushions back where he got them."

"So," the provincial says, "you know, you heard what he said, eh?"

The Mountie said, "Yes, I heard him!" And he put the cushions back where they were in the car. I was never bothered with them any more.

Taking the Booze Across

I used to take it across in old cars, old Ford trucks, on boats, but also planes. I was one of the only guys who organized that – putting the stuff on the planes. I would load them up on my own fields. I had five fields – some I rented, in a way. I just went to the farmer or the fellow with land, and they said it was okay and told me to go ahead. I gave them a case of beer – a goddamn case of beer, you know, was a lot – they'd pay twenty dollars for a case. Well, they were happy to get it. If they had a wedding, you know, and they wanted a keg of beer – well, they'd come to see me, and I'd say it was okay. Or if they wanted a bottle, if they were celebrating, they

Gangster Al Capone's support soup kitchen.

(From the collection of *The Detroit News*)

could have a bottle of whiskey. They didn't pay no money.

So anyway, I had the fields; one was my brother Art's. He had the farm, the place I was born and raised. He had that farm. We had our plant (stash for whiskey and beer) there, too.

Once one of the big guys in Windsor sold me some stuff and the police got wind of it. I had fifteen cases of alcohol, all in crates – five-gallon cans.

Well, I had a plant that nobody could touch. They tried. The Mountie police come and they walked over it. It was underground, in a big soft-water well (cistern) from the eavestroughs. We cut away the eavestroughs, pumped the

water out, and put the booze in. And it was just like walking in that door there, and it was just under that carpet. The opening to the well was right inside the house.

When the Mounties came, they thought it was in the hay in the barn, but that was a cheap trick. They were here like a swarm of bees, looking for that goddamn alcohol. But they didn't get it – they couldn't find it.

The night I brought it here, it was raining pitchforks. I took the truck and I hauled the alcohol to my plant. The next morning there were about fifteen Mountie police.

I was standing in the window of the hotel. I seen them. One fellow says, "See that hotel there? There's a guy in there that knows where that whiskey is." He was talking on the street and pointing with his finger. I knew where he was pointing. He was pointing at me, because they knew.

Well, anyway, I was the one who had the planes. That was the big business.

The Name "King Canada"

I was called "King Canada", because that's how I wanted to be known in the U.S. I gave myself that name, because here in town if the law comes looking for King Canada, well, nobody's going to know who that is. The people in town know me as Blaise Diesbourg, but they don't know King Canada. If the law comes to me and asks, I say I don't know. I did this so the law couldn't keep track of me and what I was doing.

Contract with Al Capone

Capone came to see me. He came to the dock, to the Mexico Export Dock, and he asked if there was anybody that could handle that stuff for him. Well, I was the only one that could. I mean Capone was getting the stuff by boats, but he wanted the stuff every day, by plane. I was the only one that could give him that.

So we got in the house of my brother Charlie, in the cellar, and we talked. There was another fellow with him. So we talked.

I said, "Listen, I am King Canada, and you don't fool with me. The first thing you miss, your goose is cooked."

He says he is Al Capone from Chicago.

"Yeah," I says, "I'm the King of Canada, and you know you can't fool around with me. I know every move in Chicago – every move you make."

He says, "How?"

I says, "What do you think I am? Don't you think I know something through the government of what's going on in Chicago?"

"Yeah," he said.

"Yeah," I said.

Capone was kind of a tough man – but oh, he was a good guy, you know. He was about, oh, I guess five-foot-ten or eleven – but smooth. He was never tough with me. I met him only twice – once here in Belle River when he came to see me, and once more in Chicago when I went down there with his pilots.

But you know when he come down to see me, he had this other fellow with him. I did not tell you this. He wanted me to carry dope. He says

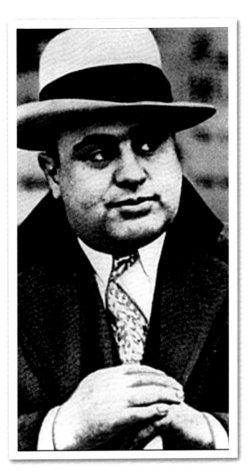

Al Capone.

it's only a little bundle – a little package – only twenty-five pounds.

Well, I says, "How much are you gonna pay?"

And he says, "$100,000! You think that's enough? I'll pay you in cash right here if you will handle it."

"No," I said, "I've never killed nobody, and I don't intend to kill nobody. And another thing, if the Mountie police ever got wind that I was

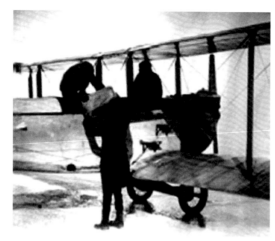

Bootleggers even flew their illegal cargo across the river. Here cases of beer are unloaded on a frozen stretch of Lake St. Clair.

(From the collection of *The Detroit News*)

handling that stuff you know what they gonna do with me?"

He said, "No."

I told him that I'd be going to bed at night, and they'd be sitting in the chair alongside the bed. If they weren't there, the minute I got into the car, they'd follow me. I couldn't make a move – I couldn't operate at all.

So I told Capone's man, "All right, so $100,000 is good, but what in the hell is it good for if I go to jail for the next twenty years? I can't use that money, you see."

Well, he says, "Yeah."

Yes, I worked for Capone. He had his own planes, old bombers – each had a pit on it about long enough to hold twenty-five cases of whiskey. At six o'clock in the morning, I'd meet the pilot there in one of the five fields. It didn't matter if it was six below, or ten below, I was there with the load. I loaded the plane up.

Capone would order from the export dock and it would be delivered to my field. I would load up the plane when it landed – that was my job. The pilot used to pay me money in a bundle from the bank. And it was stamped on the back how much it was. I never counted no money. He would give me the bundle and I'd throw it on the floor of the car. Never counted it. Never had time to count it. Because I only had five minutes to load in the plane. I used to throw on twenty-five cases every morning – 300 bottles of whiskey.

One morning, the pilot stopped at Ford's Airport in Detroit to get his car fixed – something had gone wrong with it. He called me on the phone and said, "I won't be there tomorrow morning. I'm getting my car fixed. It's in the shop. I'm going to be short $200 with the money."

Another time, the pilot said, "Capone wants you to come to Chicago." So I got in the plane and went with him to Sportsman's Park Racetrack in Chicago. And he was there – Capone, that is – with his big car. I got in with him. There were three motorcycles in the front and three in the back. And we had nine miles to go to the place they called the Fort.

So Capone says, "I want to show you a good time tonight." We started drinking, and he had about fifty girls – young girls about sixteen, seventeen. Oh, a beautiful show! He put on a real show! All dancing and everything! I got drunk and forgot where I was.

Well, the next morning, I had to take the plane because one of the men I had hired was waiting in the field with the load – back in Belle River.

The fellow sitting on the chair near me – I was

just lying in the bed there – says to me to get up. He was sitting there with a machine gun in his hands and he tapped me on the shoulder.

"Come on," he says. "Put your pants on, the car's warming up, the engine's going in the field. You got to get back. We have to send you back this morning and pick up that load."

So by jeez, I hurried up and put my pants on and I said, "I want a drink of whiskey." I used to drink a lot, you know. So that, fellow reached down on the floor and says, "Here, take a drink. Here's a glass." So I took the bottle of whiskey and I filled up the glass and drank it. I put my pants on, and when I had them on, I took the whiskey and got in the car and I come home to Belle River. Well, first he drives me to the airport, then to Belle River by plane.

Every day, I send the load to Chicago. I had, you know, a different field here. I never had them land in the same field.

But Capone was a nice fellow. Oh yeah. But they say that you couldn't double-cross him, because you'd be a dead goose.

Well, anyway, I'm the only one, the King of the Airplanes. I was called King Canada or the King of the Airplanes.

Years later when Al Capone was asked about his liquor connections to Canada, his quick retort, a great one-liner, something he was famous for, was this: "I don't even know what street Canada lives on." It could've been Diesbourg he was referring to.

Capone's attitude to liquor was typical of that era, carefree and casual. He remarked, "When I sell liquor, it's called bootlegging; when my patrons serve it on Lake Shore Drive (in Chicago), it's called hospitality."

The Purple Gang

I had a gang in Detroit I used to deal with. They were called The Purple Gang, you know. Oh, now they were tough. But they didn't bother me.

They had a big bar over there, and you knocked at the door. And there was a guy always there at the door. And when I used to go in there, I would just knock, and he'd say, "Who do you want to see?"

Well, I knew the guys there, and when the bar was running, he'd holler to another fellow to go get my friend. So, when my friend came, he'd say, "Oh, hello, it's King Canada! Let him in! Let him in!" And I'd go in, and they'd bring champagne – anything I wanted. Why sure, they knew me, all right.

You know, I made a lot of money in those days, working for people like Capone, the Purple Gang and a big fellow from Philadelphia. I was rich at one time. I had money, but just like that it was gone, and you know when you get too big in a business – you become too big of a man – and when that happens, you lose out. I bought an airplane. I paid $12,000 for it. It used to carry fifteen cases.

Well, this guy from the Purple Gang there on the other side, he come and made two trips – I couldn't fly myself – and busted it up on the other side there. He landed in the field where it

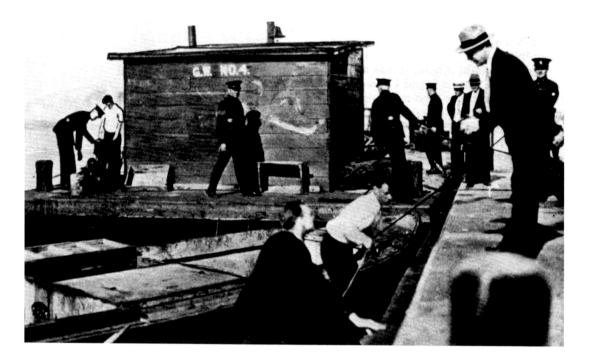

A typical export dock, Government Wharf #4 on the Windsor waterfront.

was rough. They busted up the undercarriage and then set fire to it. Got rid of it.

Well, that gang in Detroit says you better buy another one. Well, son of a bitch, we make only one trip on this side, I load them up here in my field at the end of this road here. His engine wasn't working right. So he just made it right across here at that army base. Just made it over the fence, and he crashed. Just over the fence. Right away he set fire to it, before the soldiers got there. Oh, they knew it was whiskey, but they didn't know the number of the plane, or who the plane belonged to, you see.

The Purple Gang had the pilot – a good pilot, too, most of the time – but I just wasn't lucky. Anyway, I lost $24,000 in there, crashed up two planes, a month apart. Yeah. They were $12,000 a piece.

Other Dealings

I knew a lot of guys, you know. In this business, a lot of the big shots over there would come here to get the stuff. They didn't care who supplied them with the liquor, as long as they never got caught – and as long as you can do it. I mean, no goddamn way you going to fool them – but no goddamn way they going to fool me, either. I tell them that every time.

I knew the Licavolis – now they had a gang over there, too. Now they say they were a part of the Purple Gang, but not true.

Big bucks in the canals. The intricate system of canals at LaSalle gave easy access to booze on the Canadian side. The canals led to roadhouses (Sunnyside and Chateau LaSalle) and were even close to the Hofer Brewery. Bullrushes and weeds kept a cache well hidden.

No, they were worse. There was two of them, two Licavolis. Peter and Tom. It was Licavoli who had that big boat, the *Sprite* – they called Pete himself "the *Sprite*." The boat held 400 cases of whiskey or 800 cases of beer. And the law got it, you know. They had it in the pound in Detroit. Licavoli went down and got the Purple Gang to get it out – well, they got it out. And they made two trips with it over across – 400 cases of whiskey one trip, 800 cases of beer the second trip. Well, the law was after them. They stored the stuff at Bob-Lo Island over there, and the law got them.

I used to supply them with booze sometimes. I loaded them up here.

I also used to have a fellow named Remus. He was a big dealer. He was from Cincinnati.

And he used to haul – he took 800 cases of whiskey or 800 cases of beer at a time. His load was that big, you know.

Well, I had the job to load 'em up. So we had to go across the lake with it, and he had to be loaded that night. It had to go then – that night. So I laid on four lifts across with the truck – 200 cases at a time, four trips – and he got his 800 cases.

It was no problem taking it across the ice. The ice was safe. I made the four trips in my truck. Where the channel was open, I built a bridge over it, and I'd just drive over that bridge. This channel was like a big crack in the ice. Some days it would be open, some days closed. We took eighteen-foot planks and put them one over the top of each other, you see. Then, you

hammer a spike through, into the ice so it won't slip. Then you go on it, see, and it would grab the ice. Then we added another eighteen-foot plank on the top of it. So when you go over with the truck, it went down so far into the water; it dipped into the channel and the water would come up to the truck. Well, we'd go across, unload the whiskey and have fifteen minutes to drive back. We did that quite a few times. Whiskey and beer – until we got caught – that last time we got caught going to the other side that way for that man in Cincinnati. He was a big dealer, a big fellow.

We just used a regular Ford truck, you know. Two hundred cases is a big load, you know, at a time. That's 200 cases of whiskey. I travelled that lake day after day, and that last trip I made over was a funny thing, you know. I had to take that load across at night to the same fellow, but he was short 45, 65 or 80 cases of whiskey – I don't remember how much. So we put it in two cars and then started there, and we had that much water on top of the ice here – a couple of feet.

But as we went, there was more than a couple of feet; we had rubber boots (hip-waders) up to here. We walked as far as we could and held an axe and we couldn't touch the bottom where the ice was – that's how far down it was.

My friend says to me, "We gonna cross?"

"Oh yes, we're going to go across. No goddamn shit, we'll go to the bottom of the lake, or go across. Number two is what we gotta do, you know."

So the other fellow with me, he was scared, you know, and he said, "You go first, and if you go in, you go in . . ."

So I put burlap bags around my engine, you know, on the side. And I went around and I opened her up – very wide – and I went through that water, and when I got through my engine was just tip-a-tub, tip-a-tub – just going. I said to my friend, "Don't stop the son of a bitch, or you'll never start it." So I kept going and finally got up my speed. Well, the other fellow followed me, when he seen that I went through all right. He followed, so we got to the other side – oh, maybe it was two and a half miles away – and we unloaded. But we only went two or three miles on that side of the river where we unloaded the stuff.

But when we came back to the lake, the ice was floating on the water – the ice had come up, it had melted. So this fellow – oh, he was stupid – he says to me, "How are we gonna get back?"

I said, "We'll get back with the ferry." Well, that night we slept in Detroit, and the next morning, we take the ferry back – the Walkerville ferry.

Another day, one of my dealers, another big dealer, you know, wanted about 1,000 cases of whiskey. He said, "Can you supply me with 1,000 cases?"

I said, "Yeah, 10,000 cases if you want it. That don't mean nothing to me. As long as you pay for it, I'll ship you 10,000 cases."

But he says, "How the hell am I going to get them? I want to take 400 cases at one time."

I told him, "You go to work and buy a whole bunch of cars." At that time, you only paid five, ten, fifteen dollars per car, you know. You didn't want no good car – I mean if it fell through

the ice, it was gone, so you bought old junkers. As long as they ran.

Anyway, this fellow says, "How am I going to get them all across?"

"Well," I says, "when you are ready to go, I'll get the truckload here on the ice, a truck four miles out on the ice, you see – that's where the shipment will be." So he got the cars, twenty-two cars waiting all in a circle, and we loaded them all up, and I went with them. I sent the truck back, and I went with them. I showed them the road to go.

We got across to the other side all right, twenty-two cars and 400 cases.

Yeah, that's what it was like – a lot of whiskey went over to the U.S. A lot of whiskey went over there – to be sure. It was any fellow that used to go to the docks with a little boat and take maybe ten or fifteen cases of whiskey, and fifteen or twenty-five cases of beer, and then they go around some place and they used to sell it to the blind pigs there. That was small, but nobody really got killed. But I was in the big stuff.

I knew one guy who was like Jim Cooper from Walker's – he was very rich. But he was crooked, and he paid for it. He could have bought Toronto out. And he could have thrown all the shit-ass out of Toronto – had that much money! They put him in a box, and filled the box full of cement and dropped him – goodbye,

John. They never found him. I wouldn't tell you his name. I knew him well. And they looked for him and looked for him – and they'll never find him. He's maybe 200 feet underground. How the hell are they going to find him? Yeah, he was a big guy. Oh, pretty big. But I know what happened. I'll tell you this. I don't tell you no lie. I dealt with the guy that dealt with him and beat him. I sold this guy whiskey, and he's the one that told me.

There was another guy. He lived in Toledo. He was getting whiskey across for a certain guy, you know. And them guys, they don't fool around. Play them crooked, you're gone. That's it, there's no questions asked.

Rumrunners took their stash across the icy rivers and lakes, and sometimes encountered difficulties when the ice gave way.

(From the collection of *The Detroit News*)

Jim Cooper, the amiable philanthropist, worked his way up from news vendor to millionaire selling booze during Prohibition. He was one of the very few bootleggers to die rich – which he did, mysteriously, on a German ocean liner in 1931.

The Amiable Giant of Prohibition: James Scott Cooper

James Cooper was one of the few giants from the Prohibition era to die rich. Having raised himself from humble beginnings working as an office boy and "news butcher," Cooper became one of the wealthiest and most powerful liquor barons in Canada.

The bright, amused eyes and the crooked bow tie epitomized the congenial and unpredictable nature of Cooper. His photographs in the newspapers seemed to reflect a peculiar blend of playful enthusiasm and reckless daring. Cooper was a man of adventure, an enterprising, hustling speculator, an experimenter, a thinker, and a tireless worker, who would sit amid a stack of newspapers and financial reports in his chauffeur-driven car on his way to the office, absorbed in reading about the latest inventions and money developments. His name commanded attention and respect. He was the ostentatious millionaire who built the luxurious and enviable Cooper Court, a rambling grand mansion that earned him a position among the elite of the financial set in the town named after liquor baron Hiram Walker.

But Cooper wasn't part of the snooty, self-righteous class of Walkerville. More than anyone else who had accumulated a fortune during Prohibition, Cooper remembered his roots. His new-found wealth did not blur his vivid memory of what it had been like to struggle and what it had been like to be poor. Cooper benevolently dispensed his riches, channelling great amounts of money into orphanages, schools, recreational schemes and farming ventures. He was the very definition of a philanthropist.

Like so many in Walkerville, Cooper's fortune was earned in booze. But in one sense he was never considered a bootlegger. He never rowed boats laden with crates of whiskey, and he never stole silently from Windsor carrying illicit shipments of liquor to Detroit's blind pigs. Cooper was far more conservative and clever. Instead, he sought and found the inevitable loophole in the laws, whereby he could sell and deliver liquor to Ontario residents on a completely legal basis.

Although Ontario had voted for Prohibition in October 1919, residents were still permitted to purchase liquor for "home use." Since saloons, bars and traditional liquor outlets were boarded up, booze for private consumption had to be imported. Ontario's distilleries and breweries were not allowed to sell stock to Ontario residents on a direct basis. As a result, Quebec's distilleries became the main suppliers of Demon Rum – until Cooper's arrival on the scene.

Cooper had discovered there was nothing in the law to prevent Ontario distilleries from fill-

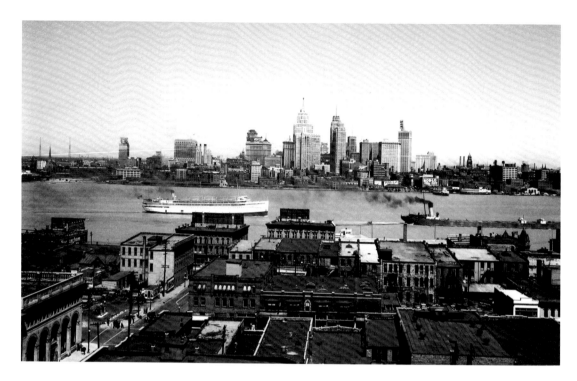

Detroit skyline, 1920s. Jim Cooper started out small, but by the time Prohibition was in full bloom, he was a dominant figure in the Windsor liquor trade.

ing orders that did not originate *within* the province, and that he could set up shop across the river in Detroit and take orders over the telephone from customers in Windsor. He worked both on a commission basis for Hiram Walker & Sons and as a director for Dominion Distillery products.

A close associate of Cooper's told the *Border Cities Star* (February 16, 1931), "He simply walked into his Detroit office in the morning, picked up the Ontario orders and cheques on his desk, and came back across the river to leave them at the distillery. The firm would then make deliveries in Ontario or elsewhere, on the strength of those orders. This was quite legal." And it was an arrangement that lasted for two

years. It was Cooper's brand of importation, since the distillery in Windsor merely acted as a warehouse, while the liquor was really being sold from Detroit.

When Ontario laws changed to prohibit importation, Cooper immediately took up the lucrative "export" business. Appointed by the Walker distillery as its agent, Cooper became "the businessman bootlegger." Arrangements were made on paper and conducted behind a desk, but liquor was still the commodity – and it flowed into the same blind pigs and bootlegging joints in Detroit as did the others. Cooper's exports were legal and above board, but in some people's estimation, Cooper was still a bootlegger. He was no different than the other export-

ers at the Mexico Export Company and the Bermuda Export Company, who directed massive cargoes of Demon Rum from the more than ninety docks that crowded the shoreline of the Detroit River. But because of Cooper's manner and bearing he appeared less corrupt than the others. Cooper managed to escape those shady dealings and the accompanying reputation. He was held in high esteem in the community, as a charming financier with an altruistic nature.

The son of William Cooper, a locomotive engineer who was killed in a train accident on the Grand Trunk line, James Cooper was born in London, Ontario in 1874. He attended school there, and his teachers, who considered him a bright scholar, predicted a successful career. Following high school, he went into routine office work, first with H. Leonard and Sons in London, then for the Grand Trunk. After two or three years, a dispirited Cooper asked to be transferred to a brakeman's job. Shortly afterwards, he quit the Grand Trunk to work for the Pere Marquette Railway out of Detroit. From there, he landed a job as a "news butcher," selling candies, cigarettes, fruits and newspapers on the trains running between London and Rochester, New York. On one of these runs, Cooper met his first wife. A few years later, she died, leaving him a "tidy" estate.

Cooper drifted for a while from job to job, before eventually being appointed manager of a large brass foundry in New York, where he remained for several years. Returning in 1910 to the Windsor-Detroit area, he operated several saloons, speculated in real estate and soon became recognized as a flashy promoter. In 1918, one of his schemes not only attracted wide attention but helped to revolutionize farming in Essex Country. Cooper bought a 105-acre farm near Belle River and began to till the acreage so that spring planting could commence ten-to-fifteen days earlier than normal. Draining with clay tiles was something that had never been tried in the rural areas outside Windsor. Cross-ditches had been the only means of drainage. Though tiling seemed an expensive and risky proposition, it proved to be the long awaited innovation needed in Essex County's farming community.

Word of Cooper's success with this experiment spread and soon neighbouring farmers wanted to tile their own farms, but none could afford to. Learning of this, the adventurous Cooper declared he would sell tiles at cost to farmers. Cooper hired a crew to commence construction of a tiling factory on his own farm. In no time the new business was manufacturing more than 10,000 tiles and 20,000 bricks daily.

Cooper's investments in agriculture were vast and unusual for his time, and they had a major effect upon Southwestern Ontario. Cooper virtually revolutionized the egg and poultry industry in Essex County, developed orchard and grape production, introduced tobacco farming, boosted the dairy and cattle industry, initiated the widespread practice of deep ploughing and mechanized farming, created muskrat farms, increased sugar beet yields and established enormous sheep ranches.

Cooper's influence knew no bounds and was matched only by his incredible generosity and devotion. Farm boys, for example, were hand-

The first Cooper Court, built during Prohibition for a mere $40,000, was not quite to his liking. He decided to move downtown, to Walkerville.

picked by Cooper to be sent, all expenses paid, to the Ontario Agricultural College at Guelph to learn about the most advanced and innovative methods in farming. Mechanized farm equipment was scattered and moved from farm to farm to enable farmers to increase efficiency, and to meet the heavy marketing demands of farmers in the district. Cooper also built the Belle River Seed and Grain Company.

Cooper's most ambitious venture however, was at St. Anne's Island near Wallaceburg. In 1925 and 1926, Cooper leased the entire 2,600-acre island and developed the land. He built dikes and canals and homes for his crews. By 1928 his efforts began to pay off. From 300 acres

of tobacco alone, Cooper's return was more than $65,000.

Though Cooper made his fortune through Prohibition, he never abandoned farming or his experiments and investments in agriculture. Farming remained Cooper's "first love." He told a newspaper reporter at the height of his liquor wealth that all he had ever wanted was to be a farmer. Urban living had never appealed to him and had never brought him much satisfaction.

Cooper's influence, power and money might be best symbolized in the first Cooper Court he built – the massive, two-storey structure in Belle River. Constructed in 1920 at a cost of $40,000, the building still stands today, and over the

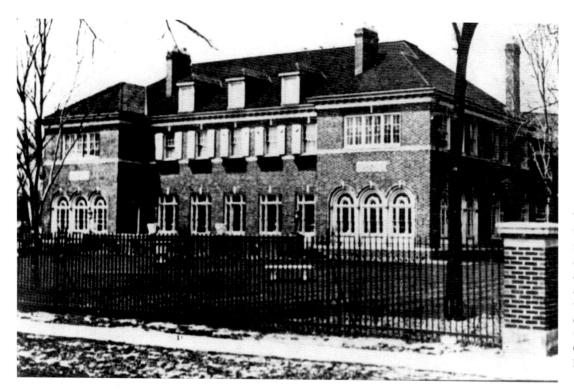

The second Cooper Court, which outshone other mansions in the area, took up an entire city block, and had an indoor swimming pool, and a massive pipe organ, which delivered music to each of the forty rooms. All that remains of the last Cooper home is the gate house.

years has been a hotel, and later a restaurant. But back then, only four years after it was built, when the huge profits from Prohibition began to roll in, Cooper commenced work on a new Cooper Court in Walkerville. This second mansion, into which he moved in 1925, far outshone the first, and overwhelmed virtually all of Walkerville, surpassing even the grand Willistead manor built by Chandler Walker, a son of Hiram Walker I.

The magnificent forty-room Walkerville Cooper Court occupied an entire city block and cost Cooper more than $200,000. The colossal organ that piped music to every room in the mansion and played music rolls like a player piano cost Cooper more than $50,000. In one wing of the building there was a conservatory and a terrazzo-tiled swimming pool. Dozens of potted plants adorned the ledges of the pool or hung from the glass roof. Dressing rooms were provided at either side. The top floor of the home was taken up almost entirely by a large ballroom, but off to one end there was also a billiard room. This was also used as a school-room for the Cooper children when the family first moved there. Cooper had arranged for a nun to direct the education of his son and two daughters. The children also studied French and music. At the other end of the ballroom, Cooper had ordered a cedar-lined room to

store winter clothing and furs, and next to this, had an exercise room designed, equipped with rubbing tables and a then state-of-the-art electric weight-reducing cabinet.

But Cooper's life in Walkerville wasn't as glorious as it may sound. Throughout the Twenties he was relentlessly tormented by inquiries concerning his huge liquor profits and widespread smuggling. He was also plagued by the high blood pressure and hardening of the arteries that eventually required a move to Switzerland.

James Cooper became one of the obvious targets of the Federal Government's scrutiny into wrongdoing and unpaid duties. Cooper fought the government head on, vehemently claiming at a 1926 parliamentary committee in Ottawa investigating Customs duty on liquor, that Hiram Walker & Sons, for which he acted as an agent, had not defrauded the Canadian Government. At the dramatic Stevens Customs Committee hearings, Cooper dramatically explained the background operation of liquor exports. He said Dominion Distillery Products, of which he had been a director, purchased liquor from Hiram Walker & Sons and sold it to their customers. Cooper also acted as a "go-between" for both companies, and as a result would tack on his own profits. Those profits amounted to one dollar per case for Dominion Distillery Products and one dollar for Cooper.

Under questioning, Cooper calmly admitted that he sold liquor to "a whiskey jobber" by the name of Scherer in Detroit. He said he didn't know the whereabouts of the rumrunner, but confessed if he needed to make a deal with

Scherer, he could be contacted through the Statler Hotel in Detroit. Cooper emphasized that duty on those shipments to Scherer, and others like him, had already been paid to the Canadian Government, emphasizing, too, that liquor he bought from Hiram Walker & Sons, had never been "short-circuited" to Windsor locations, thereby failing to clear Customs.

But Cooper wasn't off the hook. A Royal Commission investigation in 1927 revealed more of the intrigue in the liquor trade. An angry Cooper disrupted proceedings in Windsor when he claimed he had been coerced into paying into "a rat fund" organized by A. F. Healey, a former member of Parliament (1923–1925), later president of Mutual Finance Company and Guaranty Trust.

Cooper told former Ontario Liberal Leader N. W. Rowell, the commission's counsel, that, "We have a politician here named Healey. He was elected to Parliament. A week after he was elected, he called me to his office and told me to see William Eagan, a lawyer here. I went out and saw Eagan in front of Tim Healey's office, and he told me I had to pay two dollars a case on all liquor I exported and twenty-five cents a keg on beer. I kicked, but I paid him $272 right there.

"Eagan said to me, 'That's not enough,' so I went back to Tim Healey. I kicked, but he told me I'd have to see the 'Big Man.' I asked him who that was and he said it was John O'Gorman of Toronto."

Told to go to the Prince Edward Hotel (Windsor) to meet O'Gorman, who was also connected with the Super Cement Company in Detroit,

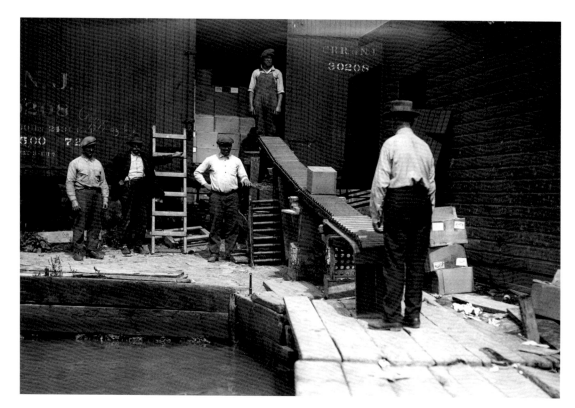

Jim Cooper found the loopholes needed to get around the law, thereby amassing his fortune. Liquor went across the river by railway car.

Cooper went to see him, but told O'Gorman he wouldn't pay "another cent."

Cooper confided to Rowell that all that he ever paid to Healey's associates was $272. He said Healey's legal influence and position caused him undue complications with exports and eventually resulted in Cooper having to pay out more than $1,000 per carload for exported whiskey.

Healey denied Cooper's accusations in the *Border Cities Star* that same day (May 6, 1927), pointing out that Cooper had in fact come to his office and boasted "of owning nearly every prominent official along the border and hinting

that if I would cooperate with him there would be millions for me." Healey told the *Star* that he ordered Cooper to leave "and stay out."

When Healey appeared before the Royal Commission's hearings in Hamilton a week later, he told Rowell under questioning that he knew nothing about "the rat fund," and that Cooper instead should be under scrutiny because of his illicit liquor business activities.

Healey, elected in a by-election in 1923, said, "He (Cooper) came into my office and told me, 'I have something to show you. I have my books with me,' and he (Cooper) took off his hat and reached into the lining and said, 'These are my

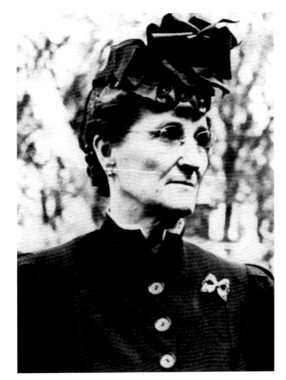

Helen Cooper, wife of James Cooper.

books.' He took out two slips of paper about the size of an ordinary letterhead, and then proceeded to unfold the greatest tale it has ever been my experience to hear, and named prominent people on both sides of politics."

Healey also acknowledged that Cooper had boasted of earning more than six million dollars a year from liquor sales and exports and urged him to cooperate so that he could share in these profits. Cooper wanted Healey to use his influence in government to bring about relaxed liquor export laws. But Healey refused.

Cooper's lawyers didn't press the matter, and Healey's charges were left unchallenged. The focus of the commission switched to other export companies who were defrauding the Canadian Government, and Cooper's revelations were largely ignored.

Near the end of the Twenties, Cooper decided to leave Walkerville and take up residence in the high altitudes of Switzerland. His illness had nearly left him an invalid. Two weeks before his death in 1931, Cooper returned to Southwestern Ontario on a business trip, but had to disembark from the train at London, Ontario, because he had been overcome by sickness. The *Border Cities Star* (February 10, 1931) reported that "finding that he (Cooper) was unable to complete his trip to the Border Cities, he sent word to Belle River for Mr. M. V. Pougnet (his secretary and business manager) to go to London, where Mr. Cooper and his secretary conferred for three days.

Cooper hastened to New York and bought passage aboard the *S.S. Deutschland.* It was on this journey across the Atlantic that the Walkerville millionaire fell overboard and drowned. His body was never recovered. News of the mishap reached Windsor on February 10, 1931 when his wife Helen Cooper, sent a cablegram to her children from Vevey, Switzerland that "Daddy fell overboard yesterday. Body not recovered."

Pougnet told the *Star* that when he had seen Cooper a week earlier in London, Ontario he had been "despondent" over his health and that "he could not understand why he was as ill as he was, and why he should have to suffer as he did, after trying to do so much good."

But despite his illness, some concluded that Cooper actually fled the Border Cities because

federal authorities and Michigan bootlegging gangs were on his heels. It was suggested that he'd cut short his Southwestern Ontario visit because he'd learned that he might be the target of vindictive gang leaders from Detroit who felt they had been cheated during the bootlegging days of the Twenties.

When Cooper died he left an estate of $488,892 to his wife, Helen, and their three children. That amount did not include the Walkerville mansion, which years before had been transferred into his wife's name. Cooper also left behind the Belle River Cooper Court and more than 500 acres of farmland around Belle River, St. Joachim and Tilbury, as well as the large stake he had in St. Anne's Island near Wallaceburg.

Cooper's financial empire had been vast and diverse. It had been built on ingenuity, clever insights into the existing laws and loopholes of government regulations – and it had been built on booze. But unlike many from that era who had made big money from whiskey, Cooper resisted the temptation to invest in the stock market, and as a result was one of the few to emerge unscathed from the October 1929 crash. His business manager said Cooper "had never lost a dime."

Pougnet told the newspapers at the time of Cooper's death that the Walkerville millionaire's only fault was his big-hearted generosity. He conceded that although Cooper was wealthy, "he gave it away as fast as he got it."

Pougnet said Cooper preferred to keep his gifts private, but they extended far and wide. In Belle River, Cooper built the town's first high school, the first ballpark and even paid for all the children in Belle River to have haircuts and their teeth fixed. In London, Ontario, the town of his birth, Cooper poured his money into two orphanages, and every year, transported the children to Port Stanley for an annual picnic for which he picked up the tab.

In the lengthy *Border Cities Star* obituary, there are countless stories about how Cooper had never turned his back on Southwestern Ontario or its people and those who had helped him in his youth. One anecdote recounts how Cooper had been stopped by an elderly wayfarer for a handout, and Cooper, recognizing this was the same man who had given him a silver dollar when he was down and out, checked the man into the Prince Edward Hotel and lavished food and new clothing on him.

The only vestige of that time and the extravagant forty-room mansion in Walkerville is a coach house that still sits inside an iron gate. Up until 1980, it bore the faded sign, "Cooper Court," but it was removed. The sprawling grand home had to be dismantled and the land sold, as it became too expensive to maintain. Other than this, the memory of James Cooper is virtually erased, except for the few old-timers who passed on stories of hobnobbing with the amiable giant of Walkerville.

Milton "Whitey" Benoit, the eccentric son of Vital Benoit, LaSalle's first mayor, sitting in his one-room apartment. By his teens he was already passing hot diamonds for Detroit's Purple Gang. His father poured money into hotels and breweries and was considered one of the giants of bootlegging in the Border Cities area.

In the Bad Old Days: Father and Son

At the time I spoke to him, Milton "Whitey" Benoit was seventy-two and still living on his beloved Pitt Street, a dumpy hard-core city street in Windsor. A product of Prohibition, he hauled whiskey across the river in small boats and old cars, worked briefly with the Purple Gang, and for a time was a bouncer in the speakeasies and whorehouses in Windsor. He was also the son of Vital Benoit, one of the wealthiest men in Essex County, Ontario. Whitey's father made his money both before and during Prohibition. And because his father was rich, Whitey was sent to the best schools – but to no avail. Whitey chose to continue the illicit activities he had picked up during his rumrunning years – and even in his seventies continued to bootleg on the side.

He was a fixture at Pitt and Mercer in Windsor smoking a rolly and wearing a sleeveless undershirt. His greeting was gruff and raspy. He shook a fist at a nearby German Shepherd that was barking insanely. He said, "There's nothing to worry about – I'm the only mad dog around here."

This white-haired man – his hair had been that colour from the age of twenty-two – was the last of the old Pitt Street gang, from when there were hotels on every corner and blind pigs and "cathouses" in between. Whitey remembered it all. He was a part of it for more than twenty-five years, when not in jail or on the run. He made a bundle on this street in the Thirties when nothing shut down until dawn.

"It was like the Old West – now it's like walking up the middle aisle at St. Alphonsus Church – nothing's happening."

This was the same Whitey that *Maclean's* magazine in the Fifties called "King of the Forgers." He ran a ring passing worthless cheques from non-existent companies from Windsor to Kirkland Lake, operating as far east as Ste. Agathe, Quebec. It ultimately took in an estimated $150,000 from the Canadian public.

It was the biggest forgery scam in Canada's history and assured Benoit of $30,000 to $40,000 a year, "and I spent every nickel of it because I knew there was more from where it came."

In 1980, he lived in a two-room flat at the back of a building on Pitt Street East. His place was furnished ascetically with a bed, refrigerator, stove, tables, and chairs.

He usually sat at the table drinking beer and reading newspapers while the television set babbled away. His wallet beside the beer was stuffed with big bills.

Outside, along the fence, was a long, narrow stretch of garden "that my girlfriend down the street takes care of – she also fixes me meals

Vital Benoit.

"I escaped the police there (the U.S.) and went back on foot across the ice – I nearly froze to death."

The papers reported him missing until he surfaced in LaSalle at his father's place.

His father, Vital Benoit, one of the richest bootleggers in the border region, owned hotels throughout the area, including the Chateau LaSalle.

"It used to be the old Wellington – oh, about 1898. We were raised there, and when Prohibition came, my father sold it, then he built the big house further down the road.

"Everyone thinks these people, like my father, were bootleggers, but they weren't because every time one of these guys came from Detroit with a canoe, with a speedboat or a launch, and brought ten cases of whiskey back with him, he had to sign a declaration and had to pay duty, so those guys weren't bootleggers – they were exporters.

"You see, my dad had the sole agency of all the Corbey's whiskey at this end – he had all the Labatt's beer at one time, too.

"We had a big tug at one time, and they used to pull in at Port Stanley (Ontario) and put 1,500 cases of beer on this tug and come around and land at my dad's slip at LaSalle. As I said, he was the sole outlet for Labatt's beer at this end. This was during Prohibition – this would be about 1921, 1922.

"Then we built Hofer Brewery in LaSalle about '24 or '25 – my dad was in that – he owned about 60% of that at that time. . . .

"But my dad made a lot of money in real estate long before all this, you know. He bought

every day, so I don't complain."

The garden was his pride and joy. He said the winos and other Pitt Streeters pilfered his tomatoes, but Whitey didn't mind as there was enough for everyone.

This attitude guided Whitey through his long career, always on the other side of the law, "close to the edge at all times."

At twelve, he stole liquor from some rumrunners to party with friends. Later he accompanied "river rats" in old jalopies on the ice taking whiskey across to Detroit.

"I was just going for the ride and one day had the lens of my glasses knocked out by a bullet and also got hit in the leg."

all those farms around where the steel plant (Canadian Steel Corporation) was going to be, and he sold it to the steel company. My dad's the one who built what they call the Seven Mile Road – he was in with three others and built that road.

"You know, my dad was the one who had LaSalle incorporated – he was the first mayor of LaSalle. At one time, the streetcars only went as far as the Wellington Hotel and then they went back to Windsor – this is long before the bootlegging business – my dad built those streetcar lines."

Vital Benoit, born in Pain Court, Ontario, was a giant in the hotel business. He not only owned the Wellington (or Chateau LaSalle) but he owned the Royal Oak, which burned to the ground, the one-time Farmer's Roost (currently Big Tony's), the Bridge House for about three years, and, of course, he owned the former Windsor Hotel on Pitt Street.

"I remember his general store – and he had a post office. Then, Vital Benoit's was the only outlet at that time. They used to bring whiskey from the basement of the hotel in barrels, and my dad's hotel was the only whiskey outlet from Windsor to Amherstburg. All these farmers used to have to come to the Wellington to get a gallon of whiskey.

"My dad was the one who built up LaSalle. You know, the streets there are named after us kids – my brothers and sisters – there's Elseworth, Allan, Robert, Nora, May, Violet, and of course, me, Milton."

When Vital Benoit came to LaSalle in 1898, he purchased the Wellington Hotel and all the

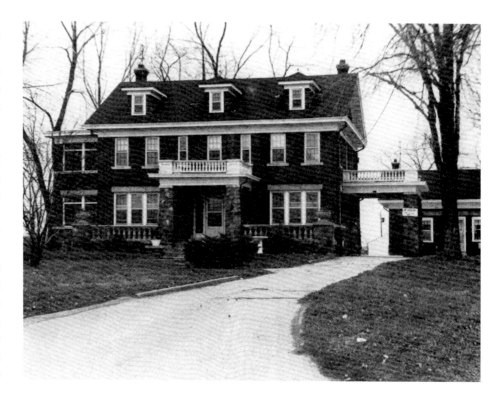

property right to the channel for $1,400. He put in the first channel behind the hotel, "and the people would come in with their launches – boy, my mother cooked many a thousand fish, frog and chicken dinners for seventy-five cents . . ."

During Prohibition, Whitey recalled his father purchasing whiskey for people in LaSalle.

"He could buy up to 100 cases of whiskey for personal use – that's during Prohibition. My dad would give these people the money to buy it, and it would naturally be his, and he would give them a couple of dollars for buying it. The stuff used to come from Quebec at that time.

"And these people would put the cases in their basement and if somebody wanted fifty

This luxurious home in LaSalle was built to Vital Benoit's specifications during Prohibition. It was just down the road from his roadhouse, the Chateau LaSalle (where Whitey was born) and the Hofer Brewery, which he also owned.

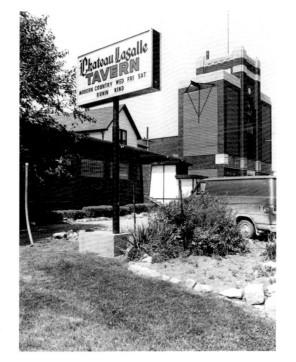

(*Left*) Whitey Benoit was born at the Chateau LaSalle, one of the leading roadhouses on the border. The Hofer Brewery, shown in the background, was also owned by the Benoit family. Whitey's father, Vital Benoit, was the mayor of the town and one of the richest men in the area. He gained most of his wealth during the Prohibition period.

(*Right*) Hofer Brewery, LaSalle.

cases of liquor, my dad was the one to call, and he'd tell the guy to bring his boat and he'd get the stuff from one of the places where the booze was stored, from one of those basements of his neighbours, then the guy would come and get it and take it to Detroit."

Whitey broke into crime under his father's tutelage during Prohibition. His earliest dealings go back to Mac's Bar on Jefferson Avenue in Detroit where he passed "hot diamonds" to the infamous Purple Gang. The diamonds came from Toronto and he smuggled them across the border to be sold to the gang and delivered the money, "and I, of course, got my cut, too."

Those, too, were the days when he was a bouncer in the local "cathouses" in Windsor.

From his size and strength even in his seventies, one wouldn't doubt why he was hired.

Pitt Street was where all the action was in Windsor. Most of the traffic was from Michigan, "and with five or six guys in the car you know what they were looking for."

In those days, Whitey said, the madam who ran the brothels gave business cards to winos who initialled them and passed them over to those looking for a good time.

"They would get paid a buck for every one that came through."

Most prostitutes, brought in from Quebec during the Depression, operated out of twelve or fourteen houses on Pitt Street.

"They were beautiful, young, some only fif-

teen – came from big families, and they didn't have much money – but after they got going, they could make up to $1,000 a week."

Windsor whorehouses paid off the authorities and prostitution flourished. Whitey was paid $1,000 once to take a "fall" for a madam. He spent two months in jail but got a $150 suit as a bonus.

Whitey had the best education money could buy. He attended Loyola College in Montreal. All this education, Whitey said, had aided him in the "paper" profession, as forgery is known.

According to *Maclean's*, Whitey had a band of cheque-passers spread across Ontario and Quebec and forged cheques in a gully near his place in Tillsonburg, Ontario where he also ran "a cathouse and a blind pig."

Police couldn't find the forging equipment. They even ripped up the floor in his hotel room.

His system was nearly foolproof, but an informer gave it away. Whitey did four years for that one.

"No one questioned Benoit's authority," the *Maclean's* article said. "He never passed a cheque himself but he was the boss, the brains."

The article said, "They (the authorities) knew he had been in the racket for fifteen years and he had served only one six-month stretch for a bad cheque passed in Kitchener."

The system was so tight that it even worked if a clerk got suspicious. A cheque passer attempted to cash a phoney paycheque in a shoe store and the clerk called the company listed on the cheque. Whitey had someone manning a telephone booth to answer the call and verify employment. He laughed about how he fooled

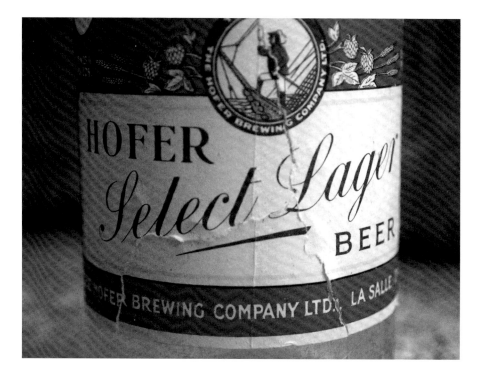

Hofer beer.

(Courtesy of Bill Marentette)

the police for years by signing cheques with his left hand. He said he could still copy anyone's signature after studying it for five minutes.

Whitey in his seventies was taking it easy. "Why bother with anything else now," he shrugged. He wasn't living badly.

"The street isn't the same anymore – it used to be quite a place – but now, I don't even lock my door – it wouldn't matter, anyway, because they know better than to break in on me."

Occasionally, newcomers to Pitt Street would challenge Whitey. One challenger found himself sailing through the front door of a pub.

Standing there, looking down the street, there was no doubt that he was still the undisputed king.

Cecil Smith, a pathetic, forlorn figure in his last days in the Fifties, was still entangled in bootlegging. He claimed that a Windsor police officer had accepted bribes paid to protect him from further convictions . . . but the policeman hadn't kept his promise.

(Windsor Star)

King of the Bootleggers: Fat Cecil Smith

Cecil Smith is a prime example of the small-time hood on the Canadian side who thwarted both the law and the lawless. He was a hood of a different class. Though he made it big he lost everything, including his self-respect. His name swamped police files at the time, and his exploits clogged the *Windsor Star*. His story begins in 1919 when he sold his first two bottles of booze, and it ends in 1953 when he was tried for perjury.

As late as the 1950s, Cecil Smith still carried with him a black book containing the names of regular clients to whom he sold liquor. A bootlegger all his life, this thumb-worn book with curled edges and cigarette burns held a history of its own. He relied upon it, just as much as the winos and diehards relied upon him.

Bootlegging was second nature to Cecil. It was an integral part of his life, and whenever a member of the Windsor Police Department stopped this hulking figure on the street for a routine search, he invariably found a few mickeys tucked away within Cecil's deep coat pockets.

The threat of a jail sentence never deterred Cecil. Bootlegging was his art, his essence, his livelihood. He once told a magistrate that peddling booze was probably far more respectable than selling brushes door to door.

Brash, daring, but rarely boisterous, Cecil Smith was known as "the brains behind the bootleggers." But he was also, tragically, luckless. Cecil's path seemed destined to continually cross the police's, even if he was never behind bars long enough to be coerced into ending his illicit liquor activity.

Cecil Smith wasn't a theatrical gang leader, he was just a hood. Not a Jimmy Cagney tough guy, just a bootlegger – overweight and hard as nails. Lacking in personality, tact, and charisma but slick, and always prepared for a new scam. Nothing stopped Smith. Not convictions for theft, smuggling aliens, obtaining money in narcotics rackets, perjury – and certainly not rumrunning.

The day he swaggered into a Windsor Police Commission hearing accusing a Windsor police constable of extorting money from him, Smith was confident, calm, and smug. It was the end of March 1953. He ambled into the meeting wearing a large, droopy hat, a loud silk tie and a tent-like overcoat. He was unshaven and unshaken. He delivered his charge that Constable Gilbert Robitaille had been paid $700 on two occasions to protect Smith from liquor convictions. However, a recent charge against Smith for bootlegging, accompanied by more demands for money, angered him to the point

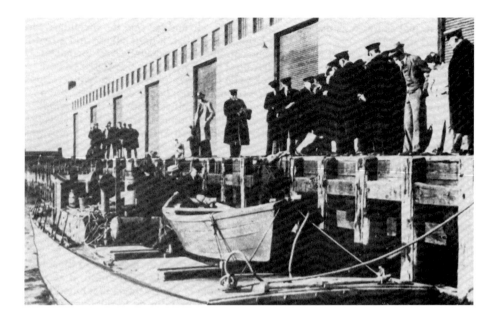

One of the larger export docks at Windsor. (*Windsor Star*)

that he was prepared to tell the commission everything.

But the unlucky Smith saw the hearing clear the police officer, and then swing around to charge him with perjury. Two months later, the swag-belly bootlegger returned for trial and skilfully beat the charge. His eyes, according to reporters covering the trial, were full of tears upon acquittal.

Though Smith grew rich though the liquor racket, his road to crime predated the temperance laws in Ontario. Cecil's name first appeared in newspapers in April 1919 when he was caught with two other men smuggling a Chinese alien across the border into the U.S. His fine was a mere $100 and court costs. In those times, it may have been a stiff penalty, but compared to what he would be forced to dole out in the future, it was nothing.

During Prohibition, the undaunted Smith was caught again for the same offence. In July 1929, he was sentenced to fifteen months in Leavenworth Penitentiary and fined $1,000 for conspiracy to violate immigration laws. This time Smith had been caught trying to smuggle three Chinese aliens into Michigan.

Picked up at River Rouge, he admitted under questioning to running a liquor dock at Sandwich near Windsor, but denied having anything to do with smuggling aliens. In the courtroom, he tried to convince the judge that though the dock where he smuggled liquor was a favourite spot for "corralling" aliens before shipping them across the Detroit River, he'd never had any part in such schemes.

In sentencing him, the Detroit judge listed the numerous offences on Smith's record and observed that the Canadian authorities "would doubtless be glad to see him go to Leavenworth."

But alien smuggling wasn't where Smith excelled. He exhibited his prowess with liquor. Besides, it was far more lucrative. So much so that in 1925 Canadian tax officials attempted to collect on his alleged illegal earnings. Ottawa wanted $28,632 of Smith's $92,020 earnings from bootlegging during 1920. Smith's own tax return differed greatly from the tax department's, touching off a legal and bureaucratic war.

First, the intrepid Smith appealed to the Exchequer Court, but he found no sympathy. According to Justice Audette's review of Smith's file, profits from bootlegging were not exempt. Next, Smith appealed to the Supreme Court of Canada and won his case.

One of the Supreme Court judges, Justice Idlington, declared that the Ontario Temperance Act "explicitly (says) that all private liquor transactions are illegal under the provincial law and that a bootlegger is not entitled to compensation."

He went on: "I can't believe Parliament ever had in its serious contemplation . . . the conception of taxing any profits or money raised from such a criminal source."

The *Border Cities Star* was quick to respond: "It now looks as though it may be necessary for Parliament to amend the income tax act of 1917 and make express provision for taxing bootlegging profits."

While all this was taking place, Smith was ensconced in Kingston Penitentiary for theft of goods from a boxcar in Windsor. From the isolation of his cell, he had been carrying on a headline-making legal battle.

The bootlegger's formative years of crime were never better described than by W. H. Furlong in October 1921 when Smith was indicted on a charge of bribing a police officer.

Furlong, a well-known Windsor criminal lawyer, recounted how Cecil Smith started "as an express driver at nine dollars a week . . . and managed to save enough money to operate a taxicab, but at the beginning of Prohibition his taxi licence was cancelled when he was convicted under the OTA for allegedly possessing liquor. At that time Smith claimed the liquor that was found in a travelling bag was left by a man who hired his taxi.

"With no means of earning a livelihood, Smith in November 1919 began dealing in liquor

and since that time he has made a comfortable amount of money."

Comfortable enough to afford him a grand home near the river on Sunset Avenue in Windsor. And comfortable enough to provide him with servants, new suits and cars. But as one can see from the court files, Smith lacked class.

In the bribery case, where he was defended by Furlong, it was revealed that Smith had gone to the Canadian Pacific Railway yards at Sandwich with seven trucks and five touring cars to haul away more than 750 cases of liquor. But he was nabbed by Constable William Allen, who attempted to seize the freight car containing shipments of whiskey consigned to various persons other than Smith.

Disregarding the officer altogether, Smith pushed past him, handing him $1,000 and ordering him "to go up the hill."

Cecil Smith profited big time from Prohibition, but often ran afoul of the law, and wound up spending a fair amount of time behind bars. His involvement ran the gamut from bribery to liquor trafficking to gambling. He paid off police officers, customs agents and funneled some of his money into bookie joints.

Bookie joint.

(Walkerville Times)

Allen's face and told him he had better take "a walk." When the obstinate constable refused to back off, Smith's thugs were called in to assist, and within a few minutes the unloading operations had begun in earnest in the freight yard.

As Constable Allen told the court, Smith offered to take him for "a little ride in a car." The officer, however, refused: "I was then met by a man wearing an overcoat . . . He held a .45 calibre Colt revolver. I seized the weapon. A scuffle followed and three other men came to his assistance. They struck me over the head with their revolvers and finally handcuffed me with my own handcuffs. I knew nothing more until I opened my eyes in a car going east on Sandwich Street. As we reached the corner of Sandwich and Bruce, I threw myself from the car and made my way to the taxi stand on Ouellette and was driven to police headquarters."

Later in the court, Smith snidely remarked to a witness, "the next time I offer Allen $2,000, he will prefer it to being beaten up."

It was this swaggering brashness that shocked the police, lawyers and courtroom spectators.

In the Essex County Assizes in Sandwich, October 13, 1921, Smith explained it had been his custom to pay off express agents at a rate of five dollars a case in order to remove his liquor before liquor licence officers arrived on the scene. The astounded magistrate queried if bootlegging was his only means of work. Smith laughed.

"I do not call myself a bootlegger, but other people do – on good grounds," Smith replied.

He then went on to elaborate for the judge

Smith had gone through this scenario so often he didn't expect opposition or honesty. But Allen refused and went ahead with his effort to impound the freight.

Not being completely unreasonable, but obviously stung, angered and holding back his aggression, Smith waved $2,000 in Constable

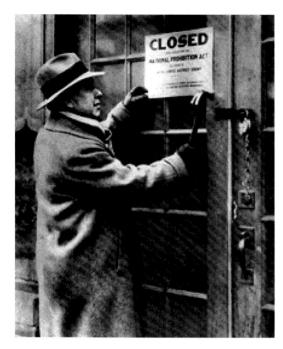

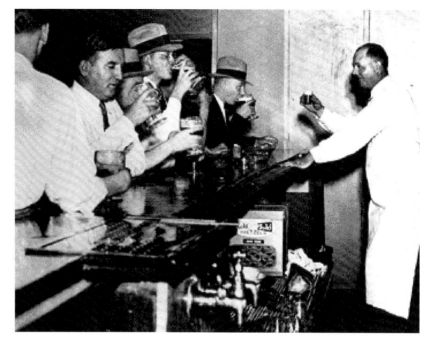

that he never sold "a drop of liquor in Ontario" and that he considered himself a bona fide exporter. With regard to bribing a police officer, the roly-poly hoodlum scoffed at the charge. Sure he had. To date, he revealed to the court, he had peeled off more than $96,000 in bribes, or as he described it, "I've paid that much to the Canadian government."

Smith was sentenced to serve five years in the penitentiary, but he asked for a second trial and won his case on a technicality.

In 1930, Smith was still dabbling in whiskey and again it was booze that got him into trouble – booze and the unblessed nature he wore like an old overcoat. This time he was shackled with a six-month sentence, having been convicted when another man claimed that Smith had hired him at fifteen dollars a week plus board to serve liquor at the Shawnee Club with the guarantee that he would also pay the man twenty-five dollars a week for any time he spent in jail as a result.

Probably the most bizarre incident occurred in the 1932 narcotics case in which Smith was sentenced to serve seven years in prison for obtaining money by false pretences. Smith's cunning scam, revealed in court, involved selling "candy" to Detroit morphine addicts. The witnesses confessed that they had paid Smith and another man in advance, but were furnished with only packages of peppermints. One indignant man complained he had paid Smith $350 and for it had only received a bag of candy.

Shrugging these claims off, Smith replied

(*Left*) Abe Lezotte, a federal agent, nails a "closed" sign on a blind pig that was padlocked in 1929. (From the collection of *The Detroit News*)

(*Right*) Blind pigs like this one at 932 Columbia East in Detroit operated at full tilt in the 1920s. This photo was taken in 1929. (From the collection of *The Detroit News*)

FINAL EDITION

The Border Cities Star.

RIVERSIDE, FORD, WALKERVILLE, WINDSOR, SANDWICH, OJIBWAY, LA SALLE

THE WEATHER
Today: Moderate winds and cool
Wednesday: Fair and cool

VOL. 14, NO. 55 24 PAGES IN TWO SECTIONS WINDSOR, ONTARIO, TUESDAY, MAY 5, 1925 PRICE—THREE CENTS

CECIL SMITH WINS APPEAL ON TAX

NEW PROOF OF *BOOTLEG PROFITS* FORKE OUITS *Where French and Riffs Clash in Morocco* REBEL FORCES

Cecil Smith attending the Police Commission meeting on the bribery charge. He died a few years later. *(Windsor Star)*

Canadian authorities by exposing these addicts. He was sentenced to seven years, and served five.

Soon after his release in 1937, the bootlegger was once again under arrest, this time for injuring Constable Jack Clark of Woodstock. Smith had been stopped by the Ontario Provincial Police constable, who merely wanted to question him about an extortion ring in town. But Smith refused to answer his questions. He told Clark to mind his own business, then promptly lurched away in his car. The overzealous officer, as hard-nosed as Smith, leapt on the running board to argue, but instead of conversing found himself hanging on for his life as Smith wheeled through the streets of Woodstock and out onto the highway. At a speed of seventy miles per hour, Clark was hurled from the swerving vehicle and thrown into a ditch.

Smith was later caught by police, but only after a police cruiser rammed into his car and shoved Smith's battered vehicle into another ditch.

Upon being sentenced to five years, an astonished Smith, feeling unfairly treated, turned to a nearby police officer and remarked, "Lots of men get less than that for murder."

he had no interest whatsoever in smuggling dope – bootlegging was his business. And, he added bemusedly, perhaps he had helped the

In Windsor the old-timers remember Smith as brash and hard-assed, but he was never one to hold a grudge.

According to former Staff Sergeant Charles Johnson of the Windsor Police, Cecil Smith was "just unlucky – other than that, he was okay. He was just always getting caught."

Johnson recalls how Smith worked as an express agent and was responsible for picking up large amounts of cash that came in nightly by the Michigan Central Railway in an iron box.

"The box didn't even have a big lock on it – just a padlock, and Cecil would pick this up and take the money out and bring it home with him. It was $50,000 to $100,000 in cash, in a case – it was the bank pool, and it would have to be delivered to all the banks the next morning.

"Well, Cecil would take it home with him, because they couldn't leave it there, and he'd bring it down to the express company the next morning, and then it would be taken to the banks.

"Cecil was no crook, if you see what I mean. I mean, he could've just taken the money. I know this, because my brother used to relieve Cecil when he couldn't make it."

He said it was only later that Cecil Smith became a bootlegger. "In the beginning, he was just a small guy – but then he made millions. Oh, he was stealing whiskey from others guys, but so were they."

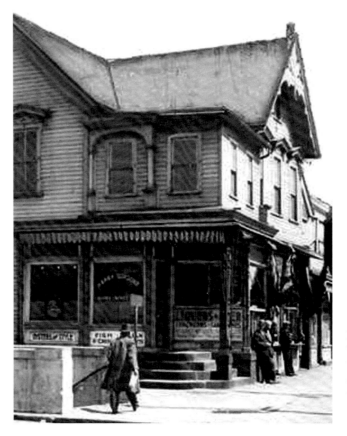

Moestra Tavern, famous Detroit saloon.

(From the collection of *The Detroit News*)

"I remember him as a quiet, easy-going guy – never cantankerous, but when he was in a fighting mood, watch out – but you know, I think when he got caught, he was like a big baby."

Johnson said the last thing he heard, Smith was running a blind pig on St. Luke Road in Windsor, "and he didn't have a nickel."

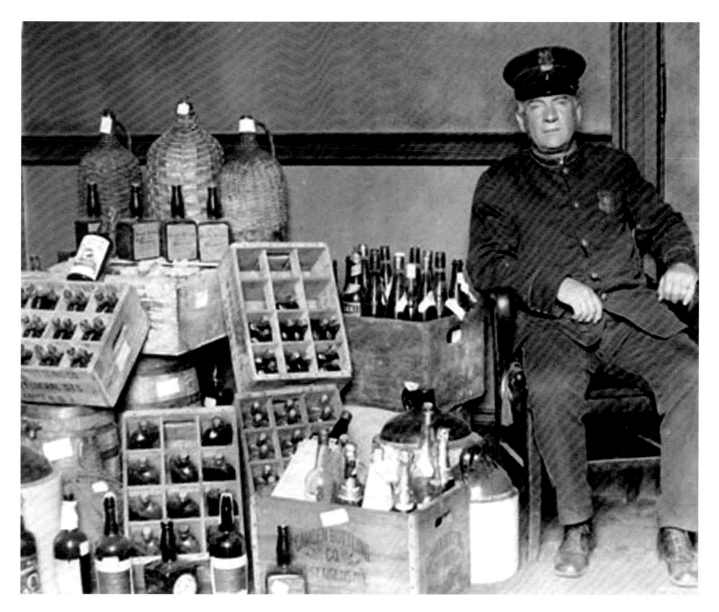

Police seizure, Camden Michigan. (Courtesy of Temple University Libraries)

Art Gignac: The Gentleman Bootlegger

by Tom Paré

Tom Paré wrote this for the Walkerville Times *about his grandfather, a man he idolized and a man who shared with him this story from the Roaring Twenties.*

On a warm Sunday morning, a Maxwell touring car headed out Sandwich Street past the Chappell House (the scene of the Babe Trumble killing of 1920) and then on toward the old Westwood Hotel before turning onto Seven Mile Road. The car sped up a bit as it was now past the city limits and on the open highway.

The driver was a tall, handsome man sporting a gray fedora and a three-piece suit, complete with watch fob. The front passenger was his wife Marie, a diminutive redhead who stood only four feet ten inches tall. She too was dressed for church with her high collar, cameo pendant, and size one black shoes. In the back sat three little girls all dressed up in their Sunday best.

Marie turned to the girls who were now jabbering giddily about little girl things and told them to quiet down. "Especially you, Emily."

"It's not only me, Mum. Olive and Evangeline are teasing me," Emily responded impishly.

The father glanced into the back seat.

"Everybody quiet down. We're almost there." And the big car turned into a lane just past the Chateau LaSalle and pulled up to a group of men waiting at a rickety wooden dock.

The girls were ushered out of the car and off to the side while the men lifted up the back cushion covers and removed ten cases of whiskey that had served as the sisters' seats and put it into a waiting boat. When the transfer was complete, the girls clambered back into the Maxwell while their dad had a short meeting with one of the men. He returned to the car and they headed back toward Windsor with little Emily still jabbering away.

"Isn't this fun," she said. "I like our rides. Don't you?"

The two older sisters didn't answer her. This is just one of the stories of Art Gignac and his bootlegging days. The little girl, Emily, is now the eighty-seven-year-old matriarch of the remaining Gignac family. She delights in telling stories about her popular dad, and her eyes light up when she is asked if she was the favourite daughter.

"Oh no," she will answer.

"Well maybe, a little bit."

Art Gignac.

Art Gignac's family was in touch with bootleggers of every stripe.

And then the impishness comes out, just like in the rides out on Seven Mile Road.

Art Gignac wasn't always a bootlegger. For a while he worked on the Great Lakes boats. He spent a number of years at the old Maxwell Automobile plant and at one time, with his brother-in-law Jake Renaud, he owned the famous (or perhaps infamous) Windsor Hotel at the corner of Pitt Street and Windsor Avenue. This establishment was not permitted to sell liquor during Prohibition but somehow it became a very popular watering hole for locals and Americans alike. Periodically, he would be notified of a coming raid and he and Renaud would pour their wares into the sewer. But once the raid was over, more liquor magically appeared.

Every so often, Windsor's finest would escort him down the street to the station and he would have to post bail or pay a fine. And guess who brought the money down to the judge? It was none other than little Miss Emily who knew where the cash was kept in the house; she would run dutifully down the alley to the station, pay the bail or fine and bring her dad home.

These occurrences actually posed no problem because in his absence, Emily handled the business at the home at 479 Windsor Avenue. Not only was the money hidden, but many areas of the old Victorian house had false floors and secret places under the stair risers, which held the whiskey cache.

"Mother did not like the idea of people drinking in our house, so my dad mostly sold whiskey by the bottle or delivered it to blind pigs and smugglers at the river," Emily said. But there were occasions when customers came to the back door and drank in the kitchen. One such person was a Windsor policeman who was a daily visitor.

"Every morning," said Emily, "this policeman would knock at the back door and Dad would let him in and put the bottle on the table for him. The guy was actually on his way to work at the station, so we had to ration his drinks 'cause he would have drank the whole damn thing if we let him."

Art Gignac also owned a taxi company in Windsor and this proved an invaluable asset in

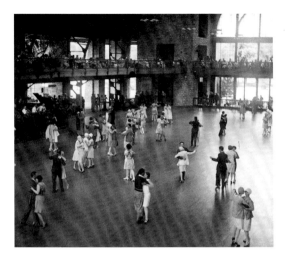

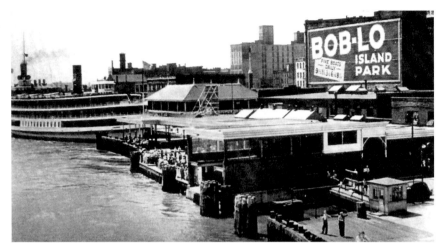

the bootlegging business. He used the cabs for delivery vehicles or to pick up prospective customers. At a party for his grandson who had just returned from Korea, Art, after a few celebratory rye and cokes, was entertaining some admirers with some of his marketing ploys.

"I'll tell you one thing," he said in his slight French-Canadian accent. "Those guys from the States are easy ones," he laughed. "Sometimes I go over to the Tunnel exit and I can always pick out the good-timers, eh? So I pick up a couple of guys who are looking for some whiskey and I tell them I can get it for them."

And now everyone is quiet. "So we negotiate the cost which is about twenty-five bucks a bottle, American, you know, and I take them over to my house. Now they stay in the car and the wife comes to the door and I wait out on the porch. She comes out with four bottles wrapped in newspapers and I bring it to the Yanks. They pay me 100 bucks for the booze and tip me twenty-five. They don't know it's my own damn

house. I drop them off at the Norton Palmer. They're happy. I'm happy." He laughed as loud as his listeners.

Emily was always fiercely proud of her dad, and remains so to this day. "He was really a handsome man, and he was known as the black sheep of the family," she says. "I guess it's because he was a bootlegger and had a lot of somewhat shady friends, but in that business, you didn't deal with angels. Now, his brother was a Papal Knight. You know, a Knight of the Order of Saint Gregory the Great. And he was president of Purity Dairy and founded Silvercup Bread. His name was Sir Harry Gignac. It's kind of funny to have two brothers in totally different occupations."

The bootlegger's first grandson idolized him. The boy was born in the old house on Windsor Avenue. And every morning for the few years that he lived with Art, the two would go for walks with the grandfather holding the boy's hand. They sat on park benches, spoke about

Bob-Lo Island was a favourite.

(*Left*) Bob-Lo flappers.

(*Right*) Bob-Lo docks.

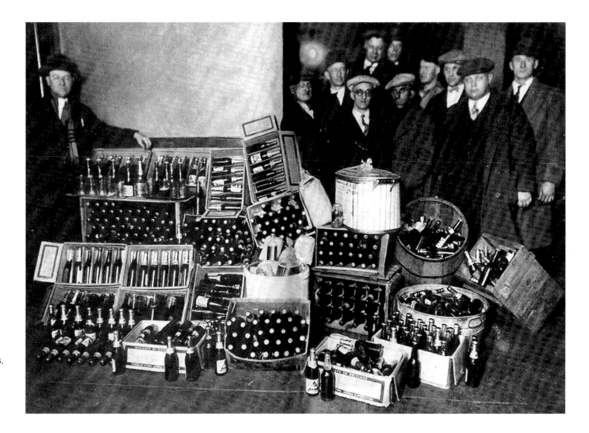

Michigan
bootleggers.
(State Archives
Michigan)

worldly things and talked to squirrels and blue
jays. The grandfather told the boy that they
understood us and that it was good to talk to
them. He taught his grandson many things like
how the streetlights turn on and off. He once
told him that someday there would be radios
with pictures and the boy believed it because
this man knew everything. He was a fine
grandfather.

Strangely enough, his grandfather's bootleg-
ging business created the circumstances that
brought the boy into the world. A few years
before, Art had hired a local blackjack dealer by

the name of Walt Paré to haul whiskey for him.
The card shark married Art's daughter and the
boy was born in 1933. They all lived in the big
house on Windsor Avenue for a few years. Walt
liked to tell of the time the old house was torn
down.

"Well, when they tore that place down, a
couple of guys found a few cases of liquor in
the old cellar. I guess Art had forgotten about
that hiding place but when these guys started
whooping it up, Art was fit to be tied," laughed
Paré. "He started yelling at them to hand it
over and they didn't know who in hell he was

so they just kept it. I thought Art was going to have a heart attack right there. And you know, he probably paid about eight bucks a case for the whiskey and now it was worth about $150 each, at least. And he could have used it because he was still selling booze at his new house over on McKay."

Well, the old house is gone now, and so is Art Gignac – entrepreneur and "gentleman" bootlegger – along with his drivers and his smuggling associates. Things have changed considerably around the corner of Windsor and Wyandotte. But if you can forget for a moment that his backyard is now a Burger King, and all the great old houses are gone, and the old elm trees have long disappeared, and if you listen very carefully, you might just hear the old player piano in the foyer and laughter in the big kitchen, while happy-time men tell stories, and smoke curls up from their Labatt's ash trays. And leading them all could be old Art Gignac and his cronies and customers, or even an occasional policeman off duty, or a Detroit-Windsor Customs official, or a couple of firemen from down the street. And you will probably see a kid under the table proudly leaning against his grandfather's knee listening to them all.

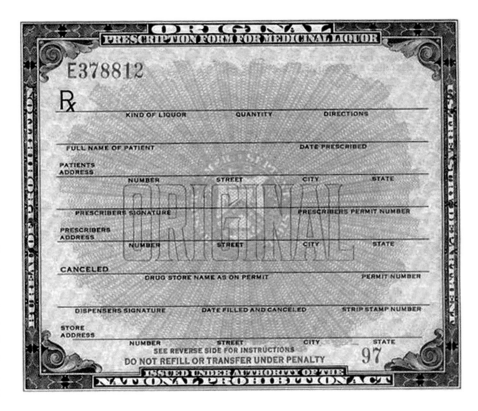

Now, where the old house used to be – in what some could consider an almost abject testimony to the old days of romance and excitement – stands the provincial beer store. Art Gignac would have preferred his chosen profession: bootlegger and entrepreneur.

Prescription Plan: Physicians were also making a bundle on the rumrunning business by charging customers for prescriptions for liquor.

Harry Low in his heyday.
He built an empire with
illicit booze, but died
penniless. (*Windsor Star*)

Harry Low's Millions

Of the hundreds of rumrunners, bootleggers, blind-pig owners and whiskey exporters, there were few giants. Harry Low was one, successfully amassing a fortune in very little time, though he lost it just as quickly. He was the epitome of extravagance and eccentricity.

Harry Low was a man of vision – limitless and foolish vision. In the fashionable old town of Walkerville, there stands a magnificent symbol of his dreams – the grand Tudor home once occupied by Paul Martin, former Prime Minister of Canada. The mansion was built and paid for by Low's huge rumrunning profits. It was lost because of poor investments, ill-fated judgements and unnecessary risks. It was lost because the boundless vision Low had during the Roaring Twenties couldn't sustain him following Prohibition.

Harry Low, a man who had raised himself from toolmaker to millionaire, made his fortune in Prohibition. He had stumbled upon a winning formula – something to which he gravitated more than machine-shop work: selling whiskey and exporting it on a massive scale. But his luck ran out after Prohibition and he died penniless. Vision had made him wealthy during the rumrunning days, but following it, it was this same far-reaching vision that resulted in his squandering large investments in extravagant projects far ahead of their time. Like the ingenious auto carburetor that was supposed to use very little gasoline – an idea that has finally, more than seventy years later, caught on. But in the Thirties, fuel efficiency wasn't a problem, and his idea was rejected – and his financial resources dried up. By the beginning of the Forties, Low was virtually broke. And when he died in 1955, he was living on the shabby fringe of Windsor's downtown as a lonely, saddened recluse.

Born the son of a machinist in Ottawa in 1888, he adopted his father's trade and soon earned himself a reputation as an excellent toolmaker. The birth of the auto industry in Detroit and Windsor attracted him to the area, and he soon found himself working as a machinist in Windsor. But Low wasn't content with such rudimentary employment. He forsook the trade to open a poolroom on Sandwich Street. Low didn't realize it at the time, but the poolroom was the first step toward rumrunning and the fortunes he had always dreamed of.

When Prohibition came into full force in the U.S. and Ontario, Harry Low saw a chance to make some easy money. He borrowed $300 from a friend and set himself up in the bootleg business selling liquor to poolroom enthusiasts. But he soon abandoned the poolroom when

The *Vedas*, Harry Low's pride and joy, put him in a different class of rumrunners. His use of huge steamers made Low a liquor baron in the Border Cities. (*Windsor Star*)

profits from the $300 spurred him on to engage in the lucrative whiskey export business. Low threw his energies into waybilling liquor from a Detroit River dock in fast speedboats, ostensibly headed for Cuba and West Indian ports, though intended for Michigan destinations and Yankee blind pigs. In no time, Low had formed a network running booze shipments from Windsor's docks to Detroit, St. Louis, Chicago and other places throughout the U.S.

But Low's rumrunning wasn't confined to speedboats. He invested his profits in large ocean vessels – the *Geronimo* and the *Vedas*.

Aware of their activities, the U.S. border patrol agents attempted to seize the *Geronimo*. They moored it to a Michigan dock and locked it up, but a storm set the vessel free and dumped it

back on the Canadian side, where it resumed rumrunning.

The *Vedas* was a World War I minesweeper. After the war it had been used as a banana boat, a sealer and general trader, and when Low purchased it, he refurbished the old ship, even fashioning iron drums to encase the engines and act as silencers. He then put the vessel to work hauling cargoes of liquor from Montreal to Windsor, sometimes boldly crossing Lake Erie to the U.S. for deliveries. But most often, the *Vedas* would transport its shipments from Quebec and rest offshore just outside the twelve-mile territorial limits of the U.S. During the night, swift cruisers would steal out and load up with cargoes and ferry them to shore.

Harry Low was a self-made man. As Gord

Steinke says in his book *Mobsters & Rumrunners of Canada,* Low would stand outside, puffing on a pipe and greeting customers. And one day, a man approached him with the idea of making a killing in the booze trade. He had already started bootlegging, but on a limited basis. He was close friends with James Cooper, who was associated with Hiram Walkers. And Low always had a supply on hand for poolroom patrons.

But now there was a bigger deal on the horizon.

As Steinke says in his book, Low went to that meeting on his own. He drove himself. That meeting was with the Mob on the outskirts of Tecumseh, Ontario, nine miles out of Windsor.

Low spotted a black sedan parked along the road with its engine running. Low pulled up, got out of his car and was asked to step inside this other automobile with American plates.

The man in that car was Eddie Fletcher.

Steinke describes it this way: "Harry tried to look calm, but his hand was trembling as he shook Fletcher's hand. He recognized Fletcher as one of the members of the Purple Gang. Fletcher was clean-shaven and had slicked-back, dark hair and movie-star looks. He was wearing tight-fitting, expensive leather gloves . . . Fletcher was a former prize fighter turned bad guy."

The deal was for Low to start sending liquor to the gang in Detroit. They knew of his connections with Cooper. Fletcher offered Low $80,000 up front, and $50,000 for every load he delivered to Detroit.

Low's response was quick. "I'm definitely your man!"

With that, the deal was struck, and Fletcher handed a leather briefcase to Low stuffed with $80,000.

Low suddenly had gone from bootlegger to high-priced businessman. This quickly led him to become head of the largest export firm in the Border Cities – Low, Leon, and Burns. That business virtually controlled the movement of liquor on the waterfront in Detroit and Windsor. It took over an entire railroad depot for its headquarters and from there, shipments of booze sped to speakeasies and blind pigs in Detroit, Chicago, Cleveland and even to the infamous Rum Row on the Atlantic Coast.

But success didn't come easy. He was coerced into devising some of the most bizarre ruses to get booze across the border. Once, workers at the Windsor Ford plant were astonished to see a Model T Ford hurtle down a street and drive off the end of a dock into the river. Low's plan was to divert attention and send the police into action to drag for "bodies," while his racketeering rumrunners rushed three truckloads of liquor along a main street into boats and along the river.

On another occasion, Low asked a friend to accompany him to Comber (about thirty-five miles east of Windsor) to pick up a load of booze. Upon arrival, Low was arrested and handcuffed to the wheel of his car. The police had wanted to hold him while they searched for more suspects nearby. Low's friend, however, wasn't manacled, and when the police left, he turned on the car's ignition and the two took off

Eddie Fletcher.

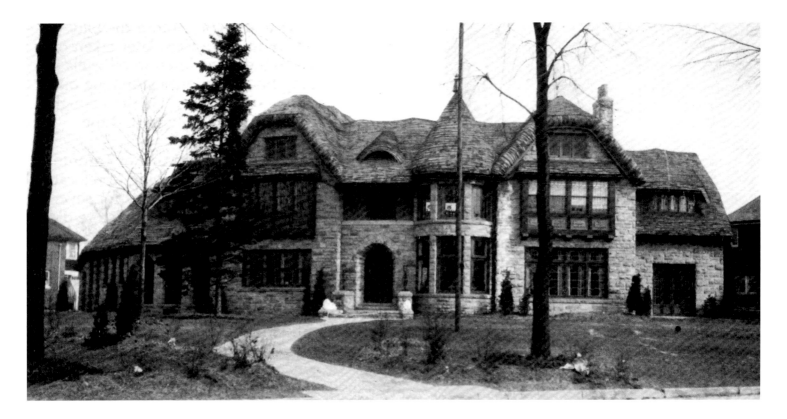

Low's grand Walkerville mansion, where he consorted with high society, was once home to the former Canadian Prime Minister, Paul Martin.

(Windsor Star)

to Windsor. They had also loaded up the cargo of liquor left behind by the police.

But bootlegging brought in small change when compared with the whiskey export business. The money Low accumulated led to great extravagancies like his Walkerville home, his pride and joy. It boasted a cloister for reflection and meditation. The windows were leaded, the floors tiled. It cost him more than $130,000 to build and it was regarded at the time as the snooty showpiece of Walkerville. One room's excesses included gold-tipped icicles. In poetic fashion, Low had ordered a slate roof to be made "like the waves of the sea."

Low's money also built the multi-million dollar Dominion Square in Montreal, a towering office building that at one time was the tallest in that city. But his vision far exceeded reality and the excess to which he had gone with the building finally led to his losing ownership of it.

At the time, Low was a partner in the export firm with Charles Burns and Marco Leon, one of the principals of the old Carling Brewery. Although the three were successful, they suffered a major blow in 1928 when the company was sued by the federal government for $21,000, which authorities claimed was owed in sales and gallonage taxes.

It was during the hearings that some of the dodges used by Low and his associates came to light. On one occasion, it was revealed how a large quantity of illegal liquor was seized on a railroad siding at London, Ontario. It had been way billed as "canned meat."

Low and his associates were also linked to the gangland murder of one of their employees – John Allen Kennedy, who was discovered bludgeoned and shot through the skull in the woods near the Ohio-Michigan State line. Low was the vice-president of the Carling Brewery at the time, and Kennedy was a bookkeeper for the company.

The Royal Customs Commission had wanted Kennedy to testify at its hearings on the liquor trade, but the bookkeeper had been whisked away to Cuba where he remained for several months. He returned to Windsor only after the heat was off and worked for a short time at the Federal Warehouse. He was killed shortly after he had been fired from that job.

Investigators probing his death claimed Kennedy had been a go-between for the export docks and customers on the American side of the Detroit River. They suspected but could never prove that Kennedy knew too much about the operation and was prepared to confess all to the federal commission. Police believed it was for this reason that he had been lured to a wooded area in Monroe Township in Michigan, where he was slugged at the base of the skull, shot twice and then dragged into the bush. The spot where Kennedy was murdered was the site of other gangland assassinations. No fewer than seven other murders had

occurred there, five of them apparently the work of the same gang.

For weeks police attempted to link the Kennedy murder to Low, but failed. In fact, police were never able to charge anyone, and the case never went to trial.

Many stories circulated about that killing, one linked to some well-known Windsor hoodlums who had consorted with Kennedy just before he was killed, and another that led the police to trace the victim's activities to a mysterious west-side Detroit house where he apparently met someone who drove him to Monroe. But police theorized that Kennedy had probably gone willingly to Monroe because he thought the business involved a large "still" known to have operated for months in the area.

As Prohibition came to a close, Low began dabbling, investing, trying desperately to broaden his wealth. First, he turned promoter and helped found the Old Comrade Brewery in Tecumseh, later taken over by O'Keefe's. He then was lured to oil wells in Petrolia, sinking his money into searching out non-existent reserves. He then bought real estate on speculation, only to find the properties worthless.

At one point Low, believing one of Toronto's largest department stores was going to relocate, paid thousands of dollars on options for several potential sites. When the store didn't move, Low lost his money. He also lost thousands when he rushed to buy up properties at inflated prices in Windsor just before the Depression set in.

His "gas saver" device was perhaps his most extravagant investment. Low believed he had uncovered a new gadget that would signifi-

Harry Low in 1953, shortly before his death. *(Windsor Star)*

cantly reduce the consumption of gasoline used in automobiles. After it failed to attract interest, Low bitterly claimed the reason he had backed off was because an oil company had paid him a bundle, fearing the device would have put them out of business.

Low had even gone to the extent of providing public demonstrations of his new carburetor and "gas saver." He rigged up two identical Dodge motors – one with the gadget and one without – and attempted to prove its efficiency. The results were impressive, but according to engineers and observers, still inconclusive.

Low's glory faded with the end of Prohibition. He failed miserably as a promoter, invested unwisely and virtually crippled himself financially due to misdirected ventures. In addition to this, he was plagued by the police. Following the 1928 hearings and the death of Kennedy, he was arrested in 1931 on a charge of trying to bribe an RCMP officer. Soon after, Low battled extradition to the U.S. to face a similar charge. He had been accused of offering a Customs officer $450 in a vain attempt to smuggle 285 cases of beer over the border. He won the extradition fight, but his troubles didn't cease.

By 1934, Low's fortune had dwindled to next to nothing. He had tried unsuccessfully to regain his former wealth with stock market investments. An attempt to seize the contents of his plush Walkerville home to pay bad debts was blocked by Low when he proved the $40,000 worth of antiques were not his property, but his wife's.

It was in 1934 that Low and some associates started the Trenton Valley Promotions in Michigan. He resigned as its president in 1936. In 1939, however, faced with a U.S. indictment charging him and Walter H. Hardie, a vice-president of Trenton Valley, with stock swindling, Low vanished from Detroit, where he had been living. The indictment said that he had falsely advertised stock in the corporation and had caused investors to lose more than $1,500,000. He was finally arrested in 1953 in Detroit when he was recognized from a fifteen-year-old photograph. Besides being charged with swindling, he was also charged

with evading income tax payments in 1935 and 1936.

On the income tax evasion charge, Low, it was claimed, had only paid $437 for the two years, although his income in 1935 had been $30,193 and in 1936, $23,239. Low received a sentence of a year and a day in prison, but it was suspended when Low was deported to Canada.

By the time the swindling case arose in court, the statute of limitations had crumpled the fraud charge laid under the Securities and Exchange Act, and Low was free.

An interesting sidelight to this story, however, is that when Low had been arrested early one morning in his Detroit apartment by Sam O'Connell, an Internal Revenue Service agent, he had been living under the name "Harry Love."

He pleaded that he had informed federal authorities in 1939 of his intention to return to Canada. (It was that year that he had been indicted for using the mail to defraud in connection with Trenton Valley stocks.) Low claimed he wasn't stopped from returning to Windsor, and since he had received no word from the U.S. authorities regarding the so-called swindle, he never bothered to follow it up.

From Windsor, Low moved to Sorel, Quebec, and worked there in the shipyards, again as a toolmaker. He returned to Detroit in 1949 and worked as a toolmaker, but when he attempted to set up his own shop, his identity was uncovered.

Low returned to Windsor and became a jobless drifter, living in a home on McKay Avenue on the fringe of downtown. He avoided the bars. He kept to himself, and when he died at Hotel Dieu Hospital in Windsor, it was two days before the police or newspapers realized which Harry Low had passed away.

Low had been a tireless dreamer, forever risking money and time on newfangled schemes and ventures, hoping to recapture the glitter of the Twenties. But these had been false hopes. His luck had withered with the end of Prohibition and the far-reaching vision of those early years had been replaced by weak excuses and subterfuge to fend off police and tax collectors.

Postscript: In 2006, the rotted-out mast of the S.S. Vedas *finally gave up the ghost to time, weather and who knows what. The cables kept it aloft, but only just. It had sat in Assumption Park at Riverside Drive for many years. City workmen finally removed the historical plaque that was placed there years ago, and hauled the mast away and chopped it up.*

Wimpy Stays Alive

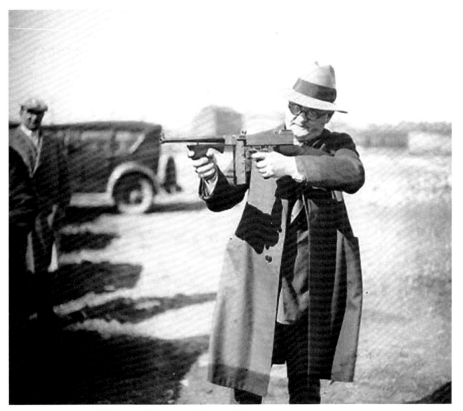

Policeman demonstrating machine gun. (Author's personal collection)

It was the late 1920s. Slim, a six-foot-four man with the strength of four horses, got word that a bootlegger hauling whiskey in a Model A had crashed through the ice.

He took two boys with him – both about fourteen or fifteen – and headed out with a sleigh as night was falling.

The bootlegger's car had gone down near Bob-Lo Island. Using a pike pole with a hook, he managed to fetch the body from the car in shallow waters. He flopped the body over on the ice, then went after the liquor.

In no time he had loaded the sleigh, and told the boys to stay put while he went back to shore where he had made a deal with some other bootleggers.

As darkness fell, the kids stood out on the empty ice, wary of every sound, and feeling awkward standing next to a corpse. Finally Slim returned and set to work fishing for more booty. He crammed the sleigh, but this time advised the boys to take it to shore. Slim then tried to pick up the dead man, but the body was frozen to the ice.

He gave the corpse a swift kick to jog it free, then tied a rope around the dead man's neck and slung the other end of the rope over his shoulder, and began to drag the body back to shore.

In January 1999, I spoke with eighty-four-year-old Dick "Wimpy" Boufford in the sunroom of his apartment building in Amherstburg, and listened to him spin this incredible tale.

He told me that he was one of those Amherstburg boys that night on the ice with Slim.

In those days, everybody was engaged in the illicit liquor trade – the police, excise men (Customs), town councillors, merchants, even kids in town.

He couldn't forget Mac McGillis, considered the kingpin back in the 1920s. Wimpy said Mac once showed him his books, how he had been raking in a half a million during Prohibition. His biggest customer was the Purple Gang. He used to meet its leader, Ray Bernstein, regularly in Detroit when he went to pick up a suitcase neatly packed with $50,000.

Wimpy, a tall man with a no-nonsense demeanour, learned early just how dangerous the liquor trade was.

Two friends of his – Doc Lester and Ott Baltzer – with whom he used to steal a few bottles of liquor from the docks, were shot in the head by bootleggers on Grosse Isle.

"We knew who did it – there were two brothers over there. We knew them. Those boys were the same age as me – fourteen or fifteen. Both were killed because those brothers thought they'd stolen their liquor. Shot in the head, they were!"

Wimpy met Goodchild one night when he paddled alongside Bob-Lo. On the way, he spotted one of the Goodchild brothers hiding in the reeds.

As Wimpy made his way further along the shore, he suddenly felt himself being yanked by his shirt collar right out of the boat by one of the two brothers who had killed his buddies.

"His name was Red – and he had a revolver pointing at me.

"'You been stealing my liquor?'

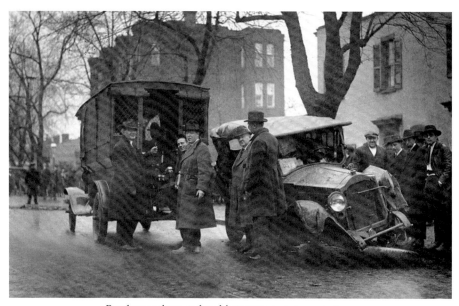

Bootlegger chase and paddy wagon. (Author's personal collection)

"'No way,' I said, scared as hell.

"'Look, if you see this Goodchild – you tell him he's dead!'

"I was scared, but couldn't believe my nerve. Here he was ready to blow my head off, and I was asking him if he'd tow me back to shore."

At seventeen, Wimpy was renting out a room at twelve dollars a shot to Bull Fielding, the slot machine millionaire. In that smoky twelve-dollar room the high-rolling merchants of Amherstburg played poker.

Wimpy also ran a gambling den from an Amherstburg hotel, where poker games could extend to two or three days at a time.

When the Depression came, Wimpy rode the boxcars with the hobos out west, meeting all sorts – bank robbers, bootleggers, failed entrepreneurs.

Eventually, he got into the navy and after the war found construction and factory work.

"It's been okay, this life," he told me.

What fuels him are the memories, the stories. He loves to tell them.

Another story that warmed Wimpy's heart is the time a stash of booze was found on Bob-Lo Island.

"Word got around town, and it was like the Klondike Gold Rush – from the town line right down to the frozen waterfront, people lined up with sleighs, baby buggies, hundreds going over there to get it.

"The town of Amherstburg was well supplied that winter."

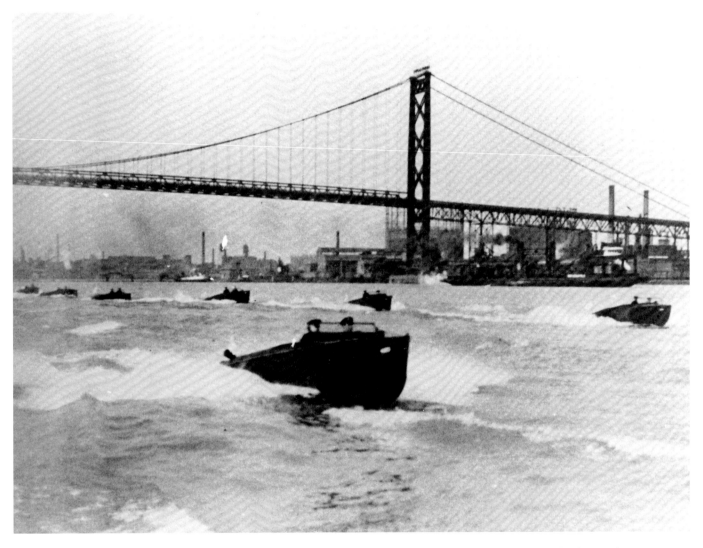

The Coast Guard with the Detroit skyline behind. The Ambassador Bridge was still under construction when large U.S. border patrols were organized to catch rumrunners crossing the river. Until that time, runners with cannon on their boats could turn on lone patrol boats and sink them. *(Windsor Star)*

When "Bathtub Gin" was Called Rattlesnake Juice and Jackass Lightning

Gayle Holman's "The Dry Era," a piece that appeared in Windsor This Month *(June 1974), points out that rumrunning wasn't done exclusively with convoys of cars and boats. The railroad played a major role.*

A resident of one of the busiest rumrunning areas at that time was working for a family who was into the trade. She didn't want to be identified, but shared some stories of that era: "They would bring it on the trains by the carload. Men would be in the cars before the train even stopped, throwing cases out to men in horse-drawn wagons riding alongside of the train. The Americans would come over and pick it up most of the time. They would bring it across the river in small boats, the whiskey in burlap bags, and if the law got close they would dump it over the side."

The crazy excitement was widespread. The money flowed in as the whiskey was run out.

"There was a lot of money made, some wouldn't bother to count it. They would keep it in cracker barrels then dump it into bags and take it to the bank. If the people at the bank had been crooked, they could have made a bundle."

As Holman found out, the police weren't naïve about what was taking place. The export docks and warehouses that covered the waterfront for miles were the clearing-houses for illicit booze, and Carl Farrow, former chief of the Windsor Police, who was provincial constable from 1928 to 1934 in Amherstburg, remembered what it was like.

This was the export area here; in other parts of Canada they were doing the same thing, but this area was very active. They used to clear loads from Canada on what they called B-13s, a Customs form. All along the river and lakes they had warehouses and export docks. Americans would come over in rowboats, motorboats and luggers and load up at these docks. When the coast was clear they would head back across to the U.S. The only time we would bother with them was if they tried to come back into Canada.

Nearly every time they would list their destinations as Cuba and quite often you would see a fellow come in with a rowboat, rowing in, load up ten cases of beer, and clear for Cuba. You knew very well he wasn't going there; he'd never make it. Well, away he would go and in a couple of hours he would be back, the same guy in the same boat. He would clear another load

Windsor
Ferry.
(Windsor Star)

Police Chief
Carl Farrow.
(Windsor Star)

for Cuba, but this time he might take twenty cases of beer. You could watch them build their business up, and I say them because there was more than one, until they quit beer and started running the hard stuff. Then they would move to bigger boats and shipments and the guy would go from rolling his own cigarettes to smoking cigars. Then you wouldn't see them for a while until one day he would be back with a rowboat again. He was either knocked off over there by the Border Patrol, or maybe hijacked. Later on they used to ship by plane. They would land back in the country someplace and bring it back that way.

They used so many ways to get it across. They filled the inner tubes of spare tires with liquor and had false bottoms in their cars and boats. Quite often they would wear a special

Walkerville
Ferry.
(Windsor Star)

belt and the bottles would be hanging down the man's pant legs or under the woman's skirts. As long as the bottles didn't clink together, they were okay. They even had false gasoline tanks and instead of filling up with gas, they would fill up with whiskey.

In the wintertime, when the water was covered with ice, they used to come over pulling big luggers, which are like huge rowboats, and sometimes they would put an inboard motor in it. Runners would be put on the bottom of these boats and several men wearing spiked shoes would pull it across the ice. When they came to open water, they would lower the boat into the water and row to the next piece of ice, pull it out, and so on.

Another thing they used to do was come over and buy up all the old cars they could get a hold of, as long as they would run. If they were touring cars fine, if they were sedans, they would just chop off the tops and load them up with liquor. This was done when it was really cold out and there weren't too many cracks in the ice. You could watch them from the shore in Amherstburg and they were just like ants. They would do it right in the daytime, open for anyone to see. I don't know what it was like on the other side, but it didn't seem like they worried about it too much. A lot of them went through the ice.

In June 1928, we fished out of the Detroit River and Lake Erie about twenty-eight bodies. They weren't all rumrunners, but I would venture to say a large percentage of them were. They had either fallen through the ice into the water, or out of their boats, or they had been

Unloading beer from the Tecumseh Brewery under Customs supervision. Provincial Police often supervised the unloading to prevent hijacking of supplies and to ensure that whole loads were not diverted to Canadian hotels. *(Windsor Star)*

hijacked by someone else. Of course, that was a bad area for bodies as far as we were concerned. If they had gone into the Detroit River up around Windsor end, by the time they could be recovered they would be around Amherstburg or out a little further in the lake. It got to be quite a job pulling them out, and it wasn't very pleasant.

There wasn't too much trouble associated with this. I was right on top of what was happening because we covered four townships, Anderdon, Malden, Colchester North, and Colchester South (in Essex County, Ontario). This was also the area where most of the export docks were. We had very little trouble with the people coming over, but we had some real characters. I met Al Capone once and some of his

people. They came into Amherstburg in a big speedboat and stayed for a while. Also Bugs Moran who was a rival chieftain from Chicago and in competition with Capone. They were just here to look over the export docks or pay some of their debts. I'm not sure. They didn't throw their weight around here, though.

In the later part of the Twenties and Thirties, the gangs got quite active in the Detroit area. There was the Purple Gang and a few others fighting for control, hijacking, shooting and so on. However, there weren't any gang fights here. Here they were just concerned with keeping the supply coming and what they were doing was legal.

Prohibition wasn't very popular in Amherstburg. For instance, there were an awful lot of

Destinations labelled. When shipping out booze from Canadian ports, in many cases the crates carried the customers' names or destination. None of these places or companies were American, of course, but in fact much of the liquor, such as this shipment slated for "Agostini Brothers, Trinidad" went "astray."

(Windsor Star)

people who made their money through that, and it paid good wages. Nearly every family in that area had somebody involved in the rum-running business. They didn't feel too bad about it. The stores and restaurants did good business from the people who came over with their boats and in the course of a day, there would be quite a few of them.

Many of them were caught, but a lot of people got through and made a lot of money – although, unfortunately, they didn't hang on to it. It was a great time for made-to-measure shirts, silk with monograms, and they paid exorbitant prices for them.

I was in Windsor for one-and-a-half years before I went to Amherstburg. We [provincial constables] had two raiding squads going night and day. We used to raid blind pigs, gambling joints, and bawdy houses. There was less rowdiness in blind pigs at that time than you find in hotels now. They had to be careful, because it was against the law and they didn't want to draw too much attention to themselves. A lot of hotels were running as just hotels, but they were doing bootlegging on the side and they were very careful.

Holman maintained that it became "almost fashionable for the young men to become involved in the goings-on." She provides this quote from an old rumrunner:

The first time we tried selling whiskey, we went to Montreal and got a load of about 150 cases. You could buy it, but it had to be for your

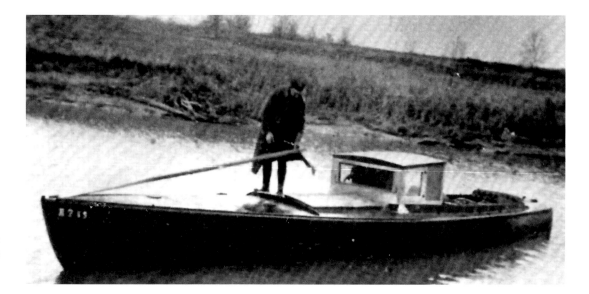

Inspection.
(Walkerville Times)

own use. They never asked any questions either, when a guy would order 200 cases. If it was for his own use, he'd be a thousand years old and still drinking.

They would bring the order in by train, and unload it into wagons pulled by horses. The day we got ours home some Americans came for it at about four in the morning. The next day, the police said we had to pay a ten-dollar fine on every case because they knew we had sold it. We had shown up at the same time as the Americans.

People used to sell their names to a guy so he could go to Quebec and get a load because it always had to be under a different name. The whiskey could be bought for about $30 to $35 a case for good stuff and sell for about $175 to $180 a case. It had to be good, though; if you bought cheap rye, you wouldn't get that much for it.

We only got two loads and I went into boot-legging, selling to four or five blind pigs, then after about two years I quit. There were a lot of blind pigs, especially in LaSalle and Amherst-burg. They were well run. You could go in to get a beer, but if they thought you had enough, you were cut off. I had a Model T Ford I used to carry the stuff in. They would call me when they needed some and I would go out with maybe ten cases of beer and a case of whiskey and drop it off. The blind pigs were in ordinary homes. There would be some people in the living room and some in the kitchen. You would have to be a friend of a friend of a friend before they would sell you a drink.

You had to be tough. You'd go into a blind pig and they would try to push you around, but you'd have to make your own way. You couldn't give a damn about anybody.

I would sell by the bottle, too. I'd buy the flat

bottles because the women would stick them down their dresses to take back across the border. I had this old stove and I used to put the bottles on it for a few minutes to warm them up for the ladies.

If you had the nerve, you made a lot of money. But money? What's money? You'd spend it as fast as you could get it. Easy come, easy go. I'd go into a blind pig and buy a drink for everyone there, maybe twenty or thirty people, and it would come to a lot of money, but you didn't care. But the blind pigs were run well. They didn't allow any riff-raff, they were good, clean people. Some were run a lot better than some of the hotels now. There was one blind pig that sold over 100 cases of beer and five or six cases of whiskey on Friday, Saturday, and Sunday. It was well run.

There wasn't much trouble and if there was, it usually had to do with someone hijacking. After we got our second big load and had sold it, these men came to the house with guns. They said that we had better let them in, so we did, because there was nothing there. They had come to steal it, and if we hadn't sold it, we would have lost it all.

You had to watch for the police all the time. When I knew where the police were going to be, that's when I took out a load. If a person found out there was going to be a raid, he would let everybody know so they could get rid of everything. They usually knew ahead of time what was going to happen.

The last time I was going to get some stuff, I was just driving out of this garage with it when a provincial policeman went by on a motorcy-

cle. If he had looked at my car, he would have known I was carrying a load because the bar of my car was almost touching the ground. But he kept going on and I got out of there fast. I went home, had a party, and that was enough for me.

People risked a lot for a few dollars. I would never do it again. There were some people who would bring it over to Detroit themselves. If that river ever dried up, the things they would find on the bottom.

An article in the Windsor Star *(October 29, 1960) focused specifically on the rumrunning vessels.*

Pipelines, underwater cable tramways and even the employment of a diver towing a sled on a river bottom were all used (to get liquor across the border to the U.S.), but it is safe to hazard a guess that 90% of all liquor illegally imported into Michigan came in surface vessels.

These vessels differed widely in size, type, shape and appearance. Steamers, tugs, fast motorboats, sailboats, rowboats and even canoes were employed. All had one purpose: using high speed, evasive tactics, camouflage and surprise to dodge the U.S. Revenue cutters and police boats waiting on the far shore.

While most boat owners depended on speed and darkness to conceal their operations, others decided to use refitted steamers for the haul. They reasoned that these old craft would be above suspicion and they had the capacity to carry a profitable cargo.

One of the old steamers, retired to the scrapyard after years of service, was the *City of Dresden*, an old wooden ship that had run for

years out of Dresden to Great Lakes ports. It was taken out of the "boneyard" at Amherstburg, refitted with the powerful engines that had been in the equally famous Wallaceburg-built *Energy*, and sent out with a full cargo of liquor.

The *Dresden*, rotting in the bottom, was a fast ship as a result of the engine switch. So it was natural when a revenue cutter gave chase in Lake Erie that her skipper elected to run for the Canadian shore.

He was winning the race when there was a sudden jolt and a crash and the old *Dresden* ran hard aground just off Morpeth dock. Her rotten timbers gave way and she filled quickly and sank, although the crew made it safely ashore.

A similar but not quite so exciting fate met the Wallaceburg tug *Maude,* which had been rebuilt out of the old *Grace Darling,* a familiar waterfront sight for many years. Originally an eighteen-ton steam tug, she was built by William Taylor at Wallaceburg in 1884 for J. W. Taylor and Hiram Little.

The *Maude* made one or two trips across Lake St. Clair with comparatively small cargoes and returned in safety. The owners finally decided to send her out with a real payload and 800 cases were jammed aboard the little craft.

October 5, 1922 was a typical fall day with a fresh wind blowing up chop on the shallow lake and the chill of fall in the air. Crew members of the *Maude*, still living in the area, recall they were apprehensive, but financial considerations persuaded them to make the trip.

The little tug made the downriver run from Port Lambton safely, but below the islands of St. Clair Delta, she felt the full force of wind and wave. She struggled out into the ship channel, though, and proceeded on her way.

Out in the open lake, however, the waves began to wash over the heavily-loaded little tug and the wave action worked the caulking out of her seams. The *Maude* finally filled up with water and nosed under, several miles from land and into twenty-five feet of water.

By good fortune, lookouts on the ore freighter *Wilpen* of the old Shenago Furnace Company Line spotted the sinking, and within minutes the soaked but otherwise unhurt tugmen were wrapped in blankets and drinking hot coffee in the galley.

Toronto Star *writer and well-known author Frank Rasky probably wrote the most colourful piece on Prohibition in* Weekend Magazine. [Weekend Magazine *was replaced by* Today.] *In speaking to old rumrunners and people who survived the era of flappers, speakeasies and jazz, he wrote the following.*

They remember the hip flasks of bathtub gin that used to be called *rattlesnake juice* and *jackass lightning*, and the F. Scott Fitzgerald flappers making whoopee in the bootlegging joints – the speakeasies and blind pigs.

They remember the fleets of rumrunning schooners sailing out of Canadian ports, purportedly carrying codfish to Cuba, but actually bearing caseloads of booze to parched Americans, and the international fuss raised when a U.S. Coast Guard cutter had the audacity to sink *I'm Alone*, a rumrunning ship from Lunenburg, Nova Scotia, 200 miles off the U.S. coast.

They remember the wisecrack of mobster Al Capone, who stopped chewing gum long

enough to tell reporters, "Do I do business with Canadian racketeers? Why, I don't even know what street Canada is on!" They remember, too, the tan spats and natty suits of Rocco Perri, Canada's self-styled King of the Bootleggers, long since dethroned and reputedly wearing a cement overcoat on the bottom of Hamilton Bay.

One "Windsor imbiber" told Rasky it was easy then to buy whiskey. You simply had to "make out a six-dollar cheque for twelve quarts of Golden Wedding Whiskey and send it, along with a $2.65 express order, to a supply house in Montreal. If he felt like assuaging the thirst of neighbouring Detroiters, he would slip bottles into the pockets of a carpenter's apron, and, with the bottle concealed under a coat, cross the river on the ferry, then sell the caseload at a tidy profit of $120."

The most ludicrous aspect of Canada's liquor regulations, Rasky cites, was "the bunghole of freedom they (the federal government) left open to Canadian breweries and distilleries." While alcoholic beverages were banned in Ontario, for example, it was perfectly legal to manufacture and export booze.

Manufacturers got around this slight restriction by forging the receipts and paying bribes to Customs officials. Since Canada's 132 part-time Customs officers earned salaries of $50 to $400 a year, this wasn't difficult. The Windsor-Detroit area – known as Rum Alley, because the two border cities were separated only by the mile-wide Detroit River – was easily the most lucrative funnel of graft. During the height of Prohibition, the marshy Canadian shore was lined with at least fifty floating "export docks," and it was estimated that Customs payoffs aver-

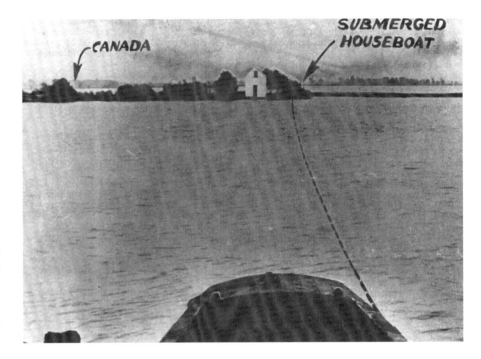

aging $2,000 a week bought immunity for liquor exporters. With a poker face, the Customs men billed out barrels of hooch to destinations like Peru, or St. Pierre and Miquelon, the French islands off Newfoundland. When a rowboat cleared for Peru in the morning and returned from Detroit one hour later to clear another cargo of liquor to St. Pierre, nobody asked questions.

Few Canadians questioned the propriety of the professional rumrunners. They were romanticized as buccaneers – Captain Kidds who outsmarted the patrol boats of the U.S. Coast Guard's "Dry Navy" to maintain freedom of the high seas and a friendly neighbour's right to liquid refreshment. Their schooners usually pulled out of Lunenburg, Nova Scotia or Victo-

Submerged houseboat filled with liquor. Looking from a boatwell on the Ecorse side, this scene shows the submarine operations of rumrunners. The dotted line shows the location of the cable along which the houseboat carrying Canadian liquor was drawn under water. *(Windsor Star)*

ria, British Columbia, their gunnysacks of booze frequently camouflaged as cargoes of lobsters, canned peaches, or coal.

In some lonely cove off Maine or Seattle, the skipper unloaded his cargo into high-powered speedboats. He made certain the purchasing agent properly identified himself; the ripped half of playing cards or corresponding torn dollar bills were commonly used.

The fleet of little boats would then wait at Rum Row – the nickname given to the line of ships anchored in international waters, three miles off of U.S. coastal cities. At a pre-arranged signal, they'd dart off in different directions. One empty boat served as decoy, trying to lure the Coast Guard cutter astray so that the others could slip ashore unmolested.

One notorious rumrunner from Lunenburg, William F. McCoy, became somewhat of a hero. He was so nimble at dodging the revenue cutters that his name passed into the language. His yacht, *Arethusa,* was equipped with armour plate and bulletproof glass, and in New Jersey speakeasies, his Canadian whiskey was reverently guaranteed to be the "real McCoy."

Rasky's article recounts how rumrunning was done by plane. He interviewed Charles Walter Wood, a Torontonian who is now retired from the Ontario Provincial Police and who "used to match wits with sky racketeers picking up liquor consignments on the Niagara Peninsula."

Wood still possesses a photo of himself and a fellow constable, posing triumphantly after they'd seized thirty cases of whiskey and champagne that a racketeer tried to smuggle out of a private airfield in St. Catharines, Ontario. "It was like one of those Keystone Cops comedies," he says. "When we broke cover, we surprised the gang with half of their gunny sack bags already loaded in the plane. The pilot stood with one leg in the open cockpit, the other on the wing strut. He shoved the throttle to make a fast getaway. But I grabbed the wing, so he couldn't fly away."

Rocco Perri was the one rumrunner who commanded Wood's greatest respect. "You could never catch Rocco actually handling his wet goods," Wood says. "He was too smart an operator for that. And his mistress, Bessie – a charming, good-looking, but brainy woman – had a mind like a steel trap when it came to organizing the business side of their deals."

Perri was a seemingly amiable, five-foot-four booze baron who looked like a sawed-off Mussolini; he had a weakness for sporty $200 suits, exclamatory neckties, and high polish on his fingernails. Yet the immigrant from Reggio Calabria in Italy started his career as a construction labourer on the Welland Canal. He opened up a grocery shop on Hess Street in Hamilton, specializing in olive oil and macaroni, but soon began bootlegging whiskey at fifty cents a shot.

His prices went up considerably when he was joined by Mrs. Bessie Starkman, an auburn-haired Polish woman seven years his senior. She deserted her two small children and her husband, a Toronto bakery wagon driver, to expand Perri's small operation into the biggest rumrunning business on the great Lakes – one with a $940,000 a year turnover.

She did all the bookkeeping herself and kept more than $500,000 available in eight Hamilton banks (under assumed names) in case of emergency.

Perri and Starkman directed their fleet of fifteen-horsepower cruisers and forty souped-up Reo trucks from a nineteen-room house on Hamilton's then-fashionable Bay Street South. The place was the envy of the neighbourhood with its Oriental rugs, $2,000 piano, billiard room, and secret subterranean room where Sicilian "alky cookers" distilled highballs for visiting socialites and cabinet ministers. Perri was invariably accompanied by a couple of bodyguards, William (Bill the Butcher) Leuchter or John (The Mad Gunman) Brown, who, despite their tough nicknames, were later rubbed out in gangland wars.

Most people agreed with Perri when he laughed scornfully to a *Toronto Daily Star* interviewer in 1924, "the law, what is the law? Am I a criminal because I violate a law that the people do not want? . . . I have a right to violate it if I can get away with it."

Chasing rumrunners sometimes had an ironic twist. Rasky interviewed former Windsor Deputy Chief Christopher Paget, who recounted how he and his fellow officers didn't mind "lending a helping hand to a liquor dealer in distress," even if that meant rowing their booze ashore in their own boats. Of course, that was usually when they were off duty.

Once, he and a fellow officer were out duck hunting in the inlet between Fighting Island and Turkey Island – two islands on the Canadian side that were a favourite rendezvous for

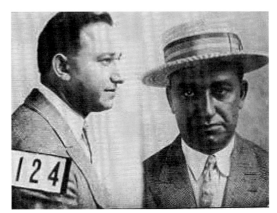

Rocco Perri.

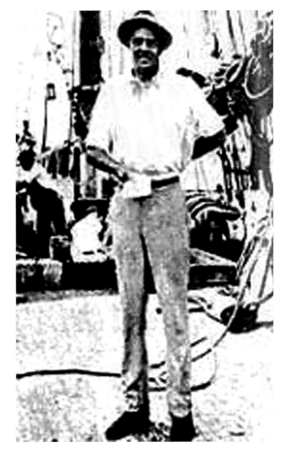

Lunenburg rumrunner William F. McCoy's activities may have been reponsible for the term "the real McCoy" being coined.

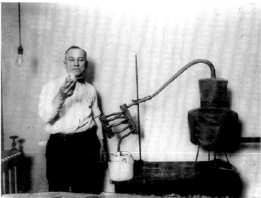

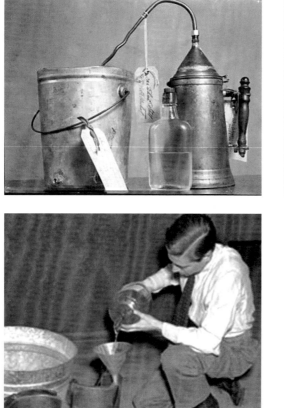

rumrunners. They came across a U.S. cruiser (with the proper legal export papers) that had run aground in a shallow; it was stuck in the mud because it was overloaded with 150 cases of beer. Paget and his friend readily agreed to lighten its load by rowing individual cases of beer ashore in their small duck boat.

But it was a laborious process, and Paget was glad to see Arthur (Mushrat) La Framboise, a celebrated Windsor muskrat-trapper and rum-runner, come chugging up in his speedboat, *The Joan of Arc*. Paget will never forget how Mushrat yelled out, "As soon as I give this fellow a bath, I'll be back to give you a hand."

Mushrat meant that his motorboat was dragging a corpse – a victim, evidently who'd been taken for a ride by Detroit mobsters and heaved into the river. After depositing the body with the local coroner, Mushrat returned to hook the *Joan of Arc* to the big cruiser and yank her free.

"We got five dollars each for our trouble and a free case of beer," Paget says. "Then my buddy and I continued our duck shooting."

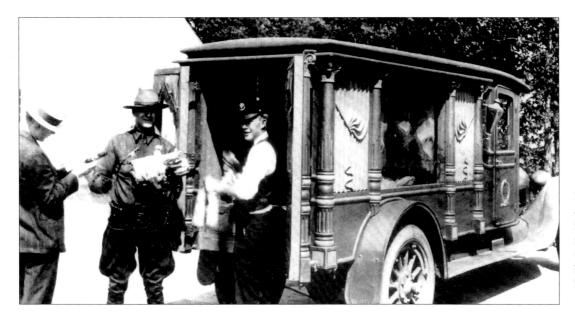

Liquor made its way across the border in ingenious ways. Some resorted to using a hearse to smuggle the illicit booze to American buyers. *(Walkerville Times)*

Mushrat La Framboise was a legend. So was his brother, "Whiskey Jack." The two were hard-working rumrunners, as Rasky details.

By day, he'd (Whiskey Jack) get $190 for rowing eight loads of fifty cases of beer across to Ecorse – the Detroit suburb known as the Gold Coast because it claimed the world's largest number of blind pigs. His customers would flash green lights or hang out white blankets to signal when the coast was clear of police patrol boats.

By night, he was paid twenty dollars – "Plus all the Old Crow Whiskey I could drink" – for guarding as much as 1,500 cases of smuggled booze cached in a clubhouse on Fighting Island. His employers, who called themselves the Fighting Island Gun Club, were a dozen liquor brokers from Detroit and Windsor, constantly worried about hijackers.

This granny smuggled liquor in eggs across the border on the Windsor Ferry. *(Walkerville Times)*

Mushrat was more daring. Rasky describes one night when the hard-bitten LaSalle rumrunner delivered 500 cases of booze across the river ice in a Model T Ford. Hijackers nabbed his load and shot a bullet into his skull. Mushrat spent only three days in jail, and his brother told Rasky, "They pried the bullet out, and it didn't affect him at all."

Speakeasy.

The Canadian terminus of the operation was well concealed in a private home. From that point, a heavy cable ran under the river to the rear of a gasoline service station in St. Clair.

When finally located, it was the service station that proved the undoing of the enterprise. The station operators were too busy to service cars and trucks, thereby causing suspicion by the authorities and an inevitable check-up and crackdown.

The tramway was powered by a heavy electric motor to drive the cable and its cargo. This was carried in a "tank," a metal container about eight feet long by four feet square.

In operation, the "tank" was loaded with at least forty cases of whiskey, a cargo found by experiment to have the right weight to hold the container well below the surface yet not allow it to drop to the bottom. On the return trip, an equal weight of water was used to hold down the container.

The first tank was lost, and is still on the bottom of the river. Enterprising scuba divers needn't make plans for salvage, though, since the tank was lost on the return trip and had no whiskey aboard. A subsequent tank was fitted with a different attachment and survived until the operation was terminated.

Mushrat, his brother said, squandered his money in the stock market by investing more than $2,500 in a gold mine "that had as much gold in it as I have teeth in my mouth."

Whiskey Jack told Rasky he believed "Ninety-five percent of them (rumrunners) died as poor as church mice."

A Windsor Star *article in the 1950s recounts some of the more bizarre methods used in transporting liquor across the border during Prohibition. One of the most ingenious methods was the "submarine tramway" used by whiskey dealers to channel whiskey from Courtright to St. Clair, Michigan.*

A newsman who worked for the Border Cities Star *on a part-time basis during Prohibition was the slight and dapper dean of Windsor newsmen – Angus Munro. Although he didn't join the staff of the Windsor newspaper until 1938, he was a correspondent for it in Detroit. It wasn't until his retirement in 1969, however, that he began to reflect upon*

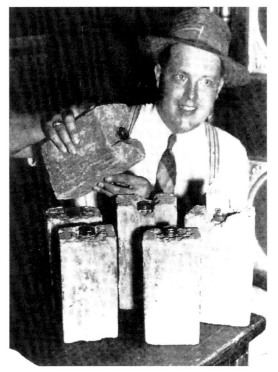

that era, and in his weekly column, "The Way Things Were," he recounted the tales from that time.

Munro described this area as "North America's largest non-commercial beer cooler," because "snugly tucked into the mud at the bottom of the river is a fortune in booze of various kinds, tossed overboard by rumrunners or dumped after seizure by the river patrol."

Munro was referring to the practice of rum-runners dumping cargoes into the river, most often in LaSalle and the St. Clair River areas in order to avoid being caught by the heavily-armed border patrols organized by the Michigan police.

"Coast Guard authorities have estimated," he wrote in his column of March 15, 1969, "that thou-

sands of bottles of choice liquors are there in the dark depths. Most of it is at least thirty-five to forty years old."

This cache is "Canada's off-shore wealth," Munro concluded with some amusement.

In a September 5, 1970 column, he recounts a quirky story about smuggling booze.

Smuggling of one sort or another always has been associated with any border community. Windsor and Detroit are no exception. This was particularly the case in the 1920s when liquor was the chief form of contraband.

The stories are numerous of the means employed by so-called "smart" smugglers. Liquor was poured into the inner tubes of auto

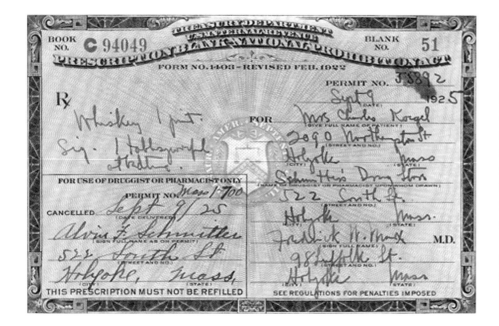

BOOK NO. C 94049 BLANK NO. 51

Liquor could be purchased legally under a prescription plan. These existed on both sides of the border. This one prescribes to the patient to take one tablespoon of liquor at bedtime.

tires, then the tubes were sealed and carried as spares. Women smugglers carried special containers under their voluminous skirts. The cans of liquor were suspended by cord dangling from a belt worn around the waist.

A story has come down through the years that indicates the lengths to which the liquor smugglers would go. It concerns a report by Customs officers who noted an increase in the importation of eggs from Windsor to Detroit, but thought little about it until one day in May 1920, when a man carrying a large market basket just off a boat from Windsor was hit by a taxicab near the foot of Woodward Avenue in Detroit.

A crowd gathered. There was an unmistakable aroma of whiskey in the air. Several dozen eggs were spread out on the pavement. The man, not seriously hurt, obviously was ill at ease. As soon as the crowd gathered and a police officer approached, he took off.

The market basket, with some of the eggs intact, remained in the middle of the pavement. Upon examination, the basket contents revealed eggs filled with liquor and carefully sealed. It was then that the Customs officers came forward to testify they had noted increasing numbers of shoppers bringing "eggs" from Windsor to Detroit. From that day on, all baskets of eggs were suspect.

In reporting the incident, the *Border Cities Star* of May 18, 1920, described the operation in the form of an advertisement:

> *Fresh Canadian eggs two dollars a dozen. Laid by Canadian Club hens, Scotch Plymouth Rocks, Brandy Pullets, Martini Leghorns, Bronx Minorcas and Gin Bantams.*

The report went on to explain that the whole smuggling package might be described as "Eggs Diable."

There was no explanation of how the original hen's eggs were tapped for their new contents. This could mean long and tedious work, but apparently nothing was too great a task for the bootleggers of the day – not even pricking holes in hen's eggs and draining them, or carefully breaking them, emptying their yolks and whites, then carefully filling and sealing them for the journey across the river.

Eggs and whiskey still mix. Today we call it eggnog.

The "prescription plan" was considered one of the many farces of Prohibition. In a May 29, 1971

account, Munro focused on "what was known in those days as a 'script' or a 'per', which actually meant a signed prescription from the doctor" that liquor would be of some aid to the patient.

The system was rather loosely enforced, especially after the first few weeks. Some were "sick" at regular intervals – say, every week or so. They appeared in sound health, but they were able to get prescriptions. These were filled by presenting them to a licensed vendor, or, later on, a government store. The banner year for scripts was 1919.

As many as 222 in one day were issued. The same doctor, according to court testimony, dispensed 1,244 in the month of December. A vendor who handed out the liquor could testify to the steady progress of "sick" people. In August he testified 619 were issued by doctors; in September, 1,095; in October, 3,259; in November, 6,827 and in December 8,512.

The same reports indicated that more than 90% of all Ontario doctors were not involved in the excess dispensation of scripts. This meant that most doctors, anxious to follow the ethics of their profession, declined to issue scripts unless there were indications of real need. As a result, they lost patients and families who might otherwise have become their patients, while the less ethical doctors gained patients.

Within a few months violations became so flagrant that the issuing of prescriptions for liquor was cut to thirty in any one month by any one doctor. This still left room for abuses, but they were cut to a minimum.

The average fell from hundreds a month to about twenty-five or thirty – some fewer. Old-time Windsor residents who recall the script era tell stories of going to a doctor and complaining of a cold or upset stomach or even remote ailments and having no trouble getting their prescription.

It was still up to the judgment of the vendor whether or not he should fill the doctor's order. If too many from the same doctor were presented by the same customer, the incident was reported and government inspectors moved in and checked the circumstance.

J. D. Flavelle, chairman of the Board of License Commissioners, told the public accounts committee of the Ontario Legislature that 80 to 90% of the prescriptions issued for quarts of liquor were not at all necessary for medical purposes. He also said that 10% of the physicians paid no heed to the current law. One doctor, he reported, scribbled out 2,500 prescriptions in one month, and demanded payment of two dollars or three dollars a piece. Premier Drury in September 1920, described this ruse in The Globe, *on the part of doctors as "using their profession as a thin cloak of bootlegging." He couldn't have been far off in his estimation, because in that same year, government dispensaries sold $3.5 million worth of liquor. In 1923, that figure had risen to $4.8 million.*

Ben Spence, secretary of the Dominion Alliance, a highly active temperance force, complained vociferously that the government was supplying more liquor than the bootleggers and rumrunners. There was also a clear indication, according to reports in The Globe, *that wily customers were forging physicians' names and printing off phony forms.*

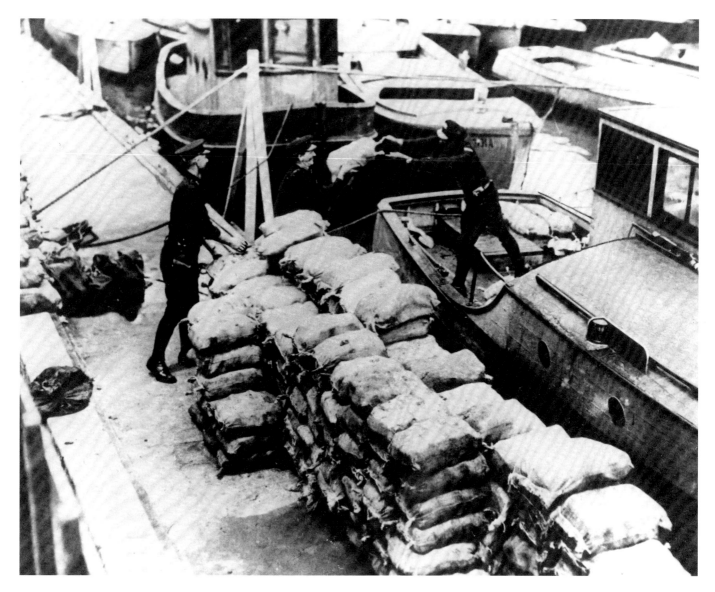

Police remove sacks of seized liquor from rumrunning vessel. *(Windsor Star)*

Assorted Stories: Whiskey Slides, Starting in the Business at Five, Iron Boxes Under the River & the Water Highway

With a few exceptions, the people who told these stories asked to remain anonymous. They telephoned in response to an advertisement in the Windsor Star. Many of those who gave me their story wished to remain unknown because they believed that even after several decades, it was better to keep quiet. These are glimpses into the bizarre ways in which people struggled to get booze across the river.

Housekeeper from LaSalle: On the Fringe

They had to watch for hijackers and one of those hijackers was Cecil Smith. There was a gang of them. I know 'cause I lived across from them when I was five years old. I got punched in the nose many a time 'cause I was a tomboy. Another group would bring the liquor to their homes, and they'd hide it in the barn or in the greenery. Then they'd make contact with the Americans to meet them at a given place, and they'd have to turn around and haul it from their home to there. So Cecil and the Brophy Gang – it wasn't only just them, there was quite a few other gangs, you know what I mean – went where they were meeting and waylaid them on the roads and took the loads away from them. Oh, you don't know the racket!

How they operated the roadhouses was – I can tell *some* tales out of school. These people are dead now. They used to pay off these Provincials. They didn't go by names. The Provincial might call and say "number nine" and he'd hang up. You knew to get the heck out. You'd grab the stuff you had in the house and put it in the boat and get out in the middle of the river. That's why the roadhouses were practically all on the river. You could get a meal in these places, and if you were known, you could get into the back room and get a drink.

Mushrat La Framboise was a real character. I think his name was Art. They called him Mushrat because he used to go muskrat hunting. Him and Pete his brother are both dead now. But anyway, Mushrat used to run up and down the river with his boat, and sometimes he was with a Mountie and sometimes he was with bootleggers. He was riding both sides of the fence. Muskrat meat was very, very lean, but they used to put on muskrat suppers up there, and if you wanted to put on a muskrat supper you got a hold of Mushrat and told him how many you needed. He went both sides, I was told. How

could they run that way? They used to be able to do it, because they were in with this one officer, and they'd pay him off, not so much in money as in favours, you know what I mean. If he wanted a party, well, you gave him a party. Or else.

Another thing, too: I got acquainted with some people that lived around Wardsville (about sixty-five miles east of Windsor). There used to be a marsh there. In between Wardsville and Glencoe, on Highway 2 – see, it wasn't paved then – and these young fellows that showed up in daytime, they'd bring a bunch of water there in barrels and they'd make a real mud hole and then at night, they'd hitch up their team and wait. The bootleggers would get stuck there and they'd pay them to haul them out.

Well, leave it to these young farmers, you know, they talk about how bad the kids are today, but you know, you stop and think about all the pranks some of these others played. Sure, just as bad or worse. They played it maybe not in as destructive ways as destroying property, but they used to do an awful lot of pranks. If they got mad at a farmer, the next morning he would get up and maybe his wagon would be on top of the barn.

A Five-year-old Girl Watches Over Daddy

I'm fifty-four and my dad has been dead for a while. But my dad was mixed up in bootlegging, though I don't think he was notorious.

Now, he used to run with a fellow named Sticks Washbroke. I think he used to smuggle Chinese and dump them in the river. Dad used to talk about it once in a while when he was drunk. And they are all dead now, so it's okay to talk about it. But I can remember I was only about six years old and it was Big Moosh and Little Moosh. [Big Moosh and Little Moosh were two French-Canadian rumrunners.] They were brothers, and I don't know what their real names were. I was just a little kid. But I know they both went to jail. They were at my house when I was a little kid and my mother was a churchgoing woman and there was always trouble about this. My dad was a real rounder and then I grew up to be kind of a rounder, too, in a way, but I'm okay now.

My father was running the stuff out in Riverside around Little River. These fellows had boats, see, and I remember as a little kid just starting school, the police bringing my dad home all full of blood.

He had crashed through a bridge, and the car was full of booze. He darn near got killed, and there were bullet holes in the car. And my mother told lies to me, but I could see all this blood.

And my mother always maintained that these people took Chinese people over to LaSalle (still on the Canadian side) and told them they were in the U.S. It's funny in a way, but not really. You know, they'd get $100 from them.

There was also Dinny Dinan. He used to run a blind pig across from the Capitol Theatre in Windsor. Up the back stairs, up those stairs they used to have a game going. My mother would make my dad take me from Riverside, because

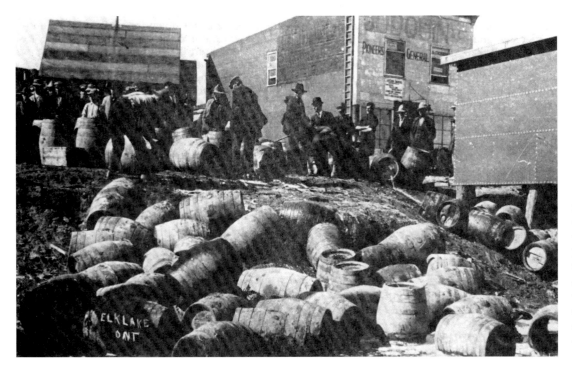

Blind pig raided by vigilantes. Windsor wasn't the only place for blind pigs. In Elk Lake barrels of the best Canadian whiskey were destroyed when a blind pig was discovered. Most of the contraband alcohol originated in Ontario.

(Ontario Archives)

he worked on the Wabash Railway. And when he picked up his paycheque, she figured that he'd get home with some money if I was with him 'cause I was a little kid.

I can remember sitting around and watching these people gambling and I started to drink beer when I was about five years old. And I did become an alcoholic incidentally. Well, it's okay now, I haven't had a drink in seventeen years. Things got so bad once, in the basement of the Metropolitan store I put an iron under my coat and I started to walk away slowly and I thought, "That's good for a couple of dollars, anyway." But they had it chained down and I could have got nailed for shoplifting.

And another time I was with a gang that had a whole bunch of stolen stuff in cars and the police raided them at the Pillette docks, and I pretended that I was necking with a fellow, and I watched them get arrested and I never got touched.

A Rounder from LaSalle

We got liquor from Montreal and sold it and bought a farm with the profits. That's how well we did with the liquor. That's what it was like for the rumrunners, as you call them. Oh, there was a lot of money to be made, to be sure. American dollars were about 15% less then. A lot different than now.

I had brothers keeping the beer docks in Amherstburg, and I was there every day with them. I was hauling for blind pigs in those days. Some of them got raided, I remember, but I never got caught. Anyway, I was taking the stuff to three or four places. I can't count all the blind pigs there were in LaSalle. I'd say about seven or eight up there, but they had quite a bit from MacGregor to Amherstburg. I used to haul ten cases of beer in the car with one case of whiskey. I never was caught. I did it for three or four years. Well, we'd pay for the fine stuff maybe $20 per case. And we had 200 cases last time and that paid $4,000. We made over $8,000 clear. Then bought a farm.

In those days, I helped out my Dad. Then he died, and I kept on for a few years, then I quit. These runners, they used to cross over the river with a boat. In the wintertime they used to have a car, and they'd have two great big planks on each side of the car. If they saw a crack in the river, they'd put the plank across the hole. They were risking their lives. They were desperate and it was never too much trouble.

When these beer docks were open in LaSalle and Amherstburg, you know they'd wait until dark, then they'd cross over. Even hauled it in planes – they had a plane that landed not far from here, and it had a bullet hole in it. The pilot had time to unload, and he just flew back.

You know, I used to be at the beer docks pretty near every night, every day pretty near, when it rained – that's when all kinds of guys were coming over. Each one had a big gun. The last load we sold here, the guy came in, and he had two great big revolvers. He put one on each side of him, and then he took out a roll of bills, large enough to choke a cow. You know we had to keep that money in the house all night. It was kind of risky. But you'd get used to it. They were tough days, but there was quite a bit stolen, too. People going around stealing loads of liquor. And if you didn't want to hold it yourself, they'd give you money. They'd give you a thousand or two to get a load sent in your name. Quite a few around here that done that.

Be better to haul the load ourselves. I wouldn't go back to it. But those days, when we had the load here, the police would come every day. We'd put a bottle and a glass on the table and they'd take a drink and go down and see if the load was in the basement. If you didn't do this, they'd seize every damn thing.

The law wasn't so strict as it is now. As long as you had the stuff in your house, it was all right. We got the last load from Windsor – used to be on the boxcar, we had 200 cases, we had two wagonloads. We came up the Malden Road with no gun or nothing. We could have been held up right there.

Airplanes and Wooden Boxes: Walter Johnston's Adventures as told by his son

They had money coming out of their ears at the time, they were smuggling so much. They were filling deflated spare tires and false gas tanks and running back and forth from Windsor to Ecorse (Michigan). They also took it over from LaSalle to the other side underwater. They

rigged up two cables and pulleys at each end, attached a wooden case to the cable, and pulled it across, not letting it touch bottom.

My father had an airplane at that time, and they were flying from here to California with liquor, but they lost the plane. They had to drop in a ploughed field one night, and they lost the plane and a load of whiskey.

They were also supposed to be smuggling Chinese across to Detroit. But they weren't. They were taking them down to LaSalle and dropping them on the Canadian side. They were getting about fifty dollars each for doing that, though they were supposed to be bringing them to the U.S. Sometimes they were. But when they didn't, they were just taking them for a ride and dropping them off in the same place. The Chinese didn't know any better. That was all in the game at the time.

The Whiskey Slide: Francis Chappus

The following was told by Bert Chappus before he died in September 1979. He was the son of Francis Chappus, former conductor of the streetcar that went into LaSalle. Chappus was also a wheeler-dealer in the whiskey business.

There's a whiskey slide on the side of this house. It's a ramp, and you'll notice all the basement windows are barred. And that house next door – it was built on pilings in the bay, on big long pilings. Half of the house was a boathouse with a big door that opened up to let the boats in. And the only thing that house was used for was to store liquor. It would sit right on the bay of the Detroit River – it was owned by my dad, Francis Chappus, That's all that it was used for at that time. I moved it back and rented it after the bootlegging days.

Anyway, they used to come in with the boat, which was a big tug. There was a cannon mounted on the bow. The boys would sleep in our house and put all the arms and ammunition on the porch. And they had everything you can think of – from machine guns to handguns. There's one revolver I used to like, a .38 with a long barrel. And I used to go out there every morning and throw a can out on the water and shoot at it. I wouldn't miss often.

These people who came worked for my dad and would come in a boat. They transported the booze from Montreal through the waterways. But oh, it was nice to watch. They used to come with that boat and throw the stuff into the house. Nobody could see them, and they'd just throw the whiskey crates down the whiskey slide, and they'd go right into the basement. Of course, guys used to put the stuff into the boathouse, too, because the boathouse was only half the house. The other half was open so they'd pile whiskey up and keep piling it up.

My job was to count the money. It was all American bills, mostly $50 and $100 bills, and some bigger ones. Every night it was $75,000 to $125,000 – and I'd have to count all that. Well, it didn't take long to count with $1,000 bills. I stuffed it into the stove, an old Moffat Electric with a warming oven on top – just stuffed it in there. I guess that's why there were people

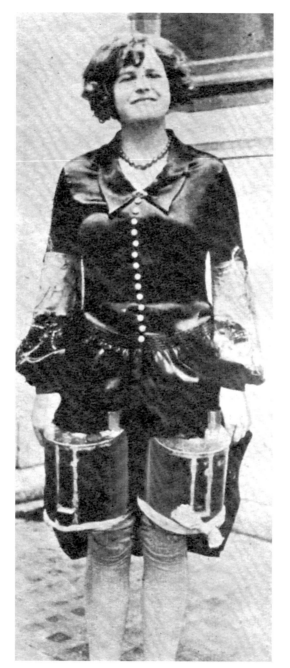

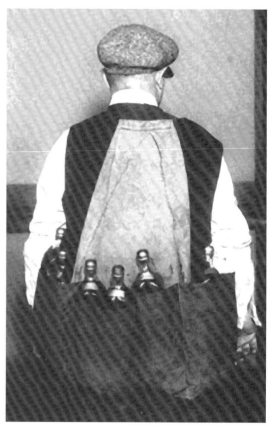

Casks of liquor worn under a dress. Bottles were stuffed in stockings, specially tailored pockets, coat sleeves, pant legs, lunchboxes, hats, spare tires – **anywhere.** (Left: *Windsor Star*) (Right: From the collection of *The Detroit News*)

around with guns – to protect against a raid. But Dad never fired a gun. He had other people to do that.

They hijacked him a few times. That's why these guys had a cannon on the bow of that boat. That's why they had machine guns. They worried but, as you can see, the house is barred and we had a good dog. That dog used to take me across the river to the island in my cabin, my fishing cabin over there on Fighting Island. Yeah, we used to be able to cross there by foot on the ice. And that dog, well, my dad fixed up a

harness for him just like a horse, and he pulled me across on the sleigh.

On Old Front Road here, they used to have to get the horses out to get the cars out of the mud. It got so mucky out there with the Whiskey Six Studebakers and all those cars. . . .

Anyway, my dad stored whiskey here, and then the boat would come across the river and pick it up. They would come over every night, as I said. My dad never went with them. I guess at that time, I was about twelve.

My dad was a streetcar conductor. There was a switch right in front of our house here, and he would go to Amherstburg and around the river, all the way along the Detroit River – all the way to Tecumseh and then back. They'd switch right here in front of our house and change cars.

The Sunnyside Tavern was operating in those days. They were serving liquor – it was run by my uncles, Albemie and Alberic. They got raided, but they used to have guys at Turkey Creek and down at the other end, and they would flash their signal lights, so everything was put away out of sight from the police. They had a big gambling casino upstairs.

The hotel was finally sold to Ray Booker. The place had screen stars coming there. Jean Harlow used to come down here, and Mae Murray had her speedboat down here.

Running Rum from Pelee Island: The Story of Edward James Betts

At the time I spoke to Edward James Betts, he was a rugged and broad seventy-three-year-old with a great sense of humour, still working part-time in the harvest months for Canadian Canners. Betts had lived in Windsor since 1951 and had worked for Ontario Hydro for twenty years.

I was thirteen years old and that's when they used to run the whiskey – down from Waterloo, they used to bring it through here in Reo Speedsters and Whiskey Six Studebakers. And the man I knew, I'd ride with him at different times, was Cecil Smith. If you look back in the records you'll find his name. He had a sister down there by the name of McCall, and I used to go to school with her kids. That's how I first met him.

He got to know me, and he used to pick me up on the road. He used to be driving a Cadillac. I hardly ever saw him with the liquor himself. But he had Whiskey Six Studebakers and Reo Speed Riders running from a distillery in Waterloo. They used to go out from that part of the country and bring it through here.

I lived down just the other side of Wheatley. My dad was a fisherman. But we moved from there when I was sixteen to Pelee Island. As you know, Pelee Island is the most southern part of Canada, except for Middle Island.

There was a little harbour on the south part of the island, and an export station there, and another one at the north end of the island.

Well, the rumrunners used to come from Amherstburg down from the river going across over to Cleveland and all that. They used to lay over at the bay at south end of Pelee Island until night, see?

The export station was run by Fred Rocheleau and a Jewish family by the name of Kovinsky.

All this rumrunning business was done in cash. Oh yes. All the dealings I ever saw, them guys used to unroll the money in $1,000 bills, $500, that was just common stuff.

My dad and I used to work for a man as fishermen, and sometimes we used to go across to Ohio in the fish boat. We used to get $100 a trip. Ross used to take $50 and Dad and I would get $25.

Well, then the Coast Guard got tough. When we first started, hell, they didn't bother. We used to run liquor back and forth there like nobody's business. We used to take over about 220 cases of beer. But then the Coast Guard got tough. They mounted one-pounder guns on the Coast Guard boats, and they had their .50 calibre machine guns. Well, Dad and I didn't go out anymore after that. We didn't get shot at, but they shot at other people.

We brought the beer to Marble Head. That's over on the higher side on the other side of Carol's Isle. It was about a two hour run at night. Yeah, we used to go there after dark and come back. We took a pretty good load for the boat we had.

Now that export station run by Rocheleau – he's dead now – didn't have no name. It was just a little harbour on the south end of the island. It's so little just small boats can get in it. Runners used to come in there. As a matter of fact, there used to be a Deputy Sheriff on the other side who'd come over and load up. Yep, from Port Clinton. Guy Tiddle, his name was. He used to bring a fishing party to the east side of Pelee Island, and on the way back he used to stop in at the export station and load up with whiskey and put it down under the deck, see.

And these other guys used to come in and pick up loads in speedboats, and they'd have twenty or thirty cases, all this stuff was done up in burlap bags, the whiskey was, but all the imported whiskey came from Scotland in wooden boxes. But our Canadian whiskey was done up in burlap bags.

So if you had to throw it overboard, it would sink. Wooden crates would float, 'cause you used to get chased sometimes.

Well, there were big boats that ran out of Amherstburg. The *Shark* was one of them. She used to carry 1,400 cases of beer. She was a big schooner. A rich man's yacht.

They were nice guys, but they were tough, too. If you got them in a corner, they weren't afraid to use a gun. They had them to use, too.

They had a little trouble in the lakes with boats being hijacked. . . . This boat came in one afternoon. We knew it was a strange boat – to us, anyway, in the harbour. So we went down there and there were five or six guys. Oh, they were tough buggers, and they wore handguns, Tommy guns and shotguns and high-powered rifles and they were in the export station talking to Rocheleau.

We asked, "What the hell are they doing around here?" Rocheleau said they'd had trouble with boats being hijacked out here in the lake. So these guys wanted to talk to these fellows, see? They were back the next morning and

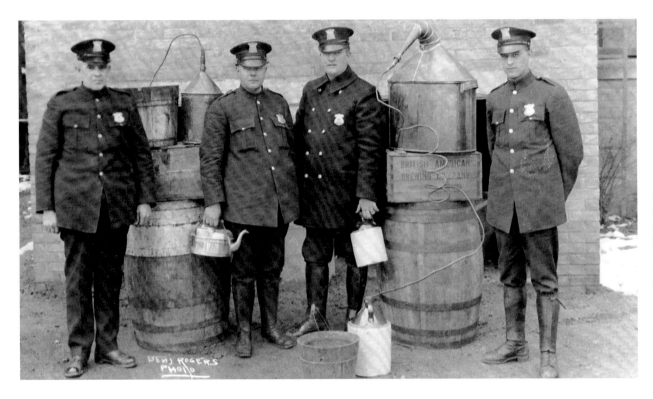

In this photo, several policemen make a bust on a blind pig. James Benjamin Snyder is standing at the far left. He was Chief of Police for the Town of Sandwich from roughly 1921 to 1924.

(Author's personal collection)

we asked Rocheleau, "Did they get the fellow that was doing this job?" He said, "I guess they did."

We heard through the grapevine afterwards about the fish boat that used to come and pick up our fish. They'd found the boat out in the lake with nobody aboard. She'd been all shot up.

One of my second wife's relations got shot up down the river, got killed. American Coast Guard. They were being chased by the Coast Guard down the mouth of the river here some-place going over probably to Monroe – that used to be quite a place over in that way, where they used to land.

And the Coast Guard chased them and shot them up. Sunk the boat. He got killed anyway. Guess he had a hole in his back.

You know that brewery down in LaSalle, Hofer's, that was built in the rumrunning days, just for rumrunning? That Calvert's Distillery in Amherstburg was just for that, too, you know. They used to bottle Old Kentucky and every-thing all out of the same vat. Old Crow would knock your hat off in them days, I know. About 100 proof. I guess it's made in the U.S. Whiskey or whatever, you'd take a drink, and your hair would stand up on end.

A guy worked there and he said they used to bottle it just right out of the same vat and all

the difference was the label on it. At Hofer's – they used to make beer, but it never went on the market that I knew of in Canada.

A Pram, A Baby, and Bottles of Booze: Norman "Yorky" Haworth

I used to do it all the time – smuggle booze, that is – I'd take my daughter over (to the U.S.) in her pram. But underneath her, there was a false floor and I'd put the bottles in there. Then I'd give her a sucker, and off we'd go. And just as we got to Customs, I'd pull the sucker out of her mouth, and she'd howl. The Customs man, not wanting to put up with a screaming baby, would just look at me and say, "Get out of here." And off we'd go. And of course, as soon as we were through, I'd give her another sucker.

Taking Bottles Across Easy Like: Two Stories

One time, we were going across at Buffalo and I had a bottle. I turned to my girlfriend and said, "I bet I can go up to the Customs man, tell him I've got this jug and walk right through, untouched."

And she said, "No way!"

So halfway across, I stopped the car and got out and she drove. When we got close to the Customs booth, I started lurching, and when I got there, the Customs official said, "Anything to declare?"

And I said, "Yeah, officer. I've got twenty-six ounces of the finest Canadian whiskey, right here," all the time slurring my words and patting my stomach, which is where I had the bottle, tucked into my belt. And the officer just said, "Get out of here." And I did.

Carrying liquor at the time was a greater offence than drinking it. The London Advertiser observed in 1919 that "the $200 fine for the bottle on you can scarcely be matched up with the ten-dollar fine for the bottle in you."

We used to take bottles across. Not a lot. But sometimes quite a few. And my lady had a rig she could put a lot of bottles in. She had these belts and she'd strapped them to her body, beneath her dress. One time, we got to the border and they asked us to get out. She got out her side and I got out mine and we were looking at each other over the roof of the car while the Customs men searched the car, when all of a sudden she got this terrified look on her face and smash smash smash smash – one of the belts let go.

Old Ford City, Whiskey from Montreal, and the Blue Top Brewery: Jake Renaud

My father (Joe Renaud) used to have a bar at that time. It was called the Ford City Pool Room, on Drouillard Road. They had a couple of pool tables and a bar. That's in the OTA (Ontario Temperance Act) days as they used to call it. My dad served the stuff right over the bar, but he was supposed to serve that 4.4 beer. But they had other, stronger stuff that wasn't legal. They had the pipes running to the same outfit that dispensed the other 4.4 beer, but you could

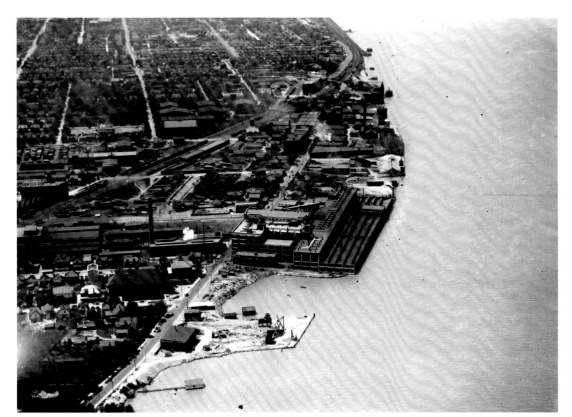

Aerial view of
Ford City.

switch it over. The copper pipes were underneath the floor, so when the law would come, my dad would just reach some place and flip the taps over.

There were only two bars like that in East Windsor at that time. My dad had another bar later on when things were legal. He started that one on Drouillard Road, too. It was called The Renaud House. The building's still there.

But before this, my dad, with my three uncles, used to haul whiskey from Montreal in suitcases. They'd bring them into Windsor and down to the docks and load them up there for others – Americans – to take it across. My dad never took the stuff across himself.

How it worked was that I had three uncles in Montreal who put the whiskey in suitcases on the train, in the baggage car, then they'd ride the load back to Windsor. Their destination ultimately would have been the Michigan Central Depot, but before they got there, they'd pay the conductor to stop at Banwell Road (outskirts of Windsor), which is where my grandfather's farm was. Anyway, they'd stop the train and throw the suitcases off. My dad would be there waiting with the horse and wagon, and he'd

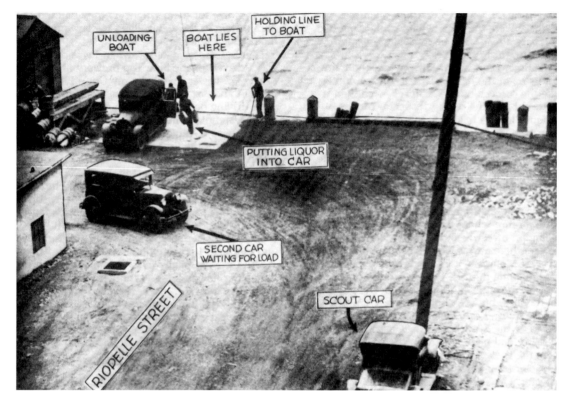

Scout cars and decoys make it easy for a quick transfer of the whiskey to waiting fast cars at the riverside. (*Windsor Star*)

bring the load into the barn where the cars were waiting to take the whiskey to Windsor. And of course the train, once the suitcases had been thrown off, would continue on its merry way to Windsor.

They used to say Mushrat La Framboise had one of those boats with a plug in it like a bathtub. When the police spotted him, he'd just pull the plug and the boat would sink. He'd go back to where it was later on when no one was around, and he'd dive for the stuff. He was really good at this, and anyway with the whiskey being in these jute bags and tied together at the top, the bags had these ears on them. Well,

when they were dumped overboard, you could dive down and pick them up by the ears and haul them to the surface. It wasn't heavy bringing them up until you got to the surface of the water, but then there'd be a guy there in a boat to pull it up and out of the water.

My dad never actually hauled any stuff across the river, though; that was for the other guys to do. However he did sell liquor in his Drouillard Road place, from the poolroom – he just had a beer licence for the 4.4 beer. He also sold liquor by the shot if you wanted it. But he had to hide it, that was on the side – fifty cents a shot, as I remember – beer at that time was

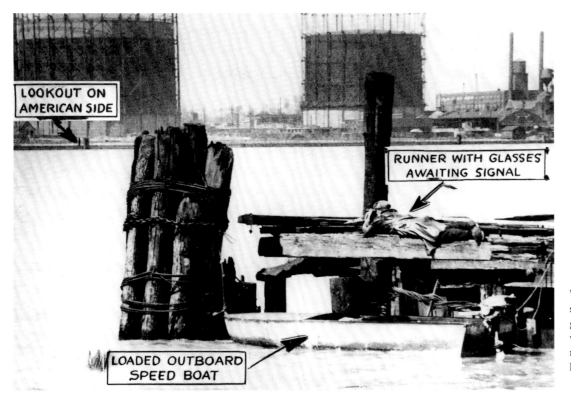

LOOKOUT ON AMERICAN SIDE

RUNNER WITH GLASSES AWAITING SIGNAL

LOADED OUTBOARD SPEED BOAT

Waiting for the go-ahead signal. As soon as it is given, the rumrunner will race across the narrow river to Detroit in his speedboat. *(Windsor Star)*

twenty-five a shooper. A shooper was like a big glass. Did he ever get caught? Well, let's put it this way, dad paid his dues. When Inspector Mousseau was going to raid us, well, we knew. We were notified ahead of time. We knew because it was his driver – Mousseau's driver – who told us. Today might be East Windsor's (Ford City) turn and tomorrow someplace else, but today it was our turn, so everything was on the up and up.

But after he came so often and didn't find anything, he'd say, "Well, look, we know you're doing it," so my dad would go out and pay somebody off, so the police would leave us alone. But one time Mousseau told my dad – my dad knew him real well – "Joe, I know what you're doing. This time you gave us the slip, but there's always next time. . . ."

Oh, they knew what was going on. You could go into my dad's place and get a bottle of whiskey, wrapped in newspaper. Anyway, my dad never got caught; he always made arrangements. There was a provincial (policeman) that lived across the alley from us. I used to bring a package over there every week. I'd run across to the house – I can only surmise what was in the parcel – to keep him quiet.

The way it was in the Ford City Pool Room

was that if you came in for a bottle of whiskey – it wasn't sold over the bar – my dad would say, "Jake, go to the house and get a package." My dad would then call my mother on the telephone so she'd get a couple of bottles of whiskey and wrap them in newspaper and put it into a bag. I'd bring the whiskey back to the poolroom, and my dad would sell it to the guy. I was the runner. I was always in the poolroom because I was a shoeshine boy after school.

We were kids then – that's the very beginning of Prohibition when you had to get all your stuff outside of Ontario – and Montreal was where you could get it. Well, we didn't know what was going on. We'd sit on the whiskey in the cars. They were all touring cars at that time, and we used to ride to LaSalle, going the back way, of course, to avoid the law. We'd bring the whiskey down to the docks and unload it. The Americans, or whoever was buying the stuff would be there to pay for it – then it was their business. You see, these were the guys who'd contact my dad to prepare a load, and he'd prepare one and deliver it right to the dock.

One time, I remember him saying, the train didn't stop at Banwell Road – it couldn't make the connection, or whatever – so then it went right into the depot. Mousseau was waiting there to inspect the loads coming in. He was standing on one side of the train at the baggage car, but instead of opening the baggage car on that side, this guy opened it on the other side, the side not facing the station. So all the suitcases were put on these four-wheel trucks and there's an elevator that takes them underneath the tracks and to a ramp where the stuff goes out to Wellington Street – well, my father loaded the stuff into cars there and was gone. Meanwhile, Mousseau's watching the rest of the baggage going into the baggage room, and he seizes all the stuff thinking he's got the goods – and he does, but it's only clothing.

These touring cars held a lot, you know. There used to be the Studebaker Sixes or Whiskey Sixes. My dad put the stuff in the back seat, or where the back seat would've been, but he'd taken it out. The whiskey used to be in these jute bags. Mushrat and all those guys used to dive for them whenever they had to dump them in the water when the law spotted them taking it across.

Then, of course, later on when I was older, I was a driver for the Blue Top Brewery in Kitchener. It was owned by my Uncle Bill Renaud and Art Diesbourg, Blaise's brother. We were driving beer in trucks down to the Brewer's Retail warehouses in Windsor, or that is what was *supposed* to happen. It was rerouted somewhere else sometimes. Well, some of the time, once a week anyway, I stopped when I got to Belle River – I'd go there for supper, or at least that was the excuse. I mean, I really did stop for supper, but I never had any beer when I left Belle River, so I'd go back to Kitchener. I would stop at Art's farm and park beside the barn, and then I went into the house for supper. When I came out, the truck was emptied. I mean, who knows where it went.

My uncle was really in the business, though. I remember he had a big yacht that was supposed to be for export purposes. He called it *Miss Liberty*. Well, the story was that he used to load up

at the export dock and head out to the lake or some doggone thing and somebody'd come and unload the stuff from his boat and put it on their own – and then they'd be gone.

The Story of Man o' War

If you travel to Kentucky, even now you will hear all about the legendary racehorse Man o' War. When I was growing up, my friend's mother, Joan, who lived across the street and taught us poker on summer afternoons, loved racing and talked our ears off about this amazing horse. And this was a story in some ways far more compelling than that of Seabiscuit, his grandson, who made a comeback from injury to be a legendary winner at the tracks.

What sparked my interest as a kid on that weekday July afternoon at Joan's house was a rare replay of Edward Muybridge's October 1920 filming of the event where Man o' War beat the favourite Sir Barton by seven lengths. Joan sat with coffee in one hand, a cigarette in the other and kept shaking her head and telling us there was nothing that could beat Man o' War. She also kept pointing out landmarks, none of which we knew, of course.

I've been told before the subdivision went in during the 1980s, Kenilworth in Windsor was a treed expanse with old fencing, and bits of the abandoned and forgotten track. The glory days of the 1920s had long ago disappeared. Windsor had buried its golden age of racing. The other day, thinking about what Joan told me fifty years ago, I drove along Howard toward Devonshire Mall and turned west into Kenilworth Gardens.

You would never know that among that collection of boulevards and manicured lawns and

Windsor hit the front pages with the widely-hailed matched horse race between the top-ranking winners of their respective countries, Man o' War from the United States, and Sir Barton from Canada. Thousands made the trip to Kenilworth Jockey Club to watch the two great animals in action. The race was won handily by the American horse. Here they are shown near the start. They finished nearly eight lengths apart. *(Windsor Star)*

neat homes that the race of the century had taken place. You would think that there would be some kind of marker, a plaque, but there is nothing, except for a modern logo of a racehorse on a bricked pillar at the housing development entrance. There is, however, a gate near where South Cameron and Howard merge: some believe this to be the only remaining fixture of the track.

But what about this leggy Man o' War, who was affectionately christened "Big Red" by racing fans because of his brilliant chestnut coat? He was foaled in Kentucky, son of two high-strung racehorses, and his fiery nature proved difficult for his trainers to break. His owner, Sam Riddle, remarked, "He fought like a tiger. He screamed with rage . . . it took days before he could be handled with safety."

It was not uncommon in those first attempts on the track for Man o' War to throw riders. The first time the famous Johnny Loftus mounted him, Man o' War catapulted the jockey about forty feet.

By 1919, the colt was ready for its first race, and won by six lengths at Belmont Park. Three days later, he won another. And the list goes on, with stunning victories and five American records over a seventeen-month period leading up to Kenilworth. In one race, prior to the one in Windsor, Man o' War had competed against a colt called Hoodwink. As one writer described it, "Despite his rider's choking hold, Man o' War beat Hoodwink by more than 100 lengths."

By 1920, the showdown between Man o' War and Sir Barton, the 1919 Triple Crown winner, was inevitable. Windsor's showing promised the biggest purse, with winnings of $80,000.

U.S. writers at the time, however, didn't have kind remarks about Kenilworth, calling it "a bush track."

What people in Windsor can't imagine today is how this city was once a racing haven. Even before such tracks as Devonshire, The Jockey Club (the location at Jackson Park) and Kenilworth, there was a track as early as the 1840s in Sandwich. The first track in Windsor proper was a half-mile stretch along Ouellette Avenue known as the Windsor Fairgrounds. It was built in 1884.

Racing was big business through the 1920s, but when Michigan legalized betting in the 1930s, it killed the action here.

However, on October 12, 1920, at the start of the Roaring Twenties, when booze and money flowed freely, Kenilworth's grandstand swelled with 8,000, 2,000 over capacity. The structure had to be enlarged to handle the excess crowds. Bleachers were also erected at the south side to accommodate more.

The thoroughbreds arrived three days in advance of the race. Sir Barton had come from Maryland in a special rail car that contained bluegrass hay, selected oats and Maryland Springs water. Man o' War arrived by private car two hours later from Belmont. He had come by way of Niagara Falls.

Twenty-four-hour guards were stationed outside Man o' War's stalls at Kenilworth after rumours began to circulate that the champion might be drugged or poisoned. Speculation over the race grew when in the last minutes on the

day of the race, Sir Barton's owner replaced his regular rider with another.

By noon, 10,000 race fans jammed Kenilworth.

As Angus Munro said of the event in the *Border Cities Star*: "Those two minutes were the most vivid in Windsor's sporting history. . . . It was simply a good horse against a super horse. The latter romped home seven lengths in the lead."

Sir Barton, however, initially took the lead. After about sixty yards, Man o' War woke up and passed him like Barton was standing still.

A *New York Times* writer described it: "He actually galloped the colt dizzy."

I watched the film, and you can see Man o' War running free down the track, getting farther and farther away from the Triple Crown winner. The horse became so famous that when Riddle was offered a million dollars for him, he said: "Go to France and bring back the Tomb of Napoleon . . . then I'll put a price on Man o' War."

And to think, it was in Windsor that history was made.

Prohibition: The Water Highway

Police kept an eye on large rail shipments, but the use of camouflage was frequent, often ingenious. Two ex-policemen recall these shipments.

There were different times that I know where different shipments would come in for prominent men in Windsor and it would probably go to Tecumseh or Belle River and with their names, prominent men of Windsor, well, we'd figure it's their own liquor, so we just wouldn't bother with it. But it was the bootleggers were doing it all the time; they were outsmarting us.

Like this racehorse that came from Montreal, it was supposed to be a $1,000 horse that was coming and they had blocked each end of the boxcar, like. The horse was right between the two doors. And the horse was in there with his hay and stuff and on each side of that horse was probably 400 or 500 cases of whiskey. You'd get clearance for that horse that you were going to get out of that car – you didn't give a damn what happened to that horse. You'd break down those two bulkheads in there and get your whiskey out.

An arrival of liquor was of interest to both police and hijackers. There was no time lost removing it from public view.

You take eight or ten guys with two or three trucks, you know, you'd unload a car in a hurry like that. Oh yes, everybody was in a hurry and looking behind him to see if anyone was chasing him and you knew that the law was close so you'd hurry.

If they wanted to hide it where hijackers wouldn't find it, they'd find a ditch somewhere and they line their whiskey in there two or three cases high, like, and then they'd just pass with the plough, fill up the ditch. Or in the marsh, in the bull rushes, cattails. Cattails grow seven or eight feet high, you know.

Well, they had a shack on Fighting Island and they'd take a load of liquor and they'd put it in this certain shack here and they'd hold it

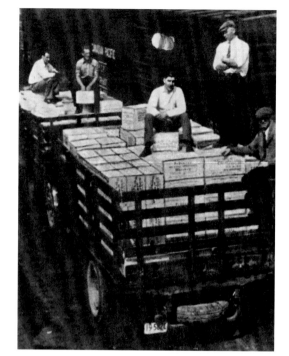

Unloading liquor from a CP rail car. Booze shipped from Montreal to the Border Cities was the starting point for much rumrunning. Here Old Log Cabin "Bourbon" and Pedigree Whiskey start their long journey, though it was really meant for home use.

ing towards the cattails through the marsh and I followed them and I got into the cattails. Mister, there was a platform there just as smooth as this floor here and twice as big as this floor, four or five cases high. The snow had drifted off the tops of those cases so I come to this fella here, and I told him, "You'd better go down to the marsh there and get your whiskey out of the marsh over there." I says, "Anybody that goes by will see it. I just found it there, I was 150 feet away from it." He says, "That's right, that's right, I can't leave the stuff there." And I found out afterwards that it wasn't his at all – and I had just given it to him.

Ontario had nothing like the vicious gang wars on the American side, but shots were fired at night in the shacks along the river and people occasionally got killed. Two rumrunners recall this.

There was lots of shooting all along the shore here. Most of them were hijackers. Like this time here in Martin Lane when they went to rob this stuff out of this barn. There was at least 100 rounds fired at that time, how come nobody got hit, nobody knows. But it was rough, it was rough. Like my brother there, he was shot in the head and this other fella too, he got shot in the leg. Oh, there were guys that got shot and were thrown in the river and never came up again, never did find them.

I seen a thousand cases of booze I'd have to pretty well defend with my life. That was pretty near every night. I'd guard them myself on Fighting Island, lots of times. There was another shanty. It used to be a clubhouse on Fighting Island over there and I'd go over there and

there until the American boys were ready to pick it up.

They had hidden places in stairways, attics, in the basement. There was one man who had over a million dollars worth of whiskey in his place, which was perfectly legal, and he built a big home on Riverside and he had a regular vault and he had a million dollars worth of liquor in there.

And sometimes, it just didn't pay to help a neighbour.

I remember this time right in this marsh in back of my house here. I got on to a load of whiskey there, 150 cases to be exact. I went out on the ice and I seen tracks coming ashore like. It had snowed and drifted and I seen those tracks com-

watch every night. The clubhouse was about the size of these two rooms here and you'd just pile the liquor up in there, case after case, right up to the ceiling. Then you'd make partitions with the cases and you'd be in the centre of it and if anyone come along to steal it you'd be well hidden, where you could also look at the door or the window, see if anybody was comin' in. You'd do your best to stop them.

The people that owned the whiskey came over there at three o'clock in the morning to find out what we'd do if hijackers ever came around. And full of whiskey ourselves, naturally, all the time. Old Crow mostly, we didn't drink the weaker stuff. And when I heard them, they were about 150 feet from shore, two boats coming at this clubhouse again, so I prepared myself. They weren't going to get in there. And the door was something we'd made ourselves. It was three inches thick and the doorknob and keyhole and all that was taken out and there was a hole there, six inches in diameter. And I seen one of the guys passing in front of that hole and I told him, "If you pass in front of that door again I'm going to shoot you right in that hole." So he passed again but he ran and I fired, and then they came to the door. They hollered first to tell me who they were. They were the guys that actually owned the whiskey.

One time in Martin Lane we unloaded a boxcar of liquor. There was 500 cases of whiskey in that barn and the gangsters came to get it.

I remember this fella was hiding underneath an old Maxwell touring car right in the gateway of this yard and he was laying down on the ground and he was gonna just shoot at that

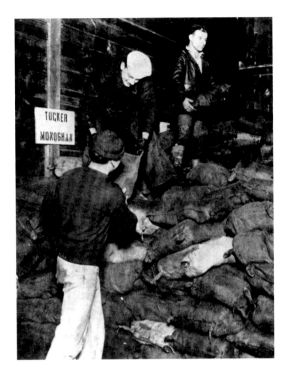

Unloading liquor in sacks at a warehouse.

bunch of fellas in that car comin' down but they opened up. They put them bullets in that car – never hit him!

How did Michiganders adapt to Prohibition? Former Detroit Police Commissioner, Ray Girardin, offers his thoughts.

This Noble Experiment was not a popular law and the people who drank broke the law by buying the stuff, using it, and really didn't think that they were morally or legally doing anything wrong and I suppose the bootlegger felt the same way, I don't know, he was supplying this demand and the demand was pretty great. Now a lot of people started into drinking during that time; probably there was a challenge to it.

Jack Carlisle, old-time reporter with the Detroit News, *recounts it similarly.*

It was a game; it was fun to go and look in a peephole and have a fella say, "Who sent ya?" and you told him and you went in. The steaks were good. There were slot machines. No, it was wide open. At a place belonging to Sammy Kurt and Cohen, the doors were wide open. "Canadian beer right on the wall," they said. It was made in the basement.

Saloon keepers defied the Volstead Act in two ways: some openly, by bribing police; others more cautiously turned to the speakeasy. All in all, then, how tough was it to get a drink in Detroit? Two rumrunners recall.

Just about as easy as buying a package of cigarettes.

Wouldn't be as hard as a bowl of custard without enough thickening in it.

That's an exaggeration but there were countless blind pigs, speakeasies.

And there were people to steer you into them before you could find one. I was there.

Of course it was better if one were known, you could get in, but many of them took chances on people who just looked all right. Some of the bars operated just as if it were legal except they had near-beer on tap and if a stranger came in they'd sell him the near-beer.

A total stranger could also become a very old friend – instant friendship service provided by the corner newsboy.

Walt never was at the newsstand very much, but it was his stand. He'd be out helping people to know different places to go and what to do when they got there. He might leave the stand and take the stranger and come back with more than he had when he started out with the stranger. Sometimes he'd go right with them, have a drink with them so he could inform the people that he brought them a very nice man. And when he gave them the wink, they'd know what he meant.

Meanwhile, the U.S. economy was growing by leaps and bounds: there was money everywhere. In Detroit and Windsor, they learned how to make a million and how to spend it. Four rumrunners recount this.

I seen a dining room table in a house over there covered in $100 bills a foot thick, all American money.

Well, one guy he made so much money that he had bushel baskets of it. He put it in bushel baskets and just slid it under his bed.

Newsboys was runnin' around town with $1,000 bills in their pockets for watchin' a certain spot to see that nobody bothered it. It was delicious.

There was a lot of good sport, a lot of good times. The wages weren't very high, but as you know, the stuff was way low also. You could buy a pair of shoes for a dollar and a quarter. Two, three dollars, that was a real good pair of shoes. A suit for thirty dollars, great living, real good days. You'd buy a brand new car, a Model T sedan, for around $900.

I recall some of the characters – probably the best known was the Lowell Brothers, Jim Cooper, Shotsy Shugard probably he was the flashiest one because he liked to flash his money

– a night's business he wasn't afraid of flashing better'n $100,000 in money. Lay it on the counter in a well-known spot called Stoakes Cigar Store down in the neighbourhood of the British American Hotel. That was the meetin' place; that, and around the corner at Gibson Brothers, the cigar store.

Well, we had to wear vests then, and I had a real gold fob, it belonged to my mother. It was a locket, but it was just right for a fob. Them days we wore spats. I did a lot of copying off of, ah, I'll tell you his name in a minute – Adolphe Menjou.

Oh, he was the best-dressed man in Hollywood. He wasn't dressed a hell of a lot better than me.

Everybody was interested in enjoying themselves, whether it was along the river or back in through the City, the speakeasies, where they all enjoyed a bottle of beer and whiskey and so forth. Windsor as it was, while it was dry, it was wet. They had more fine saloons and bars that you could get a drink in than probably any place in the U.S.

From time to time, pacing the export docks of Windsor in business suits were men who gave no inkling of their activities across the river. A rumrunner remembers Al Capone.

He was in Windsor at the export docks and he seemed a good enough fella. Down at Dave Caplan's export dock and Lou Harris – they were both in it together: two Jewish boys and they were good fellas, too. And we had quite a conversation. As a matter of fact, I was introduced to him and that wasn't the only occasion that I talked to him. They used to come over every now and again and he used to *kibbitz* around and have a little conversation and whatnot, probably crack a bottle in the export docks, have a few drinks. Well-dressed and all, you couldn't tell him from a businessman. But when they came to this country, they were gentlemen, you wouldn't want to meet better people.

Jack Carlisle also recalls Capone.

Capone had a definite big part in Windsor and Detroit, but mostly through uncut whiskey coming off the export docks in Riverside, Ontario and transplanted over here by a well-known mob. And then the other part of it, he had to do with terrible things that happened in Detroit because his execution squad sometimes didn't have anything to do, and they came to Detroit to relax and their method of relaxation led to the kidnapping of all the top gamblers in Detroit, and gave us our first machine gun killing, which we had never had before.

By 1927, Detroit had become a tough town. Bootlegging, the state's second-largest industry, now grossed an annual 215 million dollars. For this kind of money, the competition was fierce. Three rumrunners recall this.

There was an Irish gang there, and there was also what they used to call the Jewish Navy and there was also the Black Hand squad.

There was about five or six Italian gangs, you see, but among the Jewish element, the Purples had that all locked up.

The Purples? That was a loosely knit orga-

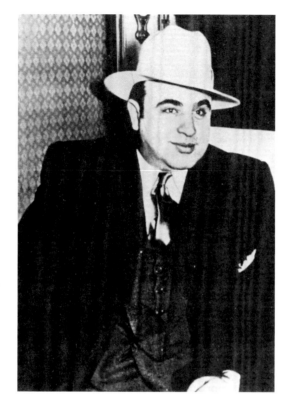

Al Capone was convicted of tax evasion and served a long sentence in Atlanta Federal Prison, giving up the luxury of his quickly acquired wealth to share a prison block with other convicts.

nization. I don't think it was ever more than eighteen to twenty people. Kids that grew up together. By loosely knit, I mean three or four of them might have a racket going here. Sometimes they'd work together. Sometimes individually. It wasn't a cohesive group.

In these tough days, this was a young man's racket. The real boss, of course, of the Purple Gang, he looked like he might be a professional dancer. He was a very handsome fellow who had a perpetual youth of eighteen or nineteen years on his face. Very dapper and very tough. Even the other gangsters of different nationalities were afraid of him. And until he went away to jail, the Purple mob was very powerful.

Canadian whiskey was far from the only thirst-quencher in 1927. Ray Girardin recalls some bootleggers.

There were a couple of characters named Sammy Kurt and Sammy Cohen who were written up in Collier's magazine as multi-million dollar bootleggers. They got notorious because they made beer underground in the basement of a blind pig on Orchestra Place, right on the fringe of downtown Detroit, on Woodward. And the only people that caused these bootleggers any trouble were the federals who came in and padlocked their place. They leased the store next door and continued to make the beer underneath and they ran seven of these one right after another.

Also busy were the alky cookers, do-it-yourself distillers with homemade equipment. Three rumrunners recall this.

They used to call it lightning. I've even heard them mention different places about where to get good lightning and where to get bad lightning – as if it wasn't all bad. You could get it as low as ten cents a gill and a gill would be a half of a pint, one of those little cream bottles and if there was about two of you, you'd get a real good spark. Pretty near every other house was an alky cooker. They used those oil drums and coils. Very crude, and mind you they didn't make that out of the valuable part of any vegetable or fruit; they made it out of the skins because they had to use the other to eat. And potatoes

were very well-known to be used, the peelings, that meant the sprouts and everything that was in them went in there to ferment.

Well, one had to have confidence in the person he was patronizing, to know whether the stuff would be lethal or not.

Fuel oil and that would mix in with their alcohol unless it was properly removed, why that was rank poison. Well, wood alcohol, it wasn't too bad, although there was fuel oil in it.

This product, as well as Canadian uncut whiskey, was close to pure alcohol. Diluted and prepared, it would pass as a beverage. In homes throughout the city, citizens were busy mixing up the now-famous bathtub gin.

And believe it or not, it was made in bathtubs. That's what they poured it out in so they could serve it and bottle it. The bathtub didn't necessarily have to be washed out. The whiskey would take care of the rings in the tub. I've seen them do it but not wanting it very bad, I didn't – I was scared to look at it, especially when I knew I was going to have to taste it. I don't know how many times I could have been killed with guys that drank too much of that stuff, only it wasn't good like it is now, so you know I had some bad cats on my back. They had to put a certain something in there to kind of heal it up, 'cause it was really sore. They had to put something in there. They would put maybe a quarter of the good stuff and the rest they'd get their colour from burnt sugar. They could burn the sugar and put a certain amount of that burnt syrup in there and it would even help give it a little flavour, but a burnt flavour and shake that up and you

Man wearing harness to be hidden under jacket. One could easily pack eight quart bottles of whiskey across the river on a winter afternoon on the Windsor Ferry.

(Windsor Star)

had your colour. And they had flavours to put in it, so if you didn't want some of that lightning they could put a corn flavour in a little vial and that would fix up a gallon very nicely for you of corn flavour, the same with rye, the same with a Greek drink called Mystika. It tastes something like liquorice. It would make you hate your friends, after you got loaded. It was powerful. They put something awful in it for about eight drams to fix up a whole gallon and they had all the labels and everything.

I can remember one time I had a bunch of labels that I could put on some different stuff after I had taken off the original labels and

cleaned up the bottles. Put the good labels on it and even the stickers with numbers across it and I'd be afraid that the party that I sold it to would ask me to have a drink. 'Cause I had something better at home.

St. Valentine's Day, 1929: a garage on North Clark Street, Chicago. A few machine gun bursts and Al Capone eliminates seven henchmen of his last major rival, George "Bugs" Moran. Capone is now king. One of his first chores: to ensure his liquor supply line through the Windsor-Detroit Funnel. Jack Carlisle recollects.

We heard that he had a suite of rooms at the top floor of the Fort Shelby Hotel. So we took his picture around. We didn't have any trouble finding out that this nice, quiet gentleman that everybody thought was from Battle Creek, Michigan was Al Capone of Chicago. And he apparently stayed here three days and apparently he had a series of conferences with very notorious gangsters of Italian extraction, about five different bootleg gangs, not only in Detroit but from Ecorse and River Rouge and from Hamtramck. He had found a market for uncut whiskey and it didn't make any difference what the price was; the problem he had was getting it out of Michigan and he would bring in his truck and he would bring in his bodyguards – because if you recall those days, they were very violent days where a lot of money was involved.

A case of whiskey, uncut, was worth a tremendous amount of money and the thing that an organized bootlegging mob had to worry about were these wild hijackers who, after they invested their money in buying this booze and while they were en route with their trucks, would come up with machine guns and shoot everybody and take the whiskey.

Detroit mobsters, apparently happy over the deal with Capone, kept their end of the bargain. Methods of pickup and delivery had already been perfected. Ray Girardin recounts.

The idea of the bootlegger, that'd have the highest speedboats possible that would at the same time be carrying a big load so they could outrun the others. But they know the shallow spots along the river. They'd dump it. They could then be stopped, they wouldn't have anything aboard. Then they'd go back with grappling hooks after the law had left and put it aboard and land it on this side. Now in the Detroit Press Club there was a very large blow-up of a photograph, an actual photograph. It was taken of bootleggers unloading a boat right downtown at the river and you'll notice two things in this photograph: the speed with which they are loading a car, and also two other automobiles parked there. They were the block cars. They were designed to get in front of any pursuing vehicle, any vehicle, enforcement vehicle that was pursuing the bootlegger, these other cars would get in front of and sort of run interference to block him off so the man driving the load of liquor could get away.

Warehouses dotted the back streets and alleys of Detroit's lower East Side, but were usually empty and deserted.

They'd have warehouses, but they wouldn't keep a large store on hand because the financial

risk would be too great if it was found. They'd try to deliver it to the retailers as soon as possible and this, of course, was a job that was done pretty openly. I've seen it. I've seen deliveries made just as if they were delivering bread to a grocery store and it would be whiskey for the blind pig.

During the summer of 1929, the signs of prosperity in Windsor and Detroit were everywhere. Plans were being drawn up for a tunnel to link the cities, replacing the old ferry service. The splendid Ambassador Bridge was almost completed. Industry was at a new peak and workers were investing their savings in the stock market. Across in the U.S., the picture was the same. America seemed to be riding a boom that would never stop. Then, on October 23rd, on Wall Street, the nation's electro-cardiograph, a jagged line flickered across the screen. Stocks fell. Diagnosis: a very mild heart attack. October 29th, Black Tuesday: panic on the market. By Wednesday, October 30th there were no buyers for anything. The market was dead. Economic paralysis began to spread across the nation and the world.

And so America entered upon the Dirty Thirties. By the spring of 1930 in Detroit, there were layoffs, reductions in the work week and over 12,000 families on relief. The only prosperous industry was crime. An apathetic public now drank to forget. Jack Carlisle recalls.

The public wouldn't convict anybody 'cause all you had to do if you were a bootlegger and you got caught was ask for a jury trial. One of the biggest scandals in Detroit was unearthed by a former reporter on the *News,* the great Victor Charles Barnsford. He went to Montreal

Windsor-Detroit Tunnel, one of Marvels of the Time

A HOLLOW steel tube, built at Ojibway in sections and floated to position on the river above the Windsor-Detroit tunnel site, is a simple way of explaining how the great traffic artery was built. Two views of the tunnel under construction are shown.

KEEP IN LINE

on a case one time and came back with an English accent and a can. But he went over to Recorders Count and the entire basement was made up of exhibits and bottles. See, if you went into a place, if you were a policeman, you had to order a drink. Then you had to confiscate it, show your badge and get that drink out of there. Well, Barnsford discovered that a couple of thousand of the exhibits had all been drunk up. You can imagine what a scandal that was. The bootleggers and the gamblers, they didn't bother ordinary people. They catered to them. They served them champagne. They served them booze in fancy labels. Nobody got hurt.

(*Above*) Hollow steel tubes, built at Ojibway in sections, were floated to position on the river above the Windsor-Detroit tunnel site.

(*Below*) The inside of the tunnel, shortly before it opened. (*Windsor Star*)

Yes, the man in the street was safe, but he had his instructions: mind your own business. Two rum-runners remember.

Well, yes, if you got nose trouble, they would take you for a one-way ride. If someone disappeared maybe someone will recognize the name, Brother Wilson. Brother Wilson, fine fellow stately gentleman. Nevertheless, Brother Wilson seemed like he did something was contrary to the code, and they found him in an isolated spot in the swamp.

Some of the nicest fellas you ever seen. When they weren't working, good spenders, good tippers, best in town. They dressed so much fancier, in much more expensive clothes that some business magnates would dress in. Well, I know one, very well – we called him a nice gentleman. I don't know whether I should bring his name up or not. He's a legitimate business man. But he used to take the whole second floor of the Prince Edward Hotel and use one of us, one of our bellmen, to just watch and see who came in and stop them first to announce their names. They were protected, in case it was the wrong one. And this fella was such a good sport – he must have had a lot of money 'cause none of the fellas he had in there had a hat on worth less than about twenty or twenty-five dollars, and in his jovial moods he'd throw all those hats out and give each one of his boys $100 and somebody on the street would be able to pick up a hat worth twenty or twenty-five dollars for nothing.

But the Great Depression was closing in. Soon there would be no money, even for the underworld. This fear drove the gangs to frenzied killing. The mobs were at each others' throats. Jack Carlisle recalls

On January 2, 1930, the gangsters of Italian extraction attempted to assassinate Inspector Henry J. Garvin and they shot up his car on the East Side of Detroit and accidentally shot an eleven-year-old girl bystander. Garvin survived. There was a fellow who was the boss of all these mobs in Detroit of Italian descent. His name was Sam Cantilonotti and he had a wonderful nickname, "Singing-In-The-Night-Time-Sam." He died in bed and they gave him a $20,000 funeral with an airplane flying overhead. Airplanes weren't as popular then as they are now.

After he died, a fellow by the name of Chester LaMarre, who was so powerful in those days as an underworld character that he had all the food concessions at the Ford Motor Company – and that was given to him so that he would not kidnap the grandchildren of Henry Ford I – decided that he wanted to be boss, so he invited all the top leaders of these five, six, seven different mobs to a place called the Fish Market on Vernor Highway on May 21, 1930. The boys got a little suspicious and they sent a man by the name of Gaspare Scabilia who was known as the "Peacemaker" among the mobs. And three fellas walked in and shot Gaspare with eighty shots and killed him and his partner, a fellow named Pariso and then of course a lot of trouble broke loose, the biggest gang war we've ever had in this town.

And here again, Ray Girardin, newsman at the time and later Detroit Police Commissioner, gives his take.

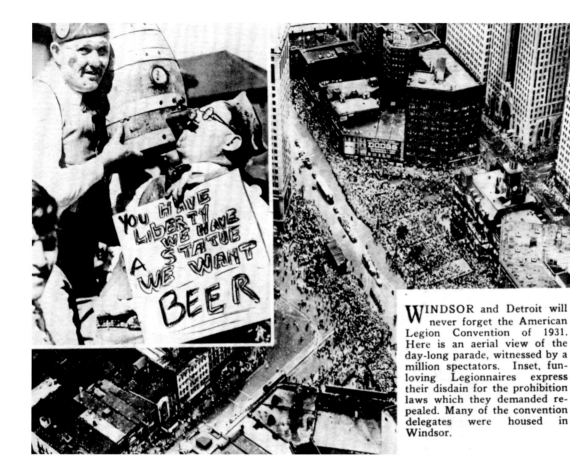

WINDSOR and Detroit will never forget the American Legion Convention of 1931. Here is an aerial view of the day-long parade, witnessed by a million spectators. Inset, fun-loving Legionnaires express their disdain for the prohibition laws which they demanded repealed. Many of the convention delegates were housed in Windsor.

American Legion Convention of 1931.

(Windsor Star)

Now, this was all over who would control certain territories in Detroit, certain territories down river, and certain parts of the Detroit River that were parcelled off. One gang would use one part, another, another. They would not intrude on one another's territory and if they did, there would be trouble. We had a great many gang murders. I remember for a while when I was on the paper (*Detroit Times*) that the phone would ring in the morning next to my bed and it got so that when the phone rang it was just getting to be daylight and I would almost know what the call was about. It would be my office telling me that they had just found another body. That was in the days of the One Way Ride, when a gangster would be taken for a ride, shot, dumped out of the car and the body left there. The gangsters were very determined to eliminate competition and a lot of people died as a result. Considering the size of this city, I think percentage-wise for a while it did pretty well. Chicago probably, and New York might

Seized boats at harbour.

(From the collection of *The Detroit News*)

R.I.P.
JERRY
GERALD E. BUCKLEY
APRIL 5, 1891–JULY 23, 1930

have been ahead of us, but I would say that we were pretty close up there because in one year we had something like twenty-five gang murders in thirty-one days. We had a lot of them.

Self-extermination by the gangsters was also a breakdown in law and order, foolishly allowed to continue. The American public forgot its overwhelming power – that of 140 million people against a handful of hoodlums. Newsmen and commentators cried out for an end to underworld rule. The death of Jerry Buckley, of Detroit's WMBC, proved that society was even losing its voice. Three reporters recall.

I covered that story. That was in a very busy hotel at Adelaide and Woodward.

Jerry Buckley was sitting in the lobby of the LaSalle Hotel reading the morning paper, at 2:23 A.M., the morning of July 23, 1930.

Buckley was just there resting, probably waiting for someone to pick him up.

Gangsters came up behind him and shot him six times in the back of the head. Buckley had threatened to expose the wide open running of everything in Hamtramck, so it was obvious that the underworld had assassinated him.

A coloured boy bellhop seen this, this killing, but he wasn't around there long after. He ducked out of there because they'd want to know who seen. Life wouldn't be worth a quarter.

Three persons were tried in Recorders Court and acquitted. Two of the three were later convicted of another murder that occurred right at that very corner, but it had nothing to do with the Buckley shooting. Because the same two were convicted, a lot of people were under the impression they were convicted for the Buckley thing, but that murder was never officially solved.

The number of killings in the streets, hotel lobbies, and restaurants in 1930 and '31 finally produced a mild public outcry. Criminals found at last that killing, even among rival gangs, was frowned on by the law. The liquidation of a rival mob could put the seal on their own fate. The Collingwood Massacre, 1931, is recounted by two rumrunners.

The Purples got in a fight with the Little Jewish Navy Gang and exterminated three of them. The three Purple people went to jail for life.

The shooting at the Collingwood Massacre was over a debt. The Little Jewish Navy Gang, which was nothing much at all, had bought a lot of alcohol from the Purple Gang because there

was a huge convention in Detroit (American Legion Convention) and they sold it to the conventioneers, cut it, made whiskey out of it and sold it. But they didn't pay the Purple Gang and it amounted to a great deal of money, way up in the thousands. The Purples couldn't collect, so they shot them.

And the leader of the Purple Mob at that time (Ray Bernstein) stayed thirty-two years in prison in Michigan for killing these three people.

Three were convicted and went to prison. But there wasn't anything from the Purple Gang after that. Prison, death or a new life accounted for all of its one-time members.

Crime, of course, would never be wiped out. But forces were gathering to bring it under control. Detroit, acting on the findings of a grand jury, began a clean-up. In Chicago, Capone had been dethroned in '31 by the federal government and was serving eight years in Alcatraz. By 1933, J. Edgar Hoover was directing a full-scale war on crime. Meanwhile, an impoverished nation decided the people would always pay money for booze and they might just as well pay it to the government.

It was December 5, 1933, almost fourteen years after that other winter's day in 1920, when it all ended. At 3:32 P.M., word came from a convention in Utah. The state was the last one required to ratify the 21st Amendment, repealing the Volstead Act. Prohibition was at an end.

Of course, people had been drinking right along, but there was a short and memorable cele-

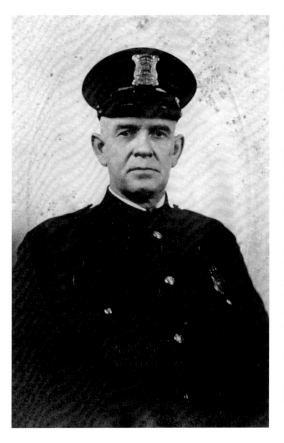

bration. Citizens repaired to the saloons for the first legal drink in twenty years. Stocks were soon exhausted.

The new liquor was heavily taxed, so bootlegging, at a reduced rate, continued. But the stock market crash and repeal brought an era to an end. The big money was gone. The vast bootlegging market was gone. The Roaring Twenties were gone. It was all over.

Shown is my great-grandfather, James Benjamin Snyder (b. Dec. 21, 1862; d. Aug. 20, 1928) He had eight children of which my grandfather, Harry J. Snyder was the second youngest (b. 1903).

After leaving the Sandwich police force in 1924, James B. bought a piece of property on the northern shore of Lake Superior near a place called Rossport, Ont. (west of Marathon, Ont.) He and one of his sons tried mining the piece of land they bought for a two year span. They found very little. After J. B.'s death his one son continued to mine the place until circa 1931 or 1932. His son sold it to a mining company (for a few hundred dollars) and the mining company within five to ten years hit a lode of silver. The silver lode wasn't what my great-grandfather had been looking for ... He wanted to find gold! (Author's personal collection)

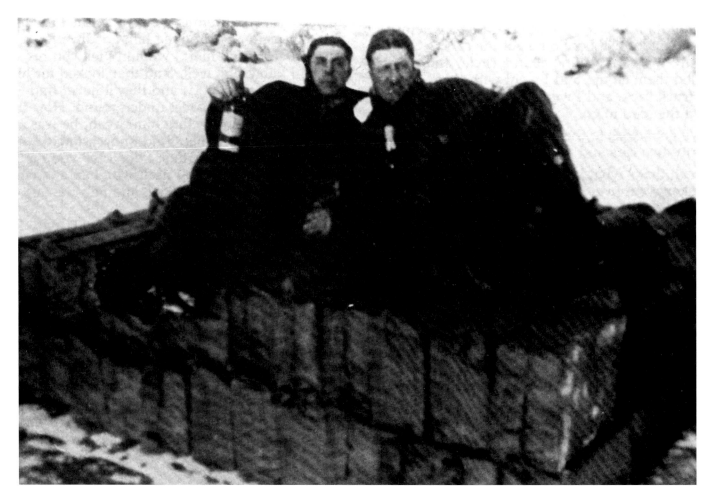

Rumrunners atop a load of booze. Walter Goodchild (*left*) with Big Mac Randolph sit on a load of contraband liquor before taking it across at Amherstburg. (Courtesy of Walter Goodchild)

The Battle of Old Crow and Other Tales: The Story of Walter Goodchild

When I spoke to Walter, he lived in Amherstburg, where he did his own canning and drove a 1938 Ford. He drank bourbon on cold, blustery days. We would sit through a long afternoon, and talk until it got dark. But Walter wouldn't say anything about rumrunning until I put a 40-ouncer of Canadian Club on the table. "Now, we're talking!" he said and smiled. He went to the cupboard, collected two large glasses, opened the Canadian Club and poured us each a good measure. That started the following conversation with him.

It was July 2, 1920. This fellow came around and asked us, "How about going for a ride?" There was a bunch of us, maybe five, and we always had a bottle of whiskey with us. It was hot in July, and so we took a ride up to the River Canard – only a few miles away from Amherstburg. We had a few drinks on the way back.

But anyway, as we were passing the Indian Burial Ground, just opposite it, there was a shot. Seemed like it went right through our car, and so to this friend of mine sitting in the back of the car, I said, "What are you doin' with that gun, you crazy fool?"

He said, "I have no gun. That shot came through the car from the ditch." So we backed up to see what it was, and when we did, we stopped in front of this farmhouse – I believe it's still there – it was gated off. There was an old car in there, and we knew the man who owned it. He used to dicker in whiskey. And in those days, you could send to Montreal and get all the whiskey you wanted, anything from one to one hundred cases. So anyway, we realized that he was loading some whiskey, and of course, we knew all the men that were in it – about eight guys, and they'd all divide up those hundred cases, but this fellow we knew who was dickering in the whiskey, he was the one who did all the buying and selling.

So anyway, someone in the car said, "Let's go back and give the boys a hand." So we went, and just as we got in through the gate – we couldn't see much because the hay was high, up to our waist. It was ready to be cut, just about the right time for hay, you know. Anyway, we got about halfway up there, and out of the hay jumped this big tall coloured guy, just about six-foot-three. He was born and raised here, and we knew him real good. He was drunk. Oh my God, he was drunk! Anyway, he had this gun right to the head of my friend – the guy that drove the car. Right to his head, and he told him to get out of here.

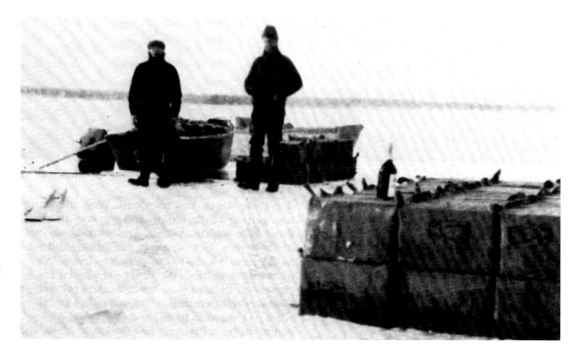

In the winter, rumrunners put sled runners under their boats and towed them across the ice. Here Big Mac Randolph and Walter Goodchild wait for a car.

(Courtesy of Walter Goodchild)

We said, "Lon, please put that gun down. We'll go back and give the boys a hand." But nothin' doin'. He was shaking his head. And he wouldn't put down that gun. So we said all right and we got back into the car. We decided to get our own ammunition. I'll tell you why.

See, at that time everyone was stealing and robbing each other's stuff. I don't say *we* were at that time, because we always had enough – mostly because we were hauling the stuff across the river all the time.

Anyway, we got back on our way, and we ran into another friend of ours who had been out of the army not too long. He had brought with him about three revolvers. He asked us where we were going, so we said, "Well, come on." His name was Rubber Hamilton.

I said, "Come'n Rubber. Bring your gun with you." We went and got ours, then went back up that lane. There was a wagon with a farmer there, a gentleman sitting on the wagon with a load of whiskey. There was also a load of whiskey right on the riverbank, close to us. So when we come back, the only one sittin' there was this farmer with the load on the wagon.

We said, "Now, you don't have to move." And we still wondered where all the men had gone. We figured if they took off – if that's the way the coloured boy was going to act – then we'd take some of this whiskey.

Quite a while passed and no one showed up. Two of the boys went back to Amherstburg and got one of our friends – he's dead now – anyway, he had a boat and was the only man

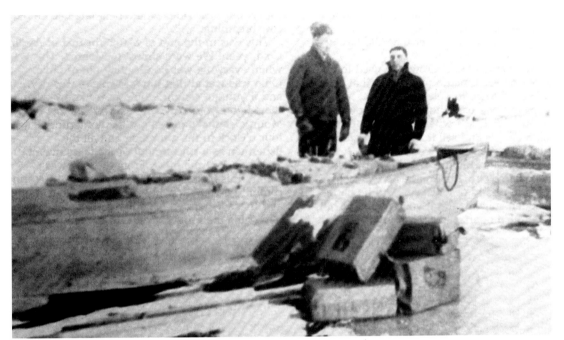

Shorty England and
Big Mac Randolph
with hundreds of
sacks of liquor.
(Courtesy of Walter Goodchild)

around here at the time that had a fairly good-sized boat.

Well, by the time they got him out of bed and got back down here, a lot of time had gone by, and still no one had shown up. It was just breaking day now when we heard someone comin'. Funny part was that it was one of the men that had an interest in this whiskey. He was one of the guys that combined all the whiskey together. So just about the time he got to the riverbank, just like a bunch of Indians, seven other guys were comin' with him, all shooting.

We were down at the bank with the first load of whiskey ready to go. It was piled so high, and it was all in those straight pine boxes or crates. So they came down upon us, shooting. So, gee, when they started shooting, we got behind all the whiskey and their bullets were going right through the crates at us. Well, to tell you the truth, we shot back. But I didn't shoot to kill nobody. I don't think the other boys did either 'cause we knew every man that was in that group, and we were all friends, you know – all born and raised together around here. But it was this coloured man who caused the grievance, you see. We got a little peeved about it. So after my revolver ran out, I ran up the beach. There was about an eight or ten-foot wide beach there. And the man who lived across from the Burial Grounds, he had a rifle. You know, he told me afterwards that he knew who I was. But as I said, it was just breaking day, and he shot on one side of me and then on the other side. The bullets were hitting the sand, and the old sand

was flying like that. He told me afterwards that he could've killed me, which he could've.

At the north end of this beach, there was an old hotel by the name of Zebb – I don't know exactly how to spell it. It was there long before I was born, even. But it was an old dilapidated thing. In between the place where we were shooting and this hotel, it was quite a piece – and there was all this wild lettuce, about so high. At that time they used to pile it up like a farmer piled hay. Well, it was all piled there but it had dried out and rotted a little. So anyway, it was early in the morning by now, and the dew was on this lettuce and I ran through this lettuce and was going for the highway. I was heading for the road where our car was.

But then I found this dried lettuce piled up and because I was wet running through the leaves, I stopped here for a while, and I laid on top of this stuff. I went to sleep on it. Yeah, I never woke up in fact until the sun woke me up. Blazing down on me, it was.

I heard some people hollering my name when I finally woke. I got a nickname – Goody's the name. I heard them hollering it, and I wasn't sure just who it was, and I thought it was the other guys who were still after us.

So anyway, I woke up – I don't know exactly what time it was, because I didn't have a watch. I took the streetcar down. It was five or six hours probably after all this happened, and everyone thought I was either drowned or dead. They were looking all over town for me. People were hollering to see if I was still around, see.

When I hit Amherstburg, they were all dumbfounded because they saw me getting off the streetcar. They had thought I was dead. And I guess it was a pretty close call, anyway, what with the guns firing off like they were. And I suppose they could've killed us if they really wanted to.

And you know this other fellow by the name of Rubber Hamilton, well, let me tell you about him. The streetcars were running then, and there's a little gully in there just right where the Indian Burial Grounds is. It goes to the river, and at that time there used to be a trestle went across made of big heavy timbers. So anyway, the guys started chasing some of our boys, and Rubber fell in between them big trestles. And my God, they kicked the devil out of him. Oh God. They really kicked him. I would say there were seven guys.

But, you know, after that feud – if that's what they want to call it – everybody was friendly again. But it was just this coloured chap that caused all the damn grievances. It was all over this stuff – Old Crow. I don't even know whether they still sell the stuff. That's why people 'round here call it the Battle of Old Crow. It was over that brand of whiskey.

Anyway, that coloured guy left town (Amherstburg), because, as we told him, when he wouldn't put that gun down, "Lon, we will get you." So he left town. He never did come back.

When I was taking care of the slot and pinball machines on the corner of Louis and Wyandotte in Windsor, there was a railing in front of the store, and who was sitting on it but this Lon Taylor. But now, this is years and years afterwards, and we really held no grudge against him.

I hollered to him, "Hello, Lon," and I started walking toward him just to talk. He took off down Wyandotte Street, and I haven't seen him or heard of him since. He must have had it in his mind that we were after him. He must have thought we intended to hurt him.

Anyway, the battle was over that Old Crow. It was old bourbon.

Before the Battle of Old Crow, we used to go to Toledo. You see, Ontario was dry at that time (1918). We used to go to Toledo to get it – in gallon jugs out of a barrelhouse. You know what a barrelhouse is? That's where they have 40- or 50-gallon barrels and sell it from the spigot. Originally, they used to have one in Amherstburg. The building is still there. There were three barrels on a bottom rack, each with a different kind of whiskey. And there were these wooden spigots, and if you wanted a shot of whiskey the bartender'd open a spigot and fill it for you. A shot glass then sold for ten cents. But anyway, we used to buy the stuff out of the barrelhouse in Toledo a dollar a quart. Just fill up a jug. We knew the chap that was bartender there, and he'd open these spigots and fill. He didn't fall smart for a while because we were taking Canadian measures in our jugs. We were gaining a quart on each gallon.

The first trip we made, we had my uncle's old lifeboat – I don't know where in the world he got it. It was a big one. It was dilapidated and the gunwales were all shot and he had a one-lung motor in it. Every time the motor'd go thup, thup, the sides would be going like an old cow breathing.

This was the end of March, or first of April.

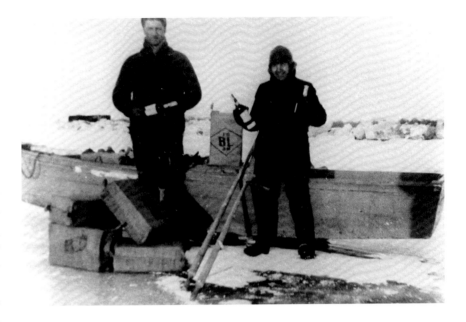

Cold, yeah! We were almost to Monroe. This was when everyone was bootlegging out of Ohio. Ohio was wet at that time. Michigan was dry, and if you got caught, you'd never know what they'd give you. Anyway, we were almost to Monroe – that's just about the borderline. It's four o'clock in the afternoon and all the fishermen as a rule are out of the lakes one or two o'clock at the most. From the east was comin' this blackest cloud I'd ever seen. A storm comin'. Of course, we weren't too far from shore and these fishermen fished what they call "trap nets." It's the same as a prawn net, only you don't use stakes, you use floats. Well, the water was getting a little rough, and you couldn't see these little wooden buoys. And we ran into one of these nets. Got caught in our wheel, and we didn't have a knife to cut ourselves loose. We didn't have nothin'. We never even had a life

Walter Goodchild and his buddy, Rubber Hamilton, pose with their liquor stash at Amherstburg before smuggling it to the U.S.

(Courtesy of Walter Goodchild)

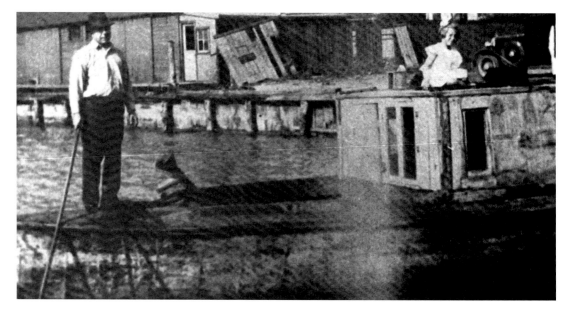

Walter Goodchild on the boat he took across Lake Erie to Cleveland.

(Courtesy of Walter Goodchild)

preserver. Besides that, we had taken my uncle's boat without permission. So we didn't know what in the world to do, and that storm was comin' in from the east. She started to blow, and I don't know, but I think the Lord was with us. I turned around and looked toward Toledo and here's a fish boat comin'. There were three men in it, and when they got to us, they cursed us and told us, "What in hell you kids doin' out here in this storm?"

We said we were caught in the nets. So this one guy said, "We see you are." And it was their nets. Well, they didn't care about that, but you see, fishermen in those days were prepared. Their boats were almost all flat-bottom, and if they got caught in the nets – you know what a corn scythe is? Well, they had one with a broom handle on it, so they could go underneath the propeller and cut it off. Well, they cut us loose,

and said, "You damned kids get into Monroe."

Well, at that time, Monroe Pier was quite long. But the fishermen were living down there on the bank. So we pulled into the piers. They said, "You get the hell in that pier," so we did. But when we pulled in there, we just pulled in halfway. We didn't want nobody to know that we had this liquor, 'cause we were in Michigan now. We stayed there all night. And the storm, oh it blew, and it was cold. We didn't have nothing but a couple of raincoats, and slept on the piers all night.

The next morning was the first of three mornings that we were there. The storm lasted three days, and we stayed at the cabin with the fishermen for all that time. They had invited us there the morning after the night we came in. Well, anyway, when we went in there first, the channel that is, we took this net, filled with the gallon

jugs in it, and lowered it into the water between the boat and the dock. The wind changed, came around and threw waves up this river every once in a while. So when everything had calmed down and we were ready to go, we went down and pulled up our nets. The whiskey! We had nothing but broken glass. The swells, you see, ran the glass back up against the rocks that were down there and broke every bit we had. So we had nothing but a few chunks of broken glass.

We headed back to Amherstburg, and I remember it was nice and calm when we come in. My uncle was sittin' on my dad's boat, and he was quite deaf, but anyway he saw us comin' in and he hollered, "Where you damned kids been?" He talked in a squeaky voice.

Well, I made every excuse I could, and he wasn't all that mad and didn't say much. About two days afterwards, we took the boat again. Yeah, we took it again, but darned if we were going to get caught again, so this time we went prepared. I got a hold of one of those scythes and put a handle on it. We also took some extra clothes with us in case. So we went out and this time we didn't hit Monroe on the way back. We brought back about fifteen gallons. Would you believe I got ten-to-twelve a quart? And each time we went, we were gaining a quart, and hell it was only costing us maybe seven or eight gallons on a one-lung motor, just one cylinder.

We had all kinds of ways of taking the stuff across to the other side. We used to haul it across the ice, too. This was during when the docks were open, about 1925.

This friend of mine used to pick up whiskey at the docks, the export docks, and he got me a job on one of the beer docks at Park Street here in Amherstburg, right at the foot of the street. So for about two years I went in it for myself, hauling from across the river myself.

For a while, too, I was buying out of Montreal. But I did not go there myself. There was five or six gentlemen around here that were pulling it, and I would buy off them. They would take my orders, and they would pull it, because you see I would have to take it across the river and deliver it over there. That meant I didn't have time to go to Montreal myself and pick it up. So I paid these guys so much per case to deliver it here, and then I would take it across to the U.S. And as far as export papers – I never filled out one in my life. "Cuba" was too close.

When the river was open, I used my rowboat. But when there was ice, well, yeah, I put runners under the boat, and pulled it with a car. I have hauled as much as twenty-five cases. I had a big boat, my Dad built it, and it could hold maybe 300 bottles – it was a deep boat – my Dad built six of them for the bootleggers.

Taking the stuff across usually took a little while, because you had to listen and watch for the law. Usually I never pulled in daylight, but for about a year I did. I pulled in broad daylight at seven o'clock in the morning, between seven o'clock and eight. And the law never caught me. Nope. I had some close calls. That's why some of these instances I could tell would surprise you.

Let me tell you about this one hour in which we pulled the stuff across. We had to work one hour – that's all the time we had. From seven to eight, because the Immigration Office on East

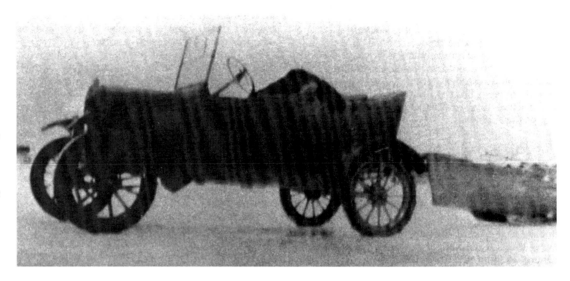

Old jalopies bought for five or ten dollars were used to haul whiskey-laden boats on skids or runners across the ice. A runner would not lose much if such a cheap car fell through the ice.

(Courtesy of Walter Goodchild)

Jefferson in Detroit would change shifts at that time. The guys would have to leave Grosse Isle, go there and relieve the other guys to go to work. That took them more than an hour. So from the time they left the other crew and came back, it was in that hour right in broad daylight that we'd unload.

At that time, we knew about where the law was, too, because when we used to come over on this bridge, we used to give the guys a case of beer a week to tell us if the law was on or off.

One time I seen the Immigration look in a fellow's boat and chop it apart. One guy I knew had two boats he had bought from Dad, and we were standing there talking to him, when all of a sudden the Immigration went down the hill where we were and looked in his boat.

We kept the bottles in jute bags. And you know when a new jute bag sheds, it leaves this fuzz-like stuff around and it will drop in the boat. Well, the Immigration saw this stuff and took that boat and chopped it right in the centre with a fireman's axe. The man had bought it only two weeks before. But these guys knew he was hauling the stuff, so they chopped it up. Boy, that made me sick – a brand new boat. Chopped right down the centre like a "V" on both sides and kicked it out into the river. The front end and the back end. . . .

You know, during these days when you took orders for liquor from people, you would have to remember all the brands by number and letter. I could do that, and I did. Not only that, I'd always memorize my customers' phone numbers, too. I had to 'cause if I got caught with anything that they thought was connected with liquor, the law would pinch me – and these fellows would be pinched for it, too.

Just how much I hauled really depended on the orders I got. Sometimes two times a week, sometimes five, maybe four, really it all depended on the orders.

Postscript
Amherstburg Headquarters

Another famous battle for liquor was waged near this town. It was called "The Battle of Indian Burial Ground," and involved a group of farmers who collected enough money to buy a load of whiskey, and planned to run it across the water to Michigan to sell. When some of the more experienced river-runners discovered this, they decided to hijack the supply. However, the farmers learned of the plot and were ready, and they carried weapons. In the dead of night, a skirmish resulted; gunfire could be heard, and the flash of pistols and rifles lit up the darkness in the channel near Amherstburg.

In the end, the farmers managed to scare off the hijackers. According to Art Montague in his book, Canada's Rumrunners (Altitude Publishing), 300 shots were exchanged "in pitch-dark, (but) not a single bottle of whiskey was hit."

In 1929, the small town of Amherstburg, Ontario became the new headquarters for liquor smuggling. Police Chief Harry Timmis of that town feared a veritable war was about to break out, and he didn't have enough men or expertise to battle it. He virtually threw up his hands and said it was out of his control because it would involve a battle with the U.S. Coast Guard.

Clashes on Lake Erie erupted between the American Coast Guard ships and the rumrunners, and it was clear from U.S. authorities that they regarded the town and its environs as the "temporary headquarters" for the distribution of Demon Rum.

Timmis said all one needed to do was to take a stroll down by the docks and count the number of strangers. The majority, he said, were associated "in various capacities with the liquor industry." He did think, however, that some might well be "undercover agents" working for the U.S. Customs.

Timmis told the Border Cities Star *that he believed the rumrunners in Amherstburg and nearby Sugar Island were "armed or are arming with Lewis guns in readiness for the much-heralded major offensive by the American forces."*

He said, "It's my opinion that these new arrivals will use the guns, that is, if they are bothered by the Coast Guard crews."

The runners had already complained openly that they had been "fired on" by Coast Guard agents who did not give them an opportunity to halt for search of their craft.

The newspaper said the Lewis guns were the choice of the rumrunners because "they can be handled expeditiously and cast overboard if the situation demands such as an imminent capture."

Timmis said, "The veteran rumrunners, in any event, would not advertise the presence of guns, although the situation naturally would be known to the American officers after the first brush with them."

The Amherstburg police chief said the town had also been frequented by Chicago gangsters. In April 1929, a gang from the windy city "shot it out on the Detroit waterfront with Customs officers, escaping after the battle in the police automobiles. Those gunmen were not apprehended."

Old jalopies take off across the ice. This photo was taken by Horace Wild and was one of the photos that got him into trouble with the rumrunners.

(Windsor Star)

The Kidnapping of Horace Wild

Leon Wild, who runs a photography studio on the west side, still shakes his head in disbelief over the story of his grandfather.

It was eighty years ago, on June 19, 1929 that Windsor was stunned with the *Border Cities Star* headline, announcing how a gang of rumrunners had kidnapped the newspaper's photographer.

The headline read: ***Star Man Kidnapped***.

In the course of their activity, rumrunners were accustomed to being chased by U.S. patrol boats, being fired upon with "tommies," battling off hijackers, virtually anything – but they were not used to having their work documented by news photographers who wanted to blaze their faces across the provincial dailies.

Angus Munro, a former writer for the *Border Cities Star,* was right when he said newspaper photographers from that era were noted "for their sheer crust in getting the pictures" they wanted. This was particularly true in the case of Horace Wild, who took his sixteen-year-old son, Noel, with him on assignment to photograph rumrunners in action.

Wielding a couple of bulky Speed Graphic cameras, Horace had ventured out on a routine assignment to snap photographs of rumrunners preparing to make a run across the river from Amherstburg.

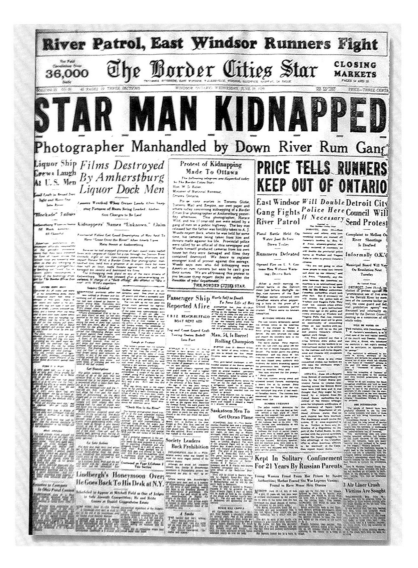

Noel Wild.
(Windsor Star)

He was accompanied by his son Noel and two *Star* reporters. The four made their way by boat to Amherstburg, and drifted out several yard from shore. As they edged closer, they spotted a dozen men loading a cache of liquor into a boat from a set of waterfront warehouses.

When the gang realized they were being monitored, they rushed to the entrances of the warehouse, nearly colliding with one another. Concluding this was futile, they started point-

ing at Wild and making faces, even waving at him.

Meanwhile stacks of export beer were fed into the boats.

Others among the illicit gang, however, began to worry about these pictures, and decided to put an end to Horace's snooping.

That's when they gave him chase. The *Star* reporters sped away but stopped a mile down river at a private dock to let Horace and his son escape on foot.

As Noel explained in a later interview: "We decided we'd jump off. So my dad and I grabbed our cameras, and ducked into the woods. But these boys weren't so dumb. They wheeled around and came back to get us. We tried running, but they grabbed Dad and me and wanted to smash our cameras.

"They took my father away and headed back to Amherstburg, and left me, because I was only a kid."

But before taking Horace back to town, they ordered him to turn over his cameras, and did not believe his protestations that he had left his gear in the boat. They then forced the photographer to retrieve the cameras stashed in the weeds.

As the *Star* reported, "The men, bearing the cameras triumphantly, hauled Wild into one of their automobiles." From there, Wild was driven back to the export dock where a mob of angry men surrounded him, and started shouting, "Chuck him in the river!" and "Smash his cameras!"

Horace was jostled about.

"It seemed as though the hot heads of the

J OHN LABATT (extreme right), wealthy London brewer, was the most noted Canadian victim of kidnappers of this era. He was hustled off to a secluded house (centre above) in the remote sections of Northern Ontario and held while his abductors attempted to collect $150,00. He was freed when the chase became too hot. The money was ready to be handed over by the kidnapped man's brother, Hugh. Clues led police of two countries on many a wild goose chase. David Misner (extreme left), Jack Bannon (second from left), and Michael McCardle (second from right) were among those suspected. The three were convicted and sentenced to 15 years. Misner later sued for false imprisonment and won his case.

gang would have their way and consign Wild into the cool waters of the Bob-Lo channel," the *Star* reported.

The rumrunners actually started fastening chains and weights to his father and were lowering him into the river. But A. J. Woods, proprietor of the export dock – calmed the others, and assured them he would make sure the film did not fall into the hands of the *Star*.

"My grandfather told me he figured he was a dead man," recalled Leon.

Noel, who had gotten away, alerted the provincial police, and they quickly rescued Horace.

What the gang members didn't realize was that though Horace had handed over his Speed Graphics from the weeds, more film was still concealed down by the water. Wild returned the next day and found the film, and his photos appeared in the *Star* days later.

Woods had Wild's battered cameras, and only gave them up to the police. He maintained he could not account for the damages caused to the cameras, but was still charged with receiving stolen goods.

Within twenty-four hours, an American Coast Guard cutter routed a Canadian boat drifting in U.S. waters, believing it was looking to unload contraband liquor. As it turned out, the boat was empty, but authorities detained five of the men for questioning, and sent two others – Charles Wood and Jack Dugan – back to Canadian authorities.

Horace identified both as having been involved in the kidnapping.

In looking back at 1929, Leon said, "The *Star* made a big deal of it, but as my grandfather said, he showed up at the *Star*, got his assignments and went out to do a job – that was it."

John Labatt kidnapping case caused sensation in Canada. *(Windsor Star)*

Two-Gun Hart

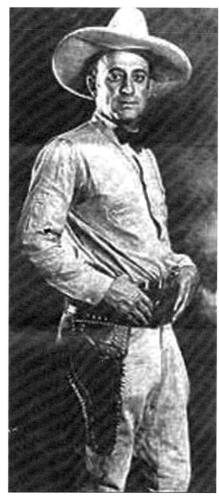

(Courtesy of Harry Hart)

It was a dream come true for this Italian-born man whose hero was William S. Hart, the silent-movie cowboy star. With the start of Prohibition, and the American Government's determination to enforce the 18th Amendment, Richard Hart signed up as an agent to stamp out the lawlessness of alcohol.

Laurence Bergreen, the official biographer of Al Capone, believes Hart's "love of guns, his adoration of William S. Hart, and his need of a steady job," prompted him to approach the Nebraska governor to designate him as such an agent. He was handed a badge and a gun. And within a couple of weeks, he was working and conducting raids on illicit stills and blind pigs.

This all took place in Homer, Nebraska, where Hart had decided upon his new identity, and changed his name from James Vincenzo Capone to Richard Hart. And throughout Prohibition, while he was making a name for himself as the toughest agent in the country, his younger brother, Al, was also making a name for himself in Chicago, but with the Mob. The newspapers of the day, however, didn't get wind of this until much later. Even as late as 1952, when Richard Hart had to give testimony regarding taxes and the Capone estate, it was front page news.

Hart did everything in his power to keep this identity secret. But it had little to do with the fact that his brother was the most sought-after criminal in the U.S. As it turned out, Hart right up until his death still had family dealings with his brother's estate.

Hart's story really begins when he left home in Brooklyn at sixteen to join the circus. He also served in the First World War as part of the American Expeditionary Force. Hart also did his best to lose his Brooklyn accent, and went to great lengths to disguise his Italian ancestry. Indeed, he filled out official state forms claiming he was born in Oklahoma, rather than Naples, Italy. And according to Bergreen's biography of his brother, Hart "allowed the impression to stand that his dark colouring came from Mexican or Indian forebears."

When Hart arrived in Homer, he got jobs as a house painter and timekeeper, but people who knew him remember the tall tales he told of himself. He boasted that he had tremendous strength, and challenged others to wrestle with him. According to Bergreen, Hart also claimed that he drank a pint of warm cat's blood daily.

His first week as a Prohibition agent brought him a taste of glory when he knocked

over five stills. In photographs from that period, he is portrayed in the newspapers wearing guns, a six-pointed star on his chest and a Stetson.

Hart was determined to make a name for himself, and set about to raid as many of the 50 to 100 illegal stills he knew about. From time to time, however, he would disguise himself as a customer and find a way to infiltrate the booze handlers. Or in one instance, Hart landed in Schuyler, Nebraska, masquerading as a handicapped veteran from the First World War, but also as someone eager to hit the gambling tables. Quickly, he was permitted access to some of the high rollers, and then contacted other agents to help him raid and shut down the town's stills. As Bergreen says, one of those stills was camouflaged in a soft-drink bottling facility.

So fearless was he in his raids, coupled with how he dressed so ostentatiously, Hart soon developed the nickname "Two-gun Hart." He was finally shipped over to becoming an agent for the Bureau of Indian Affairs and was asked to take up residence at the Cheyenne Indian Reservation in Dakota. His job was to stamp out the liquor traffic among the Indians there. As with everything else, Hart "steeped himself in Indian lore and took the trouble to learn the language of the tribes he was assigned to police," says Bergreen. "Always fond of photographs, he liked to pose for portraits with the Indians. In one, an Indian child is dressed in his most elaborate garb, while Hart, his Stetson firmly in place, tries to stare down the camera."

Meanwhile, as Capone's biographer said, the identity he had forged for himself "out of the legends of the American west" continued intact. No one suspected or realized his association with Al Capone, even though it was briefly leaked in Homer in the mid-1920s. Somehow it remained mysteriously anonymous until the 1950s.

Hart's true identity was nearly revealed after the shooting death of Ed Morvace. Hart, was positioned on the running board of the police vehicle in a chase of the criminal. He was firing shots at the tires, and his driver also took aim at the tires. Suddenly the Buick they were pursuing came to a halt, and when Hart peered in at the darkened car, he discovered that Morvace had been shot in the neck and was bleeding. He died from the wounds.

The man Hart originally had been after, however, was not Morvace but John Haaker who was a well-known moonshiner selling liquor to Winnebago Indians. The Buick had pulled up to Haaker's house just moments before the chase, and believing its driver had liquor, Hart decided to follow it.

The incident hit the papers, and bootleggers from all over the territory actually organized a mob to lynch Hart, even to the point of fetching rope. Hart decided it best to surrender to the police where he was formally charged with manslaughter but let out on $7,500 bail. As it turned out, Hart was found not guilty by the coroner's jury.

However, it prompted Hart to leave that city and find work elsewhere. That's when he was assigned to the Cheyenne Indian Reservation in South Dakota. While there,

he also was charged with protecting President Calvin Coolidge and his family on a visit to the Black Hills. Shortly thereafter, he was transferred to the Spokane Indian Reservation and was responsible for putting twenty wanted murderers away in prison. He also hunted down moonshiners and bootleggers.

Meanwhile, Hart's brother was also in the news, but on the opposite side of the law.

In 1931, Hart returned to working as a Prohibition agent and after the law was repealed, worked as a justice of the peace. He died in 1952 back in Homer. But his identity did come to light in September 1951 when the IRS investigated Ralph Capone's tax problems. Ralph was Al's brother, and had been closely associated with the Mob.

Hart was served with a subpoena to appear before the grand jury. He was suffering ill health from diabetes and was obese, and as Bergreen says in his book, "looked nothing like the man who had once tracked Indians for days across the wilderness, nor did he resemble a gangster . . . He appeared to be a civil servant."

The story of his appearance there did hit the newspapers.

Bergreen says, "Throughout his life, in so many ways, he had been Al Capone's hidden doppelganger, bringing many of the same tactics to law enforcement that Al brought to the rackets."

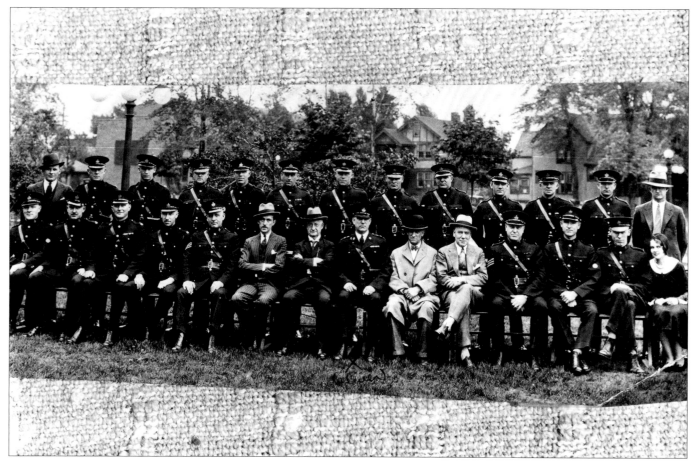

Essex Region Provincial Police.

Chapter 13
Officials on the Fringe

Charles Johnson, Windsor Police Constable

Rumrunners weren't the only individuals in the thick of Prohibition. So were the policemen. They conducted raids almost daily. They broke down doors, axed crates of booze, dumped liquor into the water, arrested bootleggers, shut down blind pigs, and battled with fists-and-guns whiskey dealers. Sometimes they triumphed, other times they failed miserably.

Charles Johnson was a retired policeman from the old Ford City Police Department and the Windsor Police Department. He was eighty-one as of the time I spoke with him. He retired as a staff sergeant in 1963 after forty-four years in police work. When he started with the Ford City Police in 1919 he was a motorcycle driver. Later he was promoted to inspector. The force was amalgamated with Windsor in 1935 and he was appointed sergeant. He worked on just about every detail, from bomb squad and bootlegging to detective and homicide.

Johnson remembered Prohibition vividly. He said the "export docks," or the places from which liquor and beer were shipped out of the country, were strung out along the riverfront "like some huge bootlegging dream." The docks, he said, stretched from Lake St. Clair, the St. Clair River, the Detroit River and all the way to Amherstburg, Ontario. They even had an export dock on Pelee Island "where the Americans used to load up with whiskey and take it back

across to the States side." Lake Erie's export docks, Johnson recalled, were devoted to serving Cleveland, Toledo and Akron, while the Detroit River "freight" was intended for Detroit and nearby parts in Michigan. The docks along the St. Clair River and Lake St. Clair shipped to Mount Clemens and Port Huron. Of course, these export docks were not supposed to be used as clearing houses for shipments to the U.S. Booze was banned in the U.S. and the export papers only permitted the exporters to send it to countries where Prohibition wasn't in force. But the rumrunners merely marked other destination points on their B-13 papers and the booze was cleared through Customs – then went to the U.S. instead.

Johnson described the rumrunners as clever and brash. Only a few of the rumrunners Johnson remembered were real businessmen. Most were small-time operators who picked up boats and hauled the whiskey in the dead of night. Many had figured out all the angles: bribing, clever ways of concealing booze, designing faster cars and more efficient engines for speedboats, rigging up signals and lights, sending out decoy boats and "just plain outwitting the Customs and police." They hauled whiskey in sprawling Chandlers or Studebakers with the back seats removed to make room for crates from Hiram Walker & Sons.

Staff Sergeant Charles Johnson of Ford City Police. *(Windsor Star)*

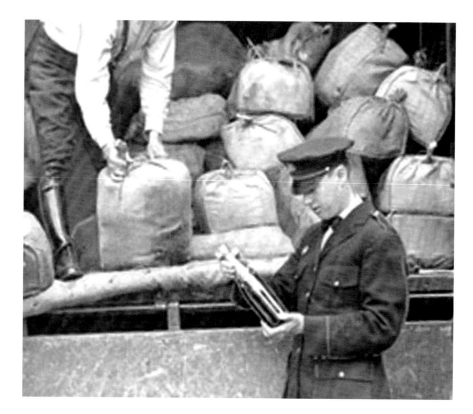

Police seize $72,000 in liquor. (Courtesy of Temple University Libraries)

The Americans over there were paying $120 a case for it. That was in Detroit. But now in Cleveland, Ohio they tell me it was worth far more than that. Now I'm not sure; I couldn't prove that.

Johnson also recalled the Americans coming over to the Canadian side.

The Americans started coming over when it went dry over there (Volstead Act, January 1920), and they started buying everything they could get their hands on. One hundred cases was nothing at a time for these guys. I've seen 300 to 400 cases of beer going to Detroit in a big boat, one of those 45-foot boats. They could take over 200 to 300 cases of whiskey, too.

Johnson recalled one bizarre case that led him into catching a rumrunner who was smuggling narcotics as well as beer.

Yeah, there was a rumrunner from the other side (U.S.) who had come over and stole a top off an old boat – cut it right off. He just selected the size and shape he wanted, and sliced it right off. Of course, we had an idea who it was, and we went across the Detroit River in a boat to scout around. We found the top right on the property. Of course, I couldn't do anything about it because we didn't have any jurisdiction in the U.S., so we called the Harbour Master. He wanted us to go down to City Hall in Detroit to press charges of theft under international law. Well, the man who owned the boat refused to prosecute or to press charges. He figured it would involve so many court days – maybe years – before it was settled, so he said for us to

You used to be able to get it from Quebec, I recall, and with a twelve-dollar money order. A person would get a case of whiskey, and they would ship it down here. The express charge would be $2.99. And then he could take it any place around the waterfront. If he had connections he could get $120 in American money. And the discount was 22% on top of that.

So the biggest majority of the poor people used to buy one case of whiskey, and when they sold that case of whiskey they had enough money to buy twelve to fifteen more. That's how they made their money so fast, and you could sell every case you wanted. There was no limit.

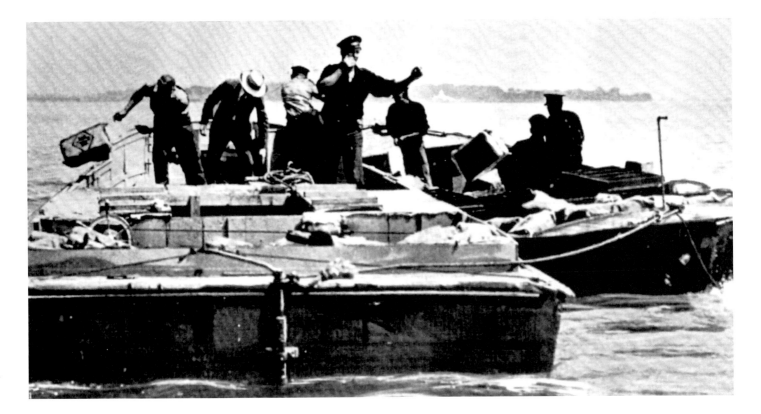

forget it. But we told him to press charges of theft on the Canadian side with the idea that when he returned we'd nail him. So, we waited for him – a long time, too, maybe two or three years.

Finally, I got a telephone call from some woman one night. She said if we wanted to catch this boy he was down at one of the docks. So I took a couple of men with me and down we went.

He jumped in the river. I sent the sergeant down there, and they pulled him out. I then grabbed him, handcuffed him and took him and locked him up.

When I was searching his boat I found he had a load of beer, but I also noticed some boxes about a foot-and-a-half long and about twelve inches high, cardboard boxes. I opened one, and saw that it was a box of cocaine. Another box contained morphine and opium. There were six or seven tubes half full, glass tubes of opium. So we had this joker locked up.

At that time we were unable to prosecute – it had to be a federal charge. The Mounted Police had a detachment in Windsor. So I sent one of my men to get them. I turned the dope over to them, so they could prosecute. That rumrunner got three years in Kingston prison.

Liquor into the Detroit River. American Border Police dispose of seized liquor after a raid. (*Windsor Star*)

Police continued to raid speakeasies and seize liquor. In some cases, they used physical force and ripped down walls and doors and smashed windows to gain access.

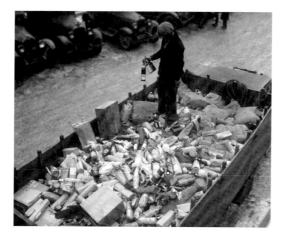

He was over here again two years later and the FBI from Detroit came over one day and looked me up and showed me a picture, and said, "Do you know this man?" I said, "Yeah. Seen him the other day." "He's wanted in about fifteen states for bootlegging." I said, "Well, I seen him the other day."

I had seen him at least two or three times before the FBI asked about him. He used to come down from Riverside and drive through old Ford City as if he was going to Detroit in his coupe. I used to see him about lunchtime generally. So I told the FBI I'd keep a lookout for him, and sure enough the very next day, there he was. I whipped around in my car and stopped him.

I asked him, "Do you know they are looking for you on the other side?"

He replied, "I know that. That's why I'm over here."

So I said, "You won't be for too long. I'm going to take you in. You're wanted over there – the FBI has been searching all over for you."

The man tried to coax and beg me not to take him in, but I showed him the warrants out for his arrest. Then I threw him in the can and called the FBI. They came over right away to get him. But they couldn't take him back to the U.S. – they had no jurisdiction. All the FBI could do was get him charged under the Immigration laws. At that time if you made a declaration at the border crossing that you weren't wanted on any charges, they'd let you through Customs.

So the guy was charged under the Immigra-

tion laws – with the hope that he'd be deported, and once deported the FBI would nab him. But it didn't happen that way.

The judge let him out on $500 bail, and of course he went back to the States, but not under the watchful eye of the FBI – they missed him somehow. In any case, they didn't catch him right away. I think there must have been indictments right through Detroit to California and Florida for him for bootlegging. And so anyway they finally chased him down somewhere and he got two years in the pen over there. They threw all the charges at him and put him away.

Later on, I knew his buddy that used to work with him, and when the bootlegging was over (after Prohibition), he kind of straightened out. He got a job teaching school in Detroit. Anyway, this guy we had chased during the bootlegging days, he committed suicide. They found him in his bathroom one morning with half his head blown off. So that was the end of him.

Johnson recalled that besides bootlegging, there was an extensive gambling racket in the Border Cities.

In those days, when Prohibition started, there was the odd poker game, craps games and whatnot – but in time they opened up huge halls. They had gambling, roulette wheels, craps games, poker games, fan-tan, horse racing – that was all included in those gambling joints. And that ran all the way through Prohibition. It was big time here.

East Windsor had a lot of gambling. It was done mostly in the roadhouses, the out-of-the-way places, you know. They'd haul in the slot machines. They had anywhere from a nickel to a dollar machine going. But of course most of this stuff, I'm sure, was by people from the States. They had all the money behind it.

Years ago when I was a boy going to school, I remember there was a man who owned all the theatres in Detroit. He used to come over here and run one of those funeral cabs with a team of horses and he'd collect his money out of the slot machines. Of course, he had to pay out so much, a percentage on whatever they took in. Then he'd go home with a bag full of nickels, dimes, quarters, silver dollars – it was a good going operation for him.

But that man finally got out of it. He started in the theatre business in Detroit, and then he started in the radio business. He had a big home here situated on Riverside Drive in old Ford City, a million dollar home. And he got all that money from gambling and bootlegging. His name was John H. Kunsky, and he later changed it to John King. He was a Jewish fellow, a nice fellow, as I remember.

Johnson said besides gambling, prostitution was also a booming business in the Border Cities. Americans would come to Canada because the atmosphere was far more relaxed. The roadhouses were isolated from the towns and cities and far enough away from the police stations.

They used to get the girls from Quebec. They'd be fourteen to eighteen years of age. Beautiful looking girls, too, and they were in it for the dough. They'd bring them right here to old Ford City. Walkerville was pretty clean. You'd never find them there. Sandwich Street was literally infested with prostitutes.

WEEKLY·FILM·NEWS

l. 1 No.

DEVOTED TO THE INTERESTS OF THE J H KUNSKY THEATRICAL ENTERPRISE

ONTROLLING
C'/e
WASHINGTON
LIBERTY
GARDEN
ALHAMBRA
COLUMBIA
EMPRESS
ROYALE ■
CASINO
THEATRES.

WEEK.

Septemb
5th
1915

J. Warren Kerrigan

"He'd (John H. Kunsky) collect money out of the slot machines. But that man finally got out of it. He started in the theatre business in Detroit . . ."

(Courtesy of Alan Abrams)

The girls hung out at the Prince Edward and Norton Palmer right in downtown Windsor, trying to pick up trade, and there were streetwalkers right on Ouellette Avenue (the main street of Windsor). In fact, any place where they thought they could make a pick-up, that's where they went. We used to snare them and throw them in the can. If we could prove our case, they'd get thirty days – and then they were right back on the street. But at that time you had to prove they had committed the act, you see, and that was difficult sometimes.

Chinese smuggling was also another lucrative business related to Prohibition, Johnson said.

Chinese smuggling was big business at one time. They used to have three or four different gangs out here in the City of Windsor. And they would take so much a head to take a Chinaman to the States. I've seen them load up five or six at one crack and take them across.

They used to say they put them in bags. Now, I've never actually seen this, but it's all true from what I've been told. It was the talk all over Windsor. They used to put these people in big bags, weighted bags. If the U.S. patrol boats got too close, these rumrunners – they'd also be taking whiskey across – would drop them overboard.

The Chinamen that got through were scared. Contact used to be made here to take them across, and they'd be delivered to a certain spot over in the States. The rumrunners were never paid until they were actually delivered.

After the Chinese smuggling started, there was smuggling of other nationalities, and they'd take them in boatloads. Ten or fifteen or twenty at a crack. They'd never let them take anything with them, only what they were wearing. There were piles of suitcases left behind and those big wicker baskets. They wouldn't let them take a thing. Half the time the smugglers would just grab the stuff they were carrying and just throw it into the river and order the people (the aliens) to get into the boats.

"There used to be a rumrunner who hauled liquor in a big Chandler or Studebaker. He had the back seat taken out."

He went over there one day and pulled right up to the Customs fellow and said, "I'd like to speak to you fellows. You know, I'm a bootlegger." And the Customs guy says, "Oh yeah?"

Daring rumrunners would slide under the ferry's fender, concealing themselves from the police and hitching a free ride.

(Windsor Star)

And he knew it. Well, the bootlegger asked him if a deal could be struck. He said, "I can come over loaded any day, and I'll give you so much a case." Well, this officer was pretty honest, and he figured he was being pretty clever, so he agreed with the bootlegger that the next time he was making a haul of whiskey, he would give him the go-ahead sign and let him through Customs. So anyway, the two struck a deal and at the appointed time, the bootlegger drove over and this fellow, a Customs officer, was ready for him. He had two or three other Customs men with him, and they searched through the car from one end to the other, tore out the front seat and everything. Someone got underneath it, and they looked in the back and under the hood, in the trunk, everywhere. They didn't find a thing. Not a drop of liquor anywhere. Nothing.

So the Customs fellow says to the bootlegger, "I thought you said you were going to bring over a load." And the bootlegger, smiling and all, said, "No. The day I was talking to you was the day I had the load."

But there were other ways, too, to get the booze across the border.

When the law was really hot, the patrol boats were really up and down, and it was practically impossible for smugglers to sneak ashore. The rumrunners used to go down and get underneath the ferries. The ferries were running at that time. They tied the end of the boat under-

neath the ferry, which had a big guardrail, and that big guardrail extended well over the hood. They would tie their boat there and be towed across the river.

I met Al Capone. He was down here at one of the export docks. That's where you'd find these guys. They were here making deals. Capone seemed like a very nice fellow, very gentlemanlike. He was over here dickering with the exporters about liquor. He came down to see Lou Harris and Dave Caplan, who ran an export dock. I suppose he wanted to know who was the best here to haul his liquor. Capone would take a thousand cases a day out of the docks here.

George Large, Customs Agent

George Large, eighty years old when I spoke with him, had worked for Canada Customs in Windsor for forty-one years. He saw Prohibition from a unique vantage point – he issued B-13 papers to the rumrunners. In the course of his work, he met the wealthy Jim Cooper, and after Prohibition, Large was involved in the seizure of Harry Low's vessel, the Vedas. *Large was a Customs collector for four years and retired in 1965.*

Large remembered the formation of the export docks soon after Prohibition came into effect in both the U.S. and in the Province of Ontario.

There was a leeway in the law. You could buy all the booze you wanted right here in Ontario, but you couldn't sell it here or serve it in the bars, but you could export it to any country that didn't have Prohibition. You made your export papers out, what we called "B-13" papers, and you could export the stuff to St. Pierre Miquelon. From Windsor to St. Pierre.

The whiskey was loaded on these rowboats and big boats, good sized boats with outboard motors, and they were loaded in the daytime. You couldn't turn the papers in after five o'clock at night, so the rumrunners would load them in the daytime. And in the night they'd run across to the U.S.

Of course, when the boat would tie up, they would just start their motor up nice and easy – they were on the American side – just go to wherever they were going.

Then the federal officers couldn't see them coming across. They wondered how they were getting over there. That's how they were getting over there. They pulled that stunt on the Walkerville ferry, the Windsor ferry, and the Windsor car boats. And they hauled any amount of stuff over there that way. Especially when they put the heat on. They would have quite a number of patrol boats on that side of the river.

The rumrunners also used to get a good, fast speedboat and fill it with empty boxes that looked like whiskey boxes.

They'd have the other boats all loaded with whiskey. This real fast boat would take off to the American side, and of course the feds and the patrol boat followed after him. While they were after him, the other boats would be sure to cross the river.

The rumrunners pulled that trick a good many times until the patrols got onto them, and then the patrols used to let the fast boat go and just sit there and wait and see if the rest would

come. At night, the rumrunners used to load those luggers down so low they only had a foot of free board, and they were so close to the water that it was hard to see them, unless they happened to get into a light and see something moving. They looked just like a big raft; that's what they looked like.

The rumrunners had plenty of ideas on how to avoid detection. Some of them tried to drive loads of whiskey across Lake St. Clair on the ice.

They would carry heavy planks and when they came to a piece of open water, they made a bridge. Some of them got through, but a lot of them were stopped by patrols.

We seized about 300 cases of whiskey in St. Joachim after a good sized boat ran up the Ruscom River to get away from police.

Large said the infamous American gangs – the Purple Gang, the Little Jewish Navy and even Capone's "hoods" were in the Border Cities continually during Prohibition.

Some of these boats were carrying 80 to 100 cases, maybe even 200 to 300, depending upon the size of the boats. This liquor was brought into Ontario and down to the export docks.

I remember working at Reaume's Dock near Brighton Beach (just outside of Windsor). The rumrunners would load up the boats. There might be 100 cases of beer for one boat, and they'd hand us four B-13 papers for that one boat. We would take it and check it over. These forms were all signed and everything, made uptown, all typed neatly with the destination St. Pierre Miquelon stamped on it. At five o'clock the boats would all be loaded up and that would be it.

Old style breathalyser test.
(Courtesy of Windsor Police)

When night came, these fellows would be back to pick up their shipments. They had signals when to leave and when not to leave. When it was the right time, they'd head across the river to Detroit.

These B-13 papers were a farce. We all knew what was going on, and we knew that stuff was all going to Detroit, but it wasn't our jurisdiction. Once it left the docks and left Canadian waters, there wasn't a thing we could do. If it got diverted, that wasn't our fault.

After Prohibition, I was working as a clerk in the old Post Office building right downtown. And as you went up the stairs, there was a little room on the left. It was kind of a storage room. We used to take those export papers and put them in there before they were to be filed away.

Well, when I went up there two years after Prohibition ended, those export papers were

still there. I think they were up there for two more years before they were thrown out. The Customs officials here never worked on them at all. They were never sent on to Ottawa where they were supposed to go. They were supposed to be sent on every day. There were so damn many of them and the Customs didn't have the staff to handle these papers, so they just ran them by the boards.

As I say, Cooper was fanatical about some things. He'd get something into his head, and nothing would stop him from going ahead with it. Like that time he was heading to Montreal on a train. He told me about this.

He was riding to Montreal when he saw a lot of ducks in a field, so he thought, that's a good idea – I'll just put a lot of ducks down at St. Anne's Island. [St. Anne's Island is part of Walpole near Wallaceburg.]

You see, Jim Cooper invested heavily in St. Anne's Island and started the tobacco business there. He brought in Kentuckians – skilled tobacco growers, and he built houses and hired people to work the land.

Anyway, he just got it into his head that he'd like to see some ducks down there, so he bought ducks by the score and transported them down there. But it was a crazy venture.

Cooper tended to be eccentric and terribly impatient. Large recalled how Cooper's chauffeur would drive the millionaire to a show in Detroit.

The chauffeur would have to sit there in his car all during the show waiting for Jim, and if he wasn't right at the door the moment Jim appeared, then Jim would hop into a cab and head home. Sometimes the poor chauffeur had to sit there all night. He was afraid to leave in case Jim hadn't come out yet.

To Large, Cooper wasn't a bootlegger in the strict sense of that definition. "I really don't think he was dishonest." Large remembered others who smuggled booze across the border.

There was one fellow who used to go over to Walkerville. He went to work there every morning. One day he came back with a big load of stuff in his car, and he told me while I was examining his car that he was just taking home a bunch of stuff from his office since he wasn't going to be working in Walkerville again. Then he told me that he used to take ten bottles of whiskey across to Detroit every day. He told me he put it in the false bottom of his car.

During Prohibition George Large got to know the wealthy Jim Cooper, who built one of the most fashionable homes – Cooper Court – in old Walkerville. He met Cooper while working at the New York Central Railway yards as a Customs officer.

I remember him telling me that he used to pay the Provincial Police off. I don't know this as a fact, I'm only quoting him. You see, they used to unload these cars at Walkerville, where the station is now, in those yards up there. And they'd unload them at night. They had to protect them, so to get the protection they used to pay the OPP off, paid them off in big bills.

So Jim says one night, "I'll fool them, or give them what they want." He wrapped up $3,000 in one-dollar bills in newspaper. His man gave it to a police officer in the boxcar or something, I

The *Vedas*, seized by the police and at anchor in Windsor. It had been nabbed by Customs as it floated off Colchester Light and towed to Windsor. *(Windsor Star)*

don't know how it happened, but anyway, when the policeman went to open it, the paper holding it busted and the bills blew all over the yard. They had a hell of a time there picking up the money.

George Large was also an invited guest at Cooper Court and remembered how it was one of the largest mansions in Walkerville.

It was a great big home, and it had a gigantic swimming pool with a dome. Oh, I was at Cooper's home several times. It was very luxurious for those times – even for today's times.

He had a big Persian rug, and it would have gone all across the size of a normal living room and dining room of any big-sized home – and it

was at least that wide as well. It cost him, I think, about $10,000 at that time.

I also remember the organ he had installed. It cost him about $50,000. It was installed right in the house. But you know, Jim couldn't play it at all, but he was fanatical about hearing music – good music. So he got an organist from the Anglican Church, the Ascension, to play for him. This organist was an accountant on Walker Road, and Jim hired him to come and play hymns for him every morning at 8:00 for a half hour.

This organist told me how he had to go to Cooper Court five mornings a week – just before he went to work – and play these hymns for Cooper. He told me old Jim would come bounc-

ing down the stairs in his shorts, singing all the way down.

The seizure of the Vedas, *Harry Low's rumrunning vessel, was vividly recalled by Large. The oceangoing ship was seized by authorities after Prohibition.*

It was impounded by the Mounties. I think it was picked up way down east someplace. Anyway, they brought it down and docked it right downtown at the former Canada Steamship offices. It sat there, I'd guess, for about a year. Finally we were told to take a crew on and destroy the beer that was still stored within it. We were told to throw it into the river.

So I took about six officers down there and brought all this beer up on the decks and we literally poured all this booze – bottle by bottle – into the river, then threw the bottles overboard. I don't know how many hundreds of cases there were. I think we were there about ten afternoons destroying this beer. Just threw it in the water – bottles and contents.

Some of the boys, however, started drinking this beer down in the hold, but God, it had been down there for about two years, and they really got sick.

The first time that Large realized that even the small-time rumrunner had a lucrative business operating was the night he returned to Reaume Export Dock at Brighton Beach.

One afternoon I came home and I realized I had forgotten to bring the B-13 papers with me, so after supper I said to my wife that I've got to go down and get those papers. We were very conscientious about them. We thought that any time we exported by the ferry or railroad or any place, these papers were being sent up to higher authorities and that they were being checked out, so we were very careful.

Anyway, I went into the office and found a great craps game going on down at the dock. There were about ten or twelve guys down there on the floor, and believe it or not, there were $1,000 bills being slapped down. I had never seen a $1,000 bill. But there they were – these fellows – just rolling the dice.

As ticket collector on the Windsor Ferry at the foot of Ouellette Avenue, William King saw many bizarre methods of taking liquor across to Detroit. He worked on the ferry from 1924 to 1932 right in the midst of Prohibition.

There were lots of people going across with liquor. Lots of them. Oh, they had a lot of different ways of taking it across. Some of them had cars, and they built tanks underneath each side of the drive shaft, and they would fill them up. A lot of them would fill up a spare tire, put a little air into it, so it wouldn't rattle. And a lot of them took out the back seat and filled in there. And they'd carry it across on their person as well. Oh, yes. There was one fellow there who used to make about three trips a day. He carried two quarts – that's all he carried. He carried them on his back. He walked very straight, you never seen under his coat at all.

The Customs people got wise to all this activity and decided they'd check all the lunch boxes being carried across. Oh, you should have seen it that morning – there were plenty of lunch boxes left on the boat – lots of them.

King remembered the Customs seizing cars if they believed the drivers were attempting to smuggle liquor to the U.S.

One time, however, they stopped a mail truck – the American mail truck. There was a big coloured guy driving. A young Customs officer asked him what he had in the truck. He pulled him over to the side and asked him to open the truck up.

"No, I won't open it! I'm not allowed to open it until I get back to the post office!"

At that time all the mailmen used to carry .45s, but the fellow beside this coloured guy carried a shotgun.

This Customs officer said, "Well, I'll open it." The coloured fellow pulled out his .45 and said, "Go ahead. Take hold of the lock and you're dead! I'll shoot you if you take hold of that lock."

They had quite a row over it. Finally, the Customs officer called up the Postmaster at midnight and asked him to come down. The Postmaster demanded to know what was the matter, and the coloured guy told him what was going on. So the Postmaster walked over to the Customs official and turned his badge over to check the numbers on it, then said, "This is the last day you'll be working with Customs." And it was.

The Customs fellow was fired. And the reason is, you can't stop a mail truck. They just go from post office to post office. There might be the odd bottle on them, who knows, but you can't stop the trucks.

In those days, however, everyone was bootlegging, and the stuff came on the ferries just as regular as the commuters. I remember the landlady where I lived was even a bootlegger. She kept her liquor in a coffeepot.

A sidelight to King's story is that contraband literature as well as contraband liquor was being smuggled on the Windsor Ferry.

American readers were introduced to James Joyce's *Ulysses*, a book banned in the U.S., when the first forty copies of the Irish novelist's work were smuggled to Detroit on the Windsor Ferry in the midst of Prohibition.

A Curtis Publishing salesman, Barnett Braverman, a friend of Ernest Hemingway's, was working in Windsor but living in Detroit at the time. He took copies of *Ulysses* one at a time across the river where he mailed them to friends in the U.S.

Braverman lived in a rooming house that is situated across the street form the Transit Windsor bus terminal. It is located on Pitt Street.

Izzy and Moe

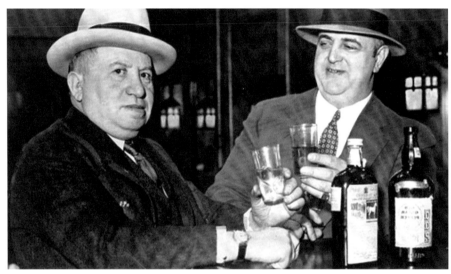

(Courtesy of Library of Congress, New York. World Telegram Collection)

When these two stopped being Prohibition agents in November 1925, *Time Magazine* wrote: "No frills and furbelows will bedeck their billowing bosoms; no petticoat will swathe their fattish calves; no busy beards will sway from their chubby chins. No more will they, wearing what-the-gentlemen-will-wear, rush into nightclubs. No more will their handsome features peer through a peek hole in a door behind which 200 topers are toping; and no more will their portly bodies enter to find a single toper dizzily sipping ginger beer. No

more need wedding guests lifting their bubbling-stemmed glasses to the bride fear sudden descent of those twain, snatching the twinkling beverage from their lip to impound it for the court. These things are not of the future. For Izzy Einstein and Moe Smith have been 'laid off.'"

The story of Izzy and Moe begins in 1920, right at the start of Prohibition in the U.S. They were the best-known government agents in the war against the saloon, and racked up more than 4,392 arrests, of which 95% ended in convictions. And they did this

in classic style of the period. They resorted to the most underhanded methods, including bizarre disguises. And their story was the subject of a 1985 Hollywood film, *Izzy & Moe*, starring Jackie Gleason and Art Carney.

But who were these fellows who wound up together?

Izzy Einstein (*left*) and Moe Smith (*right*) were police officers in New York. Einstein was born in Austria, and came to the U.S. in 1901. He owned a general store in Pennsylvania before moving to New York to work as a mail sorter in a post office. Smith, a cigar shop owner, was the son of Galician/Austrian parents, and by 1920 had already become a U.S. Marshall in New York.

When Izzy died, *Time* wrote an obituary that summed up both their lives as a team fighting booze in the Big Apple: the story said that Isidore ('Izzy') Einstein, fifty-seven, and his partner Moe W. Smith, operated the highly innovative "Einstein Theory of Rum Snooping" that directly resulted in sending over 4,000 bartenders, bootleggers and speakeasy owners to jail.

The magazine said Izzy liked to "play" streetcar conductor, gravedigger, fisherman, iceman and opera singer. And at the 1924 Democratic National Convention in

Manhattan, he strolled in with a goatee glued to his chin, announcing he was there as a delegate from Kentucky. He was actually in search of illicit liquor, but found only soda pop.

Izzy landed the job with the Prohibition Bureau only after he begged them for a trial run at it. On his first day of the job, he went into a speakeasy, ordered a drink, and busted the place. Within a few months, he was doing so well that he was assigned to work with Moe. They stayed together for five years. It was their crazy exploits that landed them in the news. They would disguise themselves as a Yiddish couple or Texas Rangers, slip into these speakeasies and blind pigs, and order a drink.

But concealed underneath their coats was a long tube that ran from the top of their collar, and down into a bottle, so that when they went to drink, they made it look as if they were downing the alcohol, but the booze would funnel directly into that bottle.

Izzy and Moe were a breed apart from other agents, at a time when it was more lucrative to take bribes and work for the "other side." These agents worked for a pittance and risked their lives to get arrests. As Sean Dennis Cashman says in his book, *Prohibition: The Lie of the Land* (Free Press), "It is hardly surprising that some (agents) fell from grace. A Prohibition agent could certainly earn another $4,000 by looking the other way while a consignment of liquor was being ferried to its destination, especially during the night."

He said in the first seven years of the service, 17,972 appointments were made but there were 11,982 resignations and 1,608 dismissals for various reasons, including bribery, extortion, corruption, embezzlement and false reports. Most of these were among the rank and file.

At point, the federal government demanded that Prohibition agents take an "exam," and this also eliminated many of them, because they couldn't pass the test. The irony was that in one instance, an agent lost his job and on that same day a speakeasy bartender, who had been arrested before by that agent, tried the exam, passed, and started working for the bureau.

But Izzy and Moe in their first few months of working together proved to be, as Cashman quotes, "the master hoochhounds alongside whom all the rest of the pack are but pups."

The *New York Times* in April 1922 reported this story of an arrest:

"Streetcar conducting seems remote from bootlegging, yet the tip that saloons near certain car barns were doing rush business took Izzy there. He appeared bright and early one morning dressed in all the regalia of a B. R. T. employee. He entered a saloon and laid a five-dollar bill on the bar.

"'Can you give me a lot of change for this?' he asked. 'I need it for my run.'

"The bartender also had use for small change.

"'Why don't you buy a drink?' he asked. 'That's the way to get change.'

"Izzy ordered a glass of beer.

"'Why don't you take a good drink?'

"Izzy ordered whiskey. He got $4.25 in change.

"The bartender got arrested."

Moe Smith, according to Albert Jenis, in an article for *Empire State Mason* in New York, played more the "straight man role" as an agent. Izzy by contrast resorted to disguises. In one speakeasy, he arrived in a mud-soaked football uniform and announced the season was over and he was ready for some "drinking" action. In Coney Island, Izzy walked into a blind pig dripping wet in a bathing suit. In another instance, he dressed up like a doctor and pretended he had just come from a hospital near a speakeasy, and as always, was able to make an arrest.

But their run at things lasted only a few years. What caught up to them was influence. Those in the agency – those who were on the take – feared the two loose cannons might wind up booking some bigwig, and so Izzy and Moe were discharged.

Scientist checking bootleg whiskey.

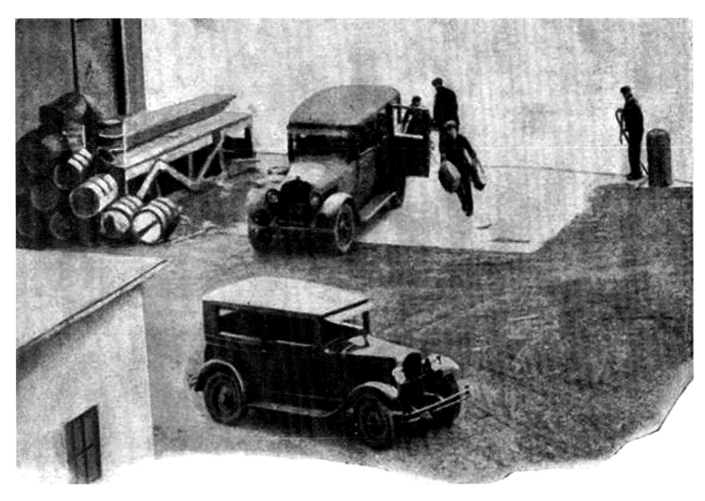

This photograph was taken by a camerman hidden from view as he captured these rumrunners
loading up liquor on the Detroit side of the river in jalopies ready to be delivered to Chicago. (Courtesy of *Modern Mechanix*)

CHAPTER 14

Getting Liquor to Chicago

Pat Roche was barely on the job as a Prohibition agent when the bribes started coming his way. In the first two weeks, he was offered more than $85,000 to look the other way, and that was only his small share of what was being pooled by a ring of dry agents in New York.

In a piece for the long out-of-print magazine, *Modern Mechanix*, Roche said the money in those days was handed out in $1,000 bills, what the gangster called "important money."

"Less important money can be had by any of untold thousands of policemen, sheriffs, deputies, highway patrolmen, state policemen, township constables and politicians – everybody, in fact, who comes in contact with the vast business of transporting and selling liquor," said Roche.

"Is it any wonder that enough of them fall for the graft to make the liquor business a fairly safe gamble?" he added. "Most of the men who can make anywhere from $100 to $100,000 by turning the head or being in the wrong place at the right time are earning in the neighbourhood of $50 to $75 a week."

Roche's job was really as a special agent of the treasury department, working chiefly "to trap crooked dry agents." To that end, he said, it meant somehow ingratiating himself with the bootleggers and rumrunners with whom he dealt.

"I saw plenty of the inside of the rum game," he said, pointing out that in some ways that wasn't difficult because all you needed to do was "draw a line around the U.S., about 250 to 300 miles back from the border, and you have marked off the chief rumrunning territory.

"In the vast hinterland the local moonshiner, the cheating druggist, the homebrew maker, and the peddler of poisonous extracts and concoctions is the chief source of supply for intoxicants.

"But within a night's automobile ride of the rum ships along the coast, the export docks of Canada – which are now going out of business – and the Mexican border is the habitat of the rumrunner and the big time bootlegger."

The business operated fairly smoothly, Roche explained, saying how it took a mere twenty dollars at the export docks along the Detroit River "to grease" the palms of the right people to get a case of liquor on its way to Chicago. He said, "Five dollars went to the boatman who ferried the case across the river, five dollars to the guard who let it slip past the border, another ten dollars to smooth the way through Michigan and Indiana into Chicago."

A case of Scotch, bearing the seals of the Quebec Liquor Commission cost $65 in Canada. If you add $20 for graft, and the expense of run-

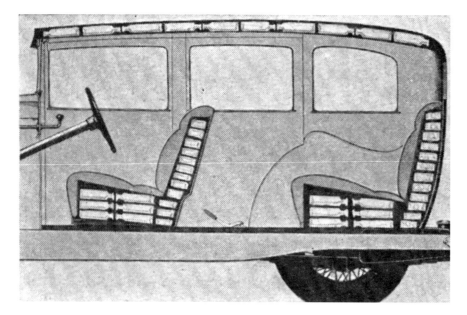

Outfitting car booze
and rumrunner.

(Courtesy of *Modern Mechanix*)

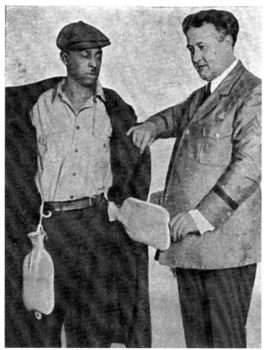

ning it by automobile at $20 a load to Chicago, it topped out at $87. A bottle would sell there for anywhere between $125 and $135 for a 40-ouncer.

One could also buy "commission-wrapped Scotch" in Chicago for $55 to $65 a case. This was liquor that went through the "cutting plants" where fake labels, fake stamps and fake wrapping was arranged.

"We have seized vast quantities of counterfeit paper that couldn't be told from the genuine if we didn't know the liquor commission controlled all the genuine supply," wrote Roche. "The cutting plant buys large quantities of genuine liquor from the runners, opens the bottles, and adds an equal part of alcohol and an equal part of water, making three cases out of one. Flavouring and colouring matter also and are added to bring the taste and appearance up to the original. Bottles, either purchased new from glass plants that make them to order and duplicate any foreign product in shape, size and appearance, or bought from old bottle dealers who have built up a market for empties, are used. The finished product cannot be told from the original."

Roche explained that if the alcohol used in cutting was pure grain, the product itself was no more harmful than the original pure liquor. But if "it is re-cooked, denatured alcohol, its harmfulness depends on the skill of the cooker and the state of his equipment. Nobody can remove the government formula denaturants completely, for their evaporation point is too near that of pure alcohol, and some is bound to pass over with the alcohol vapour to be condensed.

"An expert cooker can produce a product that is virtually harmless, but so few of them are expert, and working in dirty basement hideaways with dirty equipment, they actually cook into the product poisons that were not there before.

"Low-grade alcohol, produced from corn sugar or other sources, is also largely used in faking real liquor. There again the dirt and poisons from insanitary equipment are the chief source of danger."

Roche said the primary method of getting liquor to Chicago was to drive it there. Standard sedans were re-tooled by specialized body shops and fitted with "hidden compartments." He said a standard five-passenger sedan could be rigged up to conceal twenty cases of twelve bottles each, "without any of the secret compartments being visible, even under close scrutiny . . . That's 240 quarts, and it seems almost impossible to hide that many bottles in the backs of the seats, the sides and the roof of a car without causing undue bulging, but it is being done right along."

Roche told the story, too, of a fishing boat that had a solid concrete ballast in the hold, and dry agents ripped it out to find a thin floor "with a fortune in liquor under it."

He also said some liquor was shipped by rail "as freight in large lots, or as express in small quantities."

Roche explained: "The usual express dodge is to pack six bottles in a tin can, solder it tight, so if one is broken it can't leak, and pack two tins to a box. The shipper has labels printed purporting to show he is a dealer in radio parts,

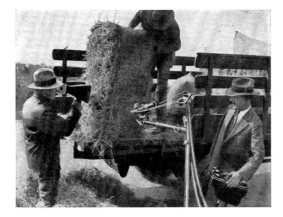

Science comes to the aid of the police in detecting liquor shipment. U.S. Government agents used a portable X-Ray machine to ferret out illicit booze. The man to the left is holding a fluoroscope looking through a bale of hay while the agent at the right operates the X-Ray machine.

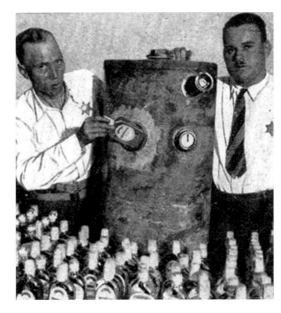

A favourite trick of rumrunners was to store their cargo in a gas tank. Note all the bottles taken from one tank. (Courtesy of *Modern Mechanix*)

printing plates, or some similar product that would be shipped in boxes of about that size and weight. The buyer pays cash in advance. If the shipment is detected and confiscated by government agents, it is the buyer who loses his money."

Reverend J. O. L. Spracklin.
(*Windsor Star*)

The Fighting Parson

Reverend J. O. L. Spracklin, more than any other person during Prohibition, symbolized the dramatic fight between temperance-minded people and the rumrunners. His campaign was waged like a war against the whiskey dealers.

For years at Sandwich United Church (now Bedford United), old-timers preferred to forget one of their former pastors. But his name is not easily buried in the church's records. His identity surfaces occasionally in anniversary editions of the *Windsor Star*, in regional historical sketches and in high school essays. He is remembered for his dynamism, fanaticism, charisma, and for carrying out his mission with a relentless iron will. He was Reverend J. O. L. Spracklin, pastor of Sandwich Methodist from 1919 to 1921.

His brief charge at the church gave him a place in the history of Prohibition. With guns strapped to his belt, Spracklin wailed from the pulpit at Sandwich Methodist about the low-lives of the community. When not in this sanctuary, he roamed the streets until the early hours of the morning, busting down doors with pistols blazing and a squad of toughs trailing close behind. When not being chauffeured in his large touring car, provided by Ontario's Attorney-General William E. Raney, he patrolled the Detroit River with the provincial government speedboat, *Panther II*, zooming into remote docks and canals to spy upon and catch whiskey dealers red-handed.

Everyone came under Spracklin's scrutiny. No one escaped, not even the members of his own congregation. While he preached on Sunday mornings his thugs often rummaged through parishioners' cars for booze.

Spracklin trusted no one. He was personally selected by Raney, and was given a free rein in the Border Cities. The attorney-general wanted someone who believed in the temperance cause; not simply an employee, but a fierce believer. In gun-slinging Spracklin, he found his man.

Spracklin went at his task of cleaning up the border with unrestrained enthusiasm, and soon earned the nickname "The Fighting Parson" by newspapers. He became a kind of teetotalling Wyatt Earp, who would stop at nothing to win.

The crux of this drama was Spracklin's rivalry with Babe Trumble, the saloonkeeper at the Chappell House. The roadhouse was only an eighth of a mile from the church and its all-night entertainment went on unobstructed, in blatant disregard of Ontario's new temperance laws and much to the chagrin of the crusading Methodists.

Spracklin and Trumble had known each other since childhood. Their mothers were close

HOTEL REGISTER

Money, Jewels and other valuable Packages must be placed in the Safe in the Office, otherwise the Hotel will not be responsible for any loss.

The Chappell House Registry.

(Author's personal collection)

Another tells of a field day race when Spracklin trailed behind Trumble to finish a close second.

In 1920 Sandwich, Trumble was a well-to-do businessman, owner of a fashionable roadhouse, and was gaining recognition and wealth, while Spracklin, a newly-appointed pastor of a church, languished with low pay and little authority outside of his congregation. But this situation soon changed. The power that Spracklin was desperate for finally came in June 1920.

On Monday, June 21st, Spracklin harangued a cowering Sandwich Council, demanding a thorough investigation into the widespread sale of liquor at nearby roadhouses. "This historic town," Spracklin railed "has become the dumping ground for the lowest element, an element that we might well be rid of and that comes to us from all parts of the U.S. to obtain what they are looking for – strong drink.

"They come to the Border Cities for it and secure it largely in the town of Sandwich. There is a flagrant disregard for the law and so far the police have made no effective efforts to cope with the situation. The streets have become unsafe for our mothers, wives and daughters on account of the open debauch that is going on here.

"At any time of night, you can hear men passing your street door using the most obscene language; drunken, rolling, spewing, fighting men in all stages of intoxication as a result of the illicit sale of liquor that is being carried on."

The main targets of his attack, however, were the Chappell House and the ineffectual Sandwich Police Chief, Alois Masters. Spracklin

friends in Woodstock, where both families originated. But Babe and "Leslie," as he was known, were never close. Trumble was flashy and had little difficulty in acquiring friends, while Spracklin, not a loner but an individualist, kept to himself. Whether deep-rooted jealousy on Spracklin's part separated them isn't known, but rivalry brewed like a poison between the two.

The stories about the two are many. One recounts how Spracklin was waltzing with a pretty girl at a school dance, when Trumble suddenly appeared at the doorway. That's all it took, apparently, for the wide-eyed girl to abandon Spracklin for the flashy Trumble.

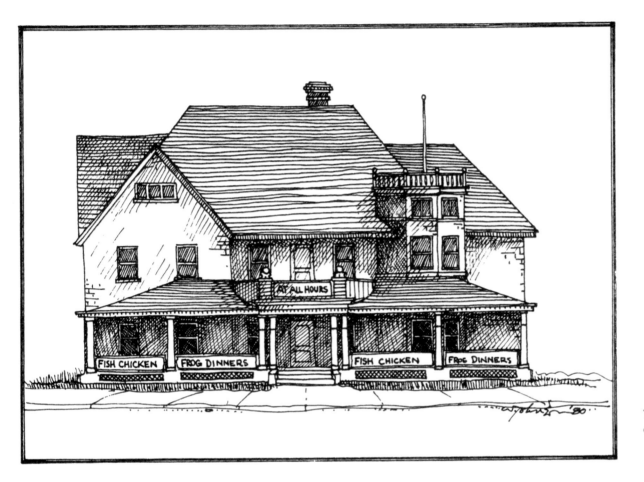

The Chappell House.

(Drawing by Bill Johnson)

claimed he'd counted nearly thirty drunken men and women leaving the roadhouse, "by the front entrance that night, with the chief of police sitting on the front steps ... twirling his thumbs." One girl came out, Spracklin said, who was "so drunk that she rolled all over the porch," and a man left the building "so loaded with liquor that he had to be helped to the end of the veranda, where he tried to sober up. Girls came out in such an intoxicated state that they had to be helped to the automobiles by their escorts, or they would have fallen down the steps."

Spracklin said that one woman sat for a moment in a drunken stupor on Chief Alois Masters' lap before he told her to leave.

Spracklin's demands were clear and emphatic. He wanted not just an investigation, but also a reorganization of the police department and a special campaign to clean up these

lawless activities. Council gave him that assurance. Still, it wasn't enough for the minister, who raised the subject once more the following Sunday with his congregation. He challenged Trumble and the police chief to carry out their threats of lawsuits. Then on July 5th, Spracklin returned to council and to another packed room of spectators. This time he was denied the opportunity to speak. In fact, Mayor E. H. Donnelly warned the pastor to leave, or risk being removed by the police. Spracklin instead agreed to put his charges in writing.

Meanwhile, Trumble vehemently denied that his roadhouse was the scene of such vileness. He told the *Border Cities Star* in an interview, "liquor has never been sold in my house with my consent, and I am prepared to deny that Mr. Spracklin saw the drunks coming out of my hotel as he said. I have discharged several waiters for having whiskey in their possession."

On July 19th, Spracklin returned to council to submit his charges at a stormy meeting, and according to the next day's account in the newspaper, "at the conclusion of the scene (in the council chamber) with the mob surging about him, shaking their fists in his face, calling him names, threatening him with personal violence, the Methodist minister stood defiantly and announced, 'I am not afraid of you. I can use my fists if necessary.'" His two page, typewritten report, charged the police chief and the law enforcement committee of Sandwich Council with neglect of duty.

Less than a week later, buoyed up by rumours that Attorney-General Raney was considering the appointment of Spracklin as head of a special force of liquor licence inspectors, the outspoken pastor warned he would lay charges against Chief Masters under the Ontario Temperance Act. The act specifically stated, Spracklin said, that any constable failing to enforce the liquor laws could be dismissed from the force and fined ten dollars.

Sandwich Council, taking up Spracklin's challenge of an investigation, carried one out, only to announce that the minister's charges were unfounded and false. But this coincided with word from Toronto that Reverend Spracklin had indeed been appointed a liquor licence inspector. The brash pastor didn't hesitate and joined two other inspectors in a raid on three roadhouses the evening of his appointment (July 30, 1920). Charges were laid at all three raids. Two days later, Spracklin exposed three more drinking holes, one in which he battled his way out of a fistfight with the bootleggers in a free-for-all brawl.

By August 5th, Raney gave Spracklin the support he needed by appointing twenty-four more inspectors for the Essex Region. From these, Spracklin hand-picked his squad of men, some like the Hallam brothers, who were considered mere thugs.

A former Windsor police officer who was part of a bootlegging squad then remembered Spracklin's men as "punks." He said, "I can remember (Spracklin and his squad) they went down to LaSalle because they knew there were some shipments being made.

"Well, they got them, and they brought the boats back. I was asked to meet them and give

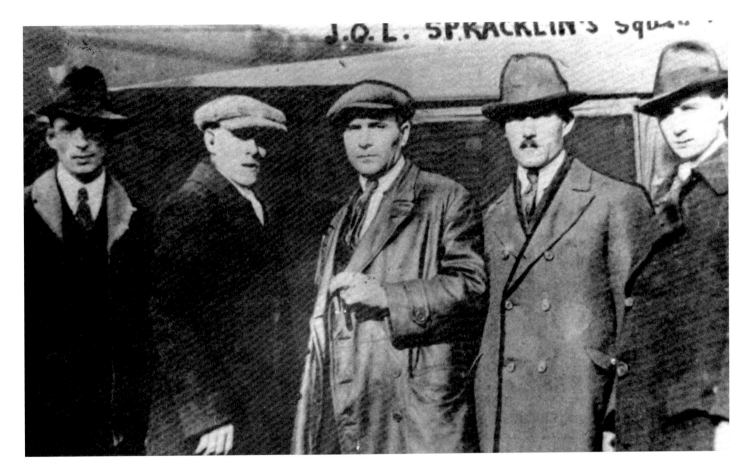

The Spracklin Gang. They carried guns, clubs and blank search warrants. Two were dismissed for being mere thugs. *(Windsor Star)*

a hand. Well, I could see them coming along the river – and those two brothers – the Hallam boys – were in the back drinking and falling all over the place. They couldn't stand up. They were just like a bunch of drunken sailors – and now Spracklin, he wasn't even looking at them – oh, I don't think he ever took a drink."

But if some of his squad were dishonest, Spracklin's own intentions were sincere.

In the beginning, Spracklin basked in this newfound attention and quickly became the most feared inspector in the country.

But fear didn't stop the rumrunners from retaliating. On October 4th, Spracklin's parsonage was riddled with bullets, shattering its windows and nearly hitting a former inspector with the Sandwich Police Force, G. A. Jewell, who had been sitting at a table in Spracklin's home reading a newspaper.

On Halloween night, Spracklin's house again was barraged with bullets; one bullet whizzed

past Spracklin's wife and embedded itself in a staircase wall. That night the pastor's squad took rooms in a Walkerville hotel and placed furniture against the doors.

Speaking before a Detroit congregation, Spracklin said, "Every time my young wife goes upstairs, she has to pass the marks where bullets came through my parsonage."

Threats on his life also came through the mail and over the telephone. Sometimes they were sent to his mother and father, who lived in Windsor. Spracklin told a *Toronto Star* reporter that despite the intense pressure upon him to quit, he refused, even if it meant carrying a pistol with him wherever he went. Later, he contended he could no longer meet a stranger in the downstairs study of his home unless he wore a gun.

Besides assaults, some tried to remove Spracklin by legal means.

By October, Inspector M. N. Mousseau was terribly disgruntled by the free-for-all clean up campaign that Spracklin had commenced. As head of the department in the district, appointed long before the pastor was selected by the attorney-general, Mousseau claimed this divided authority was disabling the war on Demon Rum.

On October 21st, the inspector warned the Board of License Commissioners that unless Spracklin ceased his freelance activities, he would quit.

Mousseau objected mainly to the tactics of Spracklin's men, especially the Hallam brothers, who were nothing but half-cocked brutes. He argued that since he was chief inspector for the region, he should control Spracklin and his squad. But under the arrangement made by Raney, Mousseau had no such power. And Spracklin wasn't about to relinquish his command.

The following day, Spracklin dismissed the Hallam brothers without explanation. A clue to the cause might be an earlier news report describing how Spracklin and the two brothers had jumped aboard a yacht owned by a lawyer, O. E. Fleming, and waved their pistols about and carelessly and recklessly searched the boat. Held captive was not a band of rumrunners, but a group of frightened ladies.

This was typical of Spracklin's approach to raids, and he would pay for this one the following spring. Another characteristic of these raids, and especially those conducted by the Hallam boys, was a total disregard for valuables. There are numerous stories about how they broke open chests of drawers and ruthlessly damaged countless cabinets in their search for booze. There are also tales of the squad roaring down the Detroit River in their patrol boat and slicing rumrunners' boats in two, leaving the occupants to swim to shore.

But although Spracklin dismissed the Hallams, under no circumstances would he be placed under Mousseau's command. To the *Border Cities Star,* he said, "I intend to maintain that status even should Mr. Mousseau find it necessary to withdraw from the service."

Spracklin's enemies mounted an effective campaign to remove him. On November 2nd, Spracklin appeared before the temperance committee of the Ontario Legislature in Toronto to hear Mousseau's vehement opposition to the

reverend's use of firearms. Mousseau declared that it was better in his opinion to let a load of liquor get away than to shoot. He thought that Spracklin often showed a lack of judgement and reckless enthusiasm. Mousseau added that he himself had only been assaulted once and he had never carried a gun.

"There are troubled times ahead for him," the chief inspector warned. Dr. Forbes Godfrey, MPP, also said to Spracklin, "That gun will get you in trouble sometime."

Spracklin retaliated by challenging the chief inspector to match up the number of convictions against his own. Spracklin boasted greater accomplishment in the short span of time than that of Mousseau over his career.

The committee, impressed by Spracklin, whose spectacular methods had caught the attention of all Ontario, was swept up in support of The Fighting Parson.

Spracklin, however, came under attack for carrying with him a handful of blank search warrants. One committee member complained, "Why not have martial law and be done with it?" But in a sharp retort, the pastor replied, "Well, you'll have that unless conditions are soon cleared up."

He argued that since his appointment road-house selling had been reduced by more than 80%. That he had searched drinking establishments after midnight was true, but that shouldn't seem unusual when these places didn't actually shut down until 4:00 A.M.

"I don't want this miserable job for the enforcement of the Act with all the risks I am taking and the disruption of my house,"

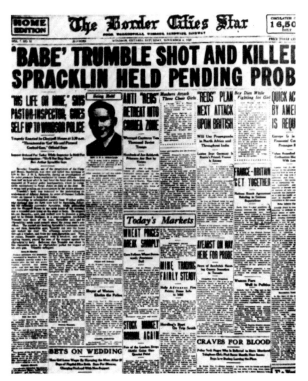

Babe Trumble shot and killed.

Spracklin insisted, "unless I can go back tonight or tomorrow feeling that I have the absolute confidence of this committee and the Government."

He was able to return to Sandwich with the endorsement he sought. The chairman of the board, J. D. Flavelle, declared, "No other place is as bad as Essex, therefore extreme measures must be taken where there are extreme conditions – Mr. Spracklin went in as a matter of public service. I think the ends justify the means." The board thus voted to keep both inspectors, in a divided command.

The "troubled times" that the chief inspector had predicted came sooner than expected. Only

Police Inspector Duncan McNab spirits Reverend Spracklin away after the inquest into Trumble's death. *(Windsor Star)*

three days after the hearing in Toronto, November 6th, a startled public read in newspapers all over Ontario that Trumble had been shot and killed by the Sandwich minister.

That eventful morning of Saturday, November 6, 1920, Spracklin had been roaming the streets of Sandwich in his touring car with his squad when he passed the Chappell House. It was about 3:30 A.M. He noticed an unconscious man, Ernest Deslippe, on the front lawn of the roadhouse. When Spracklin stopped to investigate, Trumble secured the lock at the front door, barring his entrance to the saloon.

Spracklin desperately wanted to question Trumble and broke a window of the hotel and climbed in. He raced through the main dining room into the main hall and through to the bar

in search of Trumble, but couldn't find him. He searched through the pantry and kitchen of the roadhouse, then into Trumble's private dining room, where they met face to face.

It was then that Spracklin shot Trumble, claiming the hotel owner had flashed a gun. "It was his life or mine," a tired Spracklin told police later that night.

Spracklin fled to the bulrushes and weeds across the road from the Chappell House, where he watched large expensive cars with Michigan licence plates roll up to the roadhouse. Coming to lend support, he discovered later, were American mobsters who had heard of the shooting.

Spracklin finally gave himself up, not to the Sandwich Police, but to Windsor Police, whom he believed would give him a fairer hearing. Hours later the *Border Cities Star* wrote: "'Babe' Trumble Shot and Killed; Spracklin Held Pending Probe."

No immediate charges were laid against Spracklin. But the inquest itself into Trumble's death began the night of the shooting and didn't finish until the following Monday night.

During these proceedings, Spracklin testified that "Babe Trumble pressed his gun against the pit of my stomach. 'Damn you, Spracklin,' he said. 'I'm going to shoot you.' I knew then it was his life or mine."

But Lulu Trumble, Babe's wife, contradicted the testimony, claiming, "My husband had no gun. He had only a cigarette in his hand when he went out and met Mr. Spracklin."

The minister and his men, she said, appeared at the doorway of the roadhouse's living quarters, demanding to speak to her husband. But

Trumble, walking toward Spracklin, insisted he produce "badges" for his squad.

Mrs. Trumble said, "I heard the report of a gun right after and that is the last I remember, except that Beverley cried, 'You dog, you have shot me.'" Trumble then stumbled to the bedroom and died in the arms of an assistant, Edgar Smith.

The jury's verdict was justifiable homicide and Spracklin was exonerated and freed.

That same day, Trumble's body was placed beside his mother's in the mausoleum at Windsor Grove Cemetery. The funeral had been held at the house of Hamilton Trumble, the father of the slain roadhouse owner.

Ironically, one of the mourners was Mrs. Joseph Spracklin, mother of the Fighting Parson. The November 9th *Detroit News* claimed that "There is one mother on the border who has wept for Mrs. Beverley Trumble and her two children, Robert and Leslie, now fatherless, following the shooting of Mr. Trumble Saturday morning. That woman is Mrs. Joseph Spracklin. . . . Mrs. Spracklin for the last four months has dreaded the ring of the telephone, the knock on the door, for with each she anticipated the news that her boy, Leslie Spracklin, had been killed. Letters threatening to kill Spracklin were sent to the home at 148 Cameron Avenue each week. They went into the fire as soon as they were opened. But the threats remained in the mother's mind.

"'The last few months have been terrible, and I knew Saturday morning when by five o'clock Leslie neither had telephoned nor come home that something had happened,' the mother said.

"If only it did not have to be Bev that was shot," Mrs. Spracklin told the *Detroit News* in an interview, adding, "We all knew them so well, but it just seemed to have been fate."

Following the inquest's decision, sympathetic support overwhelmed Spracklin. On November 13, 1920, the *Border Cities Star* wrote: "Probably no public official in the history of the community has suffered more criticism and risked his health and life so often in the pursuit of duty."

The Christian Guardian insisted that the real issue at Sandwich "for many months has been an open flouting of the law on the part of those represented by the unfortunate man who was buried so suddenly. And that open and barefaced and altogether unscrupulous breaking of the law is a very serious matter."

It was emphasized that Spracklin has been "fearless, and intensely alert – and has made himself a terror to evildoers, and it is no secret that his life has been in danger more than once.

"His ceaseless activity has not been agreeable to lawbreakers and their friends and his enemies – but we are glad that so far he has escaped alike their malice and bullets."

Meanwhile W. H. Furlong, a Windsor lawyer and friend of the Trumbles – he had been a pallbearer at Trumble's funeral – prepared to press for a charge of manslaughter against Spracklin.

By the end of November, Spracklin's motley band was dismissed by Raney and replaced by Superintendent W. J. Lannin, the former chief of police at Stratford, Ontario. *Panther II* and Spracklin's touring car were transferred to the new inspector November 27th. Spracklin

returned to Sandwich Methodist, humbled by his frenetic experience as a liquor licence inspector and the fanatical campaign that had ended so tragically.

But his name wasn't to disappear so quickly from the news. Ahead of him were months of worry and a lengthy trial. Mrs. Trumble's lawyer and other friends petitioned the attorney-general to charge Spracklin with manslaughter. More than 2,000 people signed a petition supporting this. Spracklin himself urged the attorney-general to consent, realizing his innocence had to be proven once and for all. Raney finally announced Spracklin would be charged with manslaughter less than two weeks after the shooting. He was arraigned at the end of November. A date of February 21, 1921 was set for trial. Sir William Mulock was named as the presiding judge, while Munro Grier, a Toronto lawyer of Furlong's choice, was appointed prosecuting attorney. R. L. Brackin, Liberal member of the legislature for West Kent, was hired to defend Spracklin.

The trial started February 22nd. More than 600 people had to be turned away. Spectators lined up at the entrance of the Sandwich Court House at 6:30 A.M. Rumours spread that Hamilton Trumble had gone into the sheriff's office the day before hurling threats at Spracklin. The proceedings got underway at 8:30 A.M., with Mrs. Trumble testifying that her husband had had no gun in his hand when Spracklin shot him.

A spectator at that trial reported that bins of guns were collected by the police from spectators. Hallways and stairwells of the courthouse were jammed, and when it came time for lunch few moved from their spots so that they could stay close to the courtroom.

Mrs. Trumble, pregnant with a third child, mounted the stand but kept one of her children in her arms until Sir William ordered her to hand him over to her father-in-law. Brackin explored her assertion that not only did Trumble *not* have a gun, but had never owned one. He questioned her about how Trumble brought in a cash register to be repaired a year before and how he had pushed a pistol up against the repairman's head, demanding that he fix the machine.

Mrs. Trumble hotly denied this, telling Brackin he only owned rifles, never a handgun.

But Mrs. Trumble wasn't the only one who was skilfully cross-examined that day. So was Spracklin, who confessed that he wore a .45 calibre automatic Colt at all times. He also revealed that it had been drawn when he went into Trumble's roadhouse. Grier also established that the weapon wasn't registered with the police and wasn't the kind permitted by the law.

At this point in the trial, the persistent question was whether Trumble had a gun in his hand that night. The police had found no evidence of one, and Lulu Trumble steadfastly clung to testimony that Babe Trumble never owned one. Brackin poked holes in these claims, but she continued to deny her husband ever had a handgun.

One thing was established: the rivalry between the two. Almost a month before the shooting, Spracklin had searched Trumble's car outside the Chappell House, with Trumble

branding the pastor-inspector a "cur," warning him, "You'll get yours!"

But the first break in the chain of testimony came February 23rd from Jack Bannon, a notorious rumrunner, (later sentenced to Kingston Penitentiary for kidnapping John Labatt). He revealed to a stunned courtroom that he saw Mrs. Trumble snatch a gun from her husband's hand after he was shot.

The startling revelation was made when the dramatic Brackin jumped to his feet to cross-examine the witness. Bannon had just been asked by Grier whether Trumble had a gun. Bannon said he didn't. An undaunted Brackin asked if Lulu Trumble had a gun in her hand, and Bannon nonchalantly admitted she had.

Brackin next masterfully cross-examined Ed Smith on his assertion that Trumble never had a gun. He revealed that the physician summoned to the Chappell House after the shooting had said that Smith told him Trumble had drawn a gun on Spracklin. He snarled at the witness: "What did you carry with you when you went to Detroit on the morning of the shooting?" Brackin tried to force Smith to admit that he had either fled to Detroit with the gun and had dropped it into the Detroit River or had sold it at a second-hand shop in the U.S. But Smith held firm to the story that Trumble didn't have a gun at all.

The following day, February 24th, the two attorneys addressed the jury. Brackin far outshone Grier, who seemed ineffectual and confused. Brackin wove together the intricate tale of the pastor-inspector and the roadhouse owner and the mounting rivalry between the

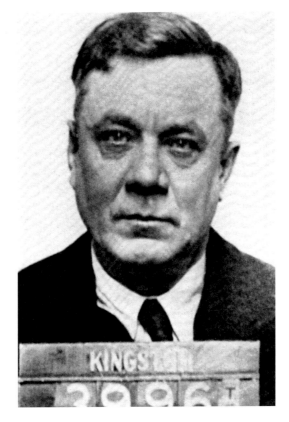

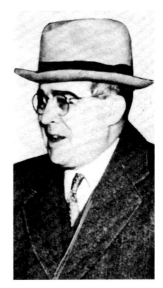

Jack Bannon, a key witness at the Spracklin trial, photographed later at Kingston, where he served time for snatching John Labatt (Below).

(Windsor Star)

two. He criticized the provincial government for appointing Spracklin, saying, "I don't think it was fair; I don't think it was right for the Government of Ontario to say to this minister of the gospel, 'You complain that conditions in your town are vile, that they have reached the unbearable point; you therefore assume the responsibility of remedying them, of cleaning up the situation you complain of.' Had I been a member of the Government with the necessary authority, I would have sent a regiment of soldiers to cope with the situation here."

Brackin also accused Mrs. Trumble of lying: "Yesterday (she) kissed the sacred book and swore to tell the truth . . . she stood there and she lied, and lied and lied." Finally turning to the jury, Brackin said, "If you need a chain of lighthouses to guide you on your way, you have only to think of the threats against Spracklin's life."

Grier stood firm on the evidence given by Mrs. Trumble and Smith. He challenged Brackin's assertion that Mrs. Trumble wasn't as grief-stricken as she might have been, and dismissed the evidence given by Bannon, since it contradicted his testimony at the November inquest.

The jury deliberated for only fifty-nine minutes before returning with a verdict of not guilty. Spracklin was set free. Over the next few days, there was an endless string of editorials in newspapers, congratulating him for his war against rumrunners. The *Border Cities Star* came to his support: "If there existed any stain upon the good name of Leslie Spracklin, it has been wiped out."

But this respite was short-lived. Only a month after his Sandwich trial, Spracklin was back in court, this time being fined $500 damages for trespassing on the yacht of Windsor lawyer Oscar Fleming. This was the vessel he ransacked with the Hallam brothers at the beginning of his border war on booze.

Spracklin appealed to the Second Appellate Court in April the following month, but it held up the previous decision. Chief Justice R. N. Meredith and four other judges declared the pastor-inspector blatantly unfit for his responsi-bilities and that he lacked proper experience, tact, patience and knowledge. In the case of Fleming, the court said his behaviour was "stupid and inexcusable."

The judgment was quoted in the *Canadian Annual Review*: "If the law is to be respected and properly enforced, the enforcement of it must never be committed to such persons as the defendant, it must be left to trained, experienced and impartial officers of the law." And the *Toronto Telegram* on April 8th called Spracklin's command of the border "Raneyism running amuck . . . it was Raneyism that shot Beverley Trumble. It was Raneyism that went buccaneering on the Windsor river."

Rumours continued to circulate that Spracklin would be assassinated, frightening both the family and his congregation. On a couple of occasions, the pastor-inspector returned to Windsor from excursions out of the city to calm the reports that someone had attempted to kill him. But the threats were real. On April 6, 1921 in London, Ontario when he was asked to attend a church service, someone passed a note to the pastor of that church, "Don't let the murderer come through here tonight. We will get him."

Spracklin's problems proved even broader than this. Despite support of the Border Cities Ministerial Association, he underwent one more trial – this one behind the closed doors of Sandwich Methodist. Spracklin was accused by some women in his congregation of having made sexual propositions; and it was these accusations that eventually forced Spracklin to leave Windsor. He fled quietly. In fact, the

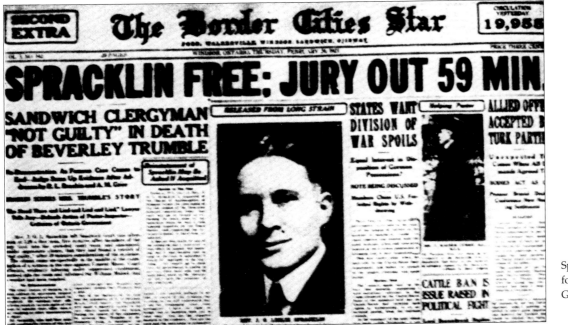

The Border Cities Star

CIRCULATION YESTERDAY 19,958

SECOND EXTRA

SPRACKLIN FREE: JURY OUT 59 MIN.

SANDWICH CLERGYMAN "NOT GUILTY" IN DEATH OF BEVERLEY TRUMBLE

Spracklin found Not Guilty.

United Church of Canada's archives in Toronto list him in its church, but without a charter, from 1922 to 1925. Spracklin actually left Sandwich to take over a charge in Cheboygan, Michigan in 1922. It was only the first in a series of Michigan churches Spracklin ministered to before his death on May 28, 1960. His death drew no publicity.

The *Woodstock Sentinel-Review* on November 8, 1920 summed up the tragedy at Sandwich better than most:

"There has been too much emotionalism, perhaps on both sides in this temperance campaign, and where there is too much emotion there is likely to be too little clear thinking. The tragedy at Sandwich may set people thinking, as the outrages associated with the Fenian rising set Gladstone thinking. And so some good may come of it."

Today at Bedford United Church, Spracklin's photograph hangs in the vestibule of the church. In the basement, among the archived material, there are pamphlets that refer to him. The pulpit from which he used to speak has been given to another church.

Few remember The Fighting Parson today, but from time to time students come through the doors of the church looking for information about the pastor who used to wear six guns during the services.

Pussyfoot

*Pussyfoot Johnson once confessed that he had to lie and bribe
and even drink to bring about national Prohibition.*

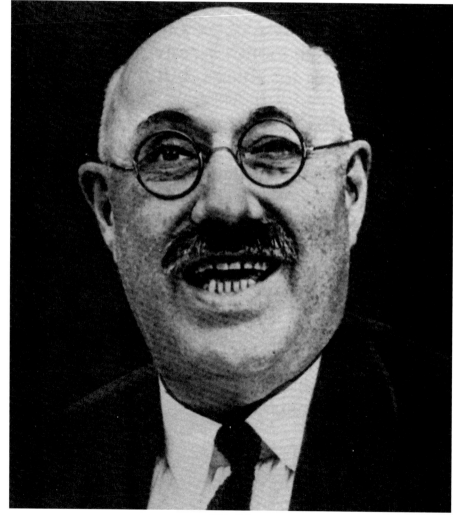

(Windsor Star)

Despite their reputation of being a mild-mannered people, Windsorites were anything but civil and respectful April 11, 1921 when the leading American Prohibition advocate, "Pussyfoot Johnson," stepped on a stage in their city.

They pelted the fiery speaker with rotten eggs, bricks, and debris, and chased him down to the ferry where he was rushed away under police escort. He was never hurt, but acknowledged there was no point staying around to fight with more than 200 irate protestors who stormed the riverfront.

At one point, Johnson's attackers tried to smash down the gate leading to the ferry, but were warded off by the police.

Johnson had been in Windsor to deliver his message at the downtown Windsor Armouries about alcohol and its evils. Residents here had no interest in hearing what this American had to say about the subject.

Long before Prohibition, William Eugene "Pussyfoot" Johnson campaigned to outlaw liquor. He readily admitted to resorting to any kind of trickery to nail his opponents – including bribery, drinking liquor, lying, and cheating. Johnson developed the nickname "Pussyfoot" from his "cat-like stealth in the pursuit of suspects" in Oklahoma, where he was first assigned as a liquor control agent.

Johnson was born in Coventry, N.Y., and was educated at the University of Nebraska. He later worked for the *Lincoln Daily News* and became the manager of the Nebraska News Bureau. In 1889, Johnson found himself at the centre of the debate over state-wide Prohibition. He posed as an anti-Prohibitionist so as to gather up information from owners of breweries and saloons. Then he turned around and published his findings, embarrassing the opposition.

His actions caught the attention of the government, and he was quickly enlisted as a special agent to enforce the laws in Indian territory and Oklahoma in 1906. In those positions, Johnson managed to register more than 4,000 convictions in a three-year period. His raids on saloons actually prompted the owners to put a $3,000 bounty on his head. Johnson was not only undeterred, he stepped up the arrests and began raiding these establishments at night. In one instance, he dumped 25,000 bottles of liquor into the Arkansas River.

His actions brought more threats against his life, and from time to time, members of his own hand-picked squad were shot at and occasionally killed. It did not stop Johnson from pushing ahead.

The Prohibitionist finally moved out of the territory to Kansas to join the Anti-Saloon League. There, he resorted to more underhanded measures, at times posing as a potential brewer and approaching others in the business to find out ways of combating temperance workers. As soon as he got this advice, he made public the suggestions that were being offered, again embarrassing his enemies.

Johnson went on to serve as the managing editor of thirty-five Anti-Saloon League publications. His travels in the cause took him to Paris and Milan, as well as to places in Canada, including his brief and stormy stay in Windsor, Ontario.

Windsor's visit came at the end of his Ontario April 1921 tour. The *Border Cities Star* reported that Johnson was "driven out by a mob." He had resolved to address the Armouries, even though it was overwhelmingly dominated by "wets." But Johnson never got to speak. The crowd became increasingly surly and wouldn't heed the pleas of the organizers. At one point, J. W. Brien, chairman of the meeting, tried to appeal to the crowd to give Johnson a chance to speak, but he couldn't make his voice heard over the din.

As the *Border Cities Star* reported: "What he attempted to say will never be recorded as it was drowned out in the deafening uproar from the gallery and rear of the hall . . . where shrieks, howls, catcalls and prolonged cheering came. . . ."

In a further attempt to quell the audience, a local clergyman told the press at a table near the stage that Johnson had addressed meetings in Hamilton, Toronto, London and St. Thomas, and was "accorded a hearing in all of those places."

He said, "There is a difference between liberty and license – men who mass together to break up a meeting have a strange idea of liberty."

But the clergyman's claim about these other appearances wasn't entirely true. In Toronto, Johnson was met by a crowd of more than 2,000 outside of Massey Hall who tossed stones, sticks and bottles at the doors of the theatre, demanding to be allowed in. The police were sent in to disperse the mob. And those inside Massey Hall were so loud, Johnson could not be heard.

Even the *New York Times* carried the story, saying the American Dry Advocate was "howled down" by "jeers, singing and whistling." Johnson was quoted as saying, "They're making more dry votes than I could if I talked all night." He also said, "This is the best demonstration against me that I have yet seen."

Finally, Inspector Mortimer Wigle and two constables with the Windsor Police hurried Johnson from the stage and out a side door to the street, where they were met with bricks and eggs.

As the ferry boat was pulling away, the rabble of wets at the dock hurled more bricks and eggs and shouted, "Goodbye, Pussyfoot!" and "Go home, Pussyfoot!"

Angus Munro, formerly of the *Border Cities Star*, said Johnson went on to live "a remarkable life." Indeed, he did; for fifty years, he waged war on drinking in every major country in Europe and America. He died in Binghampton, New York, in 1945 at age eighty-two.

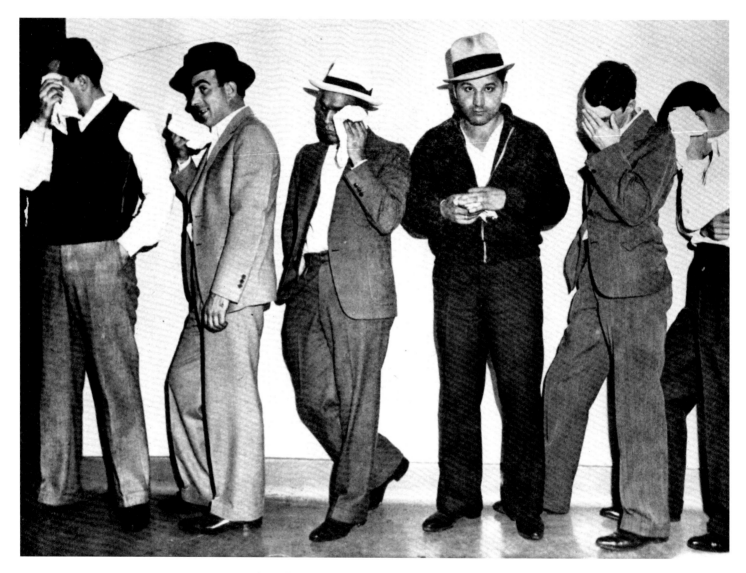

Members of The Purple Gang and associates at time of arrest.
(*left to right*) Sam Drapkin, Joe Bomerito, Jimmy Licavoli, Nick Desmond, George Rose, Abe Axler. (*Detroit Free Press*)

CHAPTER 16

The Purple Gang's Reign of Terror

In "Appointment with Death," Joseph Wolff describes the ominous events of the 1920s this way: "Detroit was quiet. The hoodlums, the gorillas and the musclemen of the illicit beer and liquor trade were in hiding. The alcohol cutting business and the bookmaking establishments were at a standstill from Grosse Pointe to Wyandotte and known gangster hangouts were as deserted as the old Michigan lumber camps. But the peace and quiet was ominous and strained."

Wolff was speaking about the events of Sept. 16, 1931, dubbed the "Collingwood Manor Massacre," which was immediately compared to Chicago's St. Valentine's Day Massacre of February 14, 1929. Dead were three transplanted Chicago gangsters and former members of the Little Third Avenue Navy (Little Jewish Navy): Herman (Hymie) Paul, Joseph (Nigger Joe) Lebovitz and Joseph (Izzie) Sutker. The trio, it seems, had miscalculated by believing they could muscle in on the action in Detroit. They had been sent to Detroit from Chicago in 1926 by the Oakland Sugar House Gang, an outfit that supplied booze to several bootlegging organizations in the area.

As Wolff explains: "The Sugar House needed 'rod men' – hired killers to protect its lucrative alcohol trade while it was waging war with powerful downriver gangs. And the trio did

their job well, but soon their own greed moved them into the rackets and they became associated with the Third Avenue Navy, a gang so called because it landed its river cargoes of Canadian Whiskey in the railroad yards between Third and Fourth."

Harry Troy, Wayne County prosecutor, immediately ordered "the roundup" of all underworld figures, and listed among the sixteen arrested were four members of Detroit's villainous Purple Gang. He told police he wanted them "dead or alive."

Trouble had been brewing for months in the beer and liquor business, and even Al Capone didn't want to push his way into the fray. He had his own dealings with the Purple Gang, as well as connections in Canada. And so when the trio arrived in Detroit, they weren't popular among those who had been controlling most of the action. They were "outsiders."

But there was an underworld code, and these Chicago gangsters weren't about to follow the rules: "They hijacked from friend and foe alike. They double-crossed the men with whom they were in alliance and were found so untrustworthy that no one dared work with them. They refused to stay within their own boundaries in their alcohol and whiskey trade and encroached on domains of other gangs."

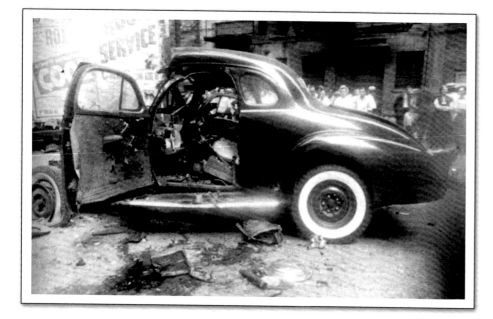

It is not certain that the three were involved in the hijacking of a major supply of liquor that was being funnelled to the American Legion convention being planned for the city, but when the supply was intercepted, Sutker, Lebovitz and Paul were tagged as the culprits.

Another gang, eager for revenge and to regain their stock, sent some gun-toting men to a warehouse, only to wind up in a battle that resulted in the death of one of their men.

"The trio's imported gunmen had begun a series of extortions, extracting protection money from blind pigs and bookmakers, selecting among others friends of such gangs as the Purples," Wolff writes. "This effort was short-lived, however, when the Purple Gang sought out and found the extortionists, forced them to repay several of their clients and ordered them out of town under penalty of death."

That spring, 1931, the trio hired a local hoodlum, Solomon (Solly) Levine, as a partner in its own bookmaking operation. The gang, however, fell behind in payments over one deal, and "fearing vengeance if they did not pay the debt . . . bought fifty gallons of alcohol from the Purples on credit, diluted it, and undersold the 'market price' to make a quick profit."

If this wasn't underhanded enough, they did it again, once more buying booze from the Purples, diluting it, and underselling the market.

Wolff said, "They had pushed their luck. Their activities spelled death; it was just a matter of time and which gang would move to stop them first."

On Sept. 14th, Levine ran into Ray Bernstein, the godfather of the Purples, outside of a restau-

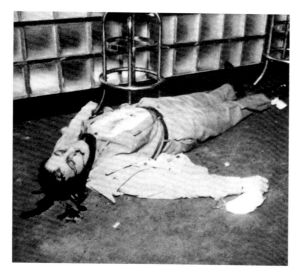

Harry Millman was killed by the Purples in 1937 after several other attempts on his life – these included a car bombing in which an innocent valet who was retrieving Millman's car was killed. *(Walkerville Times)* Millman was finally assassinated, in a downtown restaurant/bar, purportedly by the Purples.

(Courtesy of Estella Cox)

As a result, Sutker, Lebovitz and Paul were blamed for any and all unrest in the booze trade, and plans were hatched to get rid of them.

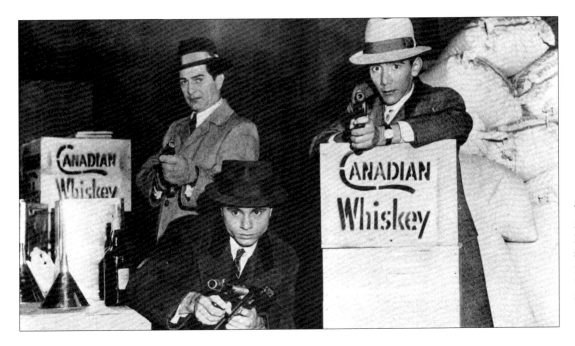

The movie version – Allied Artists romanticized the Purple Gang in its 1959 film starring Robert Blake. Note the cases, not sacks, of "CANADIAN WHISKEY."
(Allied Artists)

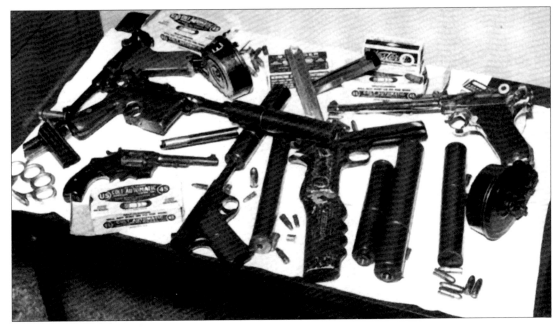

Weapons were seized in a raid of the Purple Gang.

Irving Milberg, Ray Bernstein, Harry Keywell at the "Collingwood Massacre" trial. (*Windsor Star*)

rant on Woodward. He confided in him, and told him he hoped to make peace with the Detroit gang, pay their debts to them, and promised to do future business in a more forthright manner.

Levine, being from Detroit, was the natural intermediary between the two rival gangs.

Later Levine would quote Bernstein: "We've got everything straightened out and we're going to let you boys handle the horse bets and alcohol when you straighten out that bill."

He told the Purples' boss that "the boys needed more time to pay off the bill, that the Legion convention was near and they would have an opportunity to sell the liquor."

Meanwhile, Levine and Sutker had been running a full-blown betting operation for four months, and had no intentions of quitting. Levine knew the trio well, but his alliance with the Purple Gang went back to childhood. He had grown up in the same neighbourhood.

When he told the trio about his meeting with Bernstein, they thought all was well. As Wolff explains: "They felt they were now an accepted part of the Detroit underworld and could negotiate with other gangs on equal terms rather than as hirelings."

On the morning of September 16th Levine got a call to meet the Purples at 1740 Collingwood, Apartment 211 at 3:00 P.M. He then called

Sutker, Lebovitz and Paul and told them of the arrangement. The three met at Levine's and then drove away from the betting house. Levine drove Sutker's car.

"They were laughing as they passed a corner drugstore and waved to a couple of detectives who had stopped to buy some cigars," Wolff wrote. "They were also unarmed; it wouldn't look good to carry weapons to a peace meeting."

In his later testimony, Levine described in detail that fateful day. It took a mere fifteen minutes to drive to Collingwood, and the gang pulled up at 3:00 P.M. sharp.

The four made their way to the apartment, pressed the buzzer, and Ray Bernstein opened the door, and greeted them. Purples Harry Keywell, Harry Fleisher and Irving Milberg were also present.

Later, Levine would say that he'd been surprised that Fleisher was there because he was wanted by federal authorities.

The four sat on a long sofa and talked, and then Bernstein made the excuse to leave because he needed to talk to his bookkeeper. All the while the conversation continued in the room, the Purples never sat down. They stood at a distance across the room.

A few moments later, Bernstein reached the alley behind the apartment and started his car, tooted the horn, then headed back to the apartment.

That's when the Purples drew their guns, and started firing at those on the sofa. "Levine sat frozen to his seat . . . one bullet whizzed past (his) nose and struck Sutker in the head . . .

Ray Bernstein in a wheelchair. He is being released from prison thirty-two years later after suffering a stroke.

(United Press International)

(and) the three men he had brought to the apartment made desperate but futile efforts to flee as slugs from smoking guns slammed into their bodies. It was over in seconds.

"Levine was shocked that he had not been hit. He saw Keywell, Milberg and Fleisher huddle for a moment, then one of them turned to him and said, 'Come on!'

"As the men retreated through the kitchen, each dropped his gun into can of green paint they had left on the floor near the stove.

"The registration markings on the weapons had been filed down and the green paint would eliminate any fingerprints. They ran down the back stairs to the waiting car. With Bernstein

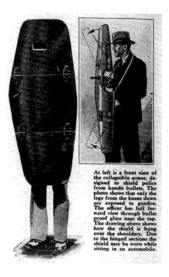

Caption from above illustration from *Modern Mechanix* reads: At left is a front view of the collapsible armour, designed to shield police from bandit bullets. The photo shows that only the legs from the knees down are exposed to gunfire. The officer has full forward view through bulletproof glass near the top. The drawing above shows the shield is hung over the shoulders. Due to the hinged sections the shield may be worn while sitting in an automobile.

(Courtesy of *Modern Mechanix*)

driving, the car sped away, nearly hitting a little boy playing nearby."

Levine was driven a short distance and was released. About a half hour later, detectives arrested him, along with a host of other underworld figures. They also picked up Bernstein and Keywell two days later. On Sept. 19, Milberg was tracked down, and police confiscated five pistols and a rifle. Police didn't catch Fleisher for several months. Levine himself spilled the beans on the Purples at the preliminary hearing on the first degree murder charges against the Purples.

The murder trial opened October 28, 1931, a month after the slaying. As Wolff writes: "Sol Levine remained the key witness, although the caretaker of the Collingwood apartment building and a little boy who was almost run over also testified and identified the Purples." But the prosecutor also had forty other witnesses. And at one point during the trial, the police, armed with machine guns, led the jurors to the site of the murder.

In his summary, the prosecuting attorney Toy said of the case, "These men checked their books with bullets and marked off their accounts with blood. They lured the victims to the apartment with promises of partnership and killed them when they were unarmed and helpless."

The jury returned to the courtroom November 10th and after one hour and thirty-seven minutes found three defendants guilty of murder. Wolff writes: "The verdict brought bedlam to the courtroom. Friends and relatives of the defendants began to scream hysterically and

court officers climbed onto chairs and tables in an effort to restore order.

"And so, according to Chief of Detectives James E. McCarty, the conviction 'broke the back of the once powerful Purple Gang, writing finis to more than five years of arrogance and terrorism.'"

Each of the Purples was sentenced to serve a life sentence at Michigan State Prison at Marquette. No one spoke when the sentence was read out.

The three were sent to Marquette in a special Pullman car quietly added to the northern Michigan-bound train on Wednesday, November 18, 1931. Shortly before it was to leave at 9:30 A.M. a convoy of black cars pulled close to the depot siding. Shotguns and machine guns bristled out the windows of the convoy, in the middle of which was a Detroit Police wagon.

The three killers were placed aboard the Pullman and shackled to their seats with heavy chain. They were accompanied by several members of the Detroit Police Force, all of whom were heavily armed.

The gunmen were blasé about the sentencing and prison. The three joked occasionally, chatted with the guards and took great interest in reading about themselves in the newspapers. They also lunched on corn beef sandwiches and played pinchole aboard the train. Bernstein meanwhile flashed "a roll of bills and tipped a Pullman waiter five dollars for breakfast."

This carefree attitude may have had to do more with their age than anything else. However, as the train got closer to their destination, they were visably worried. Keywell in particu-

lar kept asking Bernstein whether it would be okay in prison, and though Bernstein was only twenty-six, he assured the younger gangster life behind bars would be fine.

Wolff writes: "When the gray steel doors of the big brownstone penitentiary closed behind them on November 20th, they lost all outside identity, Bernstein, twenty-six, became No. 5449; Keywell, twenty, No. 5450, and Milberg, twenty-eight, was given No. 5451. Although their lives in Marquette prison were subdued, their names continued to come before the public as efforts to free them continued for many years."

A new trial was sought by the Purples, but nothing came of it even though Bernstein's attorney claimed he could prove Bernstein was making phone calls to Chicago, Cincinnati and New York bookmakers at the time of the murder. Milberg also appealed, and maintained that his maid would swear he was home at the time of the murders. Both appeals failed to sway anyone.

Milberg died in prison in 1938 after serving seven years.

Bernstein eventually suffered a crippling stroke in Marquette and was transferred to Jackson State Prison. He was paralyzed on the left side and his speech was impaired when he was brought before the parole board. He had a blanket wrapped around him, and he sat forlornly in a wheel chair. He had already served thirty-two years in prison. He had been a good prisoner

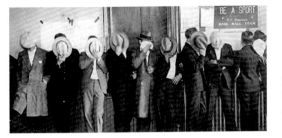

Members of The Purple Gang hiding their faces from camera 1929.

and had helped other inmates financially and taught elementary classes to others.

He continued to tell the parole board that he'd had nothing to do with the Collingwood Massacre, and he was finally released on mercy parole Jan. 16, 1964. He was placed at the University of Michigan Medical Centre, and died two years later on June 9, 1966.

Keywell also had a spotless prison record, and remained behind bars for thirty-four years before walking out, free, on Oct. 21, 1965. The same month Fleisher – though never tried for his alleged role in the murder – was also released. Wolff said that he had been sentenced for a different crime, and "after a nationwide manhunt, walked nonchalantly into city hall and surrendered."

Although Levine's affidavits were produced on several occasions and defence attorneys stated they could produce him for testimony at a retrial of the three convicts, law enforcement agencies could never find him. (*The* Detroit News Magazine, *"Appointment with Death," September 26, 1971.*)

Pete Licavoli in 1952. Head of the syndicate in Michigan and friend of "godfather" Joe Bonnano. *(Windsor Star)*

The Rivals: The Licavoli Squad

The Licavoli Squad were rivals to the Purples in Detroit. Equally vicious, though more reckless and persistent, this gangland-style organization led by Thomas, or "Yonnie," Licavoli and his brother, Pete, became the most notorious criminal gang in the northern states.

The two brothers, originally from St. Louis, arrived in Detroit to cash in on the huge profits being amassed through rumrunning. In no time, the gang came to dominate the smuggling operations on the upper Detroit River and virtually seized control over the bigger east side business in the city.

Yonnie was perhaps the most unfortunate of the two cold-blooded brothers. He was sentenced to serve thirty-seven years for murdering a man with whom his girlfriend had had an affair. He was sixty-eight-years-old when finally released from Ohio State Penitentiary, and upon being freed, he told reporters, "I have never killed anybody and never conspired to kill anyone."

But the former rumrunner and gang leader confessed, "I admit I was a bootlegger and broke the law. But I don't feel I should have been convicted of murder; no man should spend that much time in prison for anything . . . you might as well take him out and shoot him. . . ."

Pete was the successful one. He skilfully dodged the law until the Fifties, when he was finally caught for tax evasion. It is said that Pete was arrested more than a dozen times, but only nailed with two convictions. One was a $200 fine in 1929 for carrying a concealed weapon, the other involved an attempt to bribe a border patrol official to ignore Licavoli's rumrunning operations.

The two brothers, came to Detroit with another gang member and friend, Frank Cammarata, after a fulfilling apprenticeship with the "Hammerhead Gang," a band of wild juveniles who terrorized St. Louis and earned their name from conking robbery victims over the head. From this, the boys acquired new roles as triggermen for one of the most feared gangs of bank robbers in that city. Working out of St. Louis, they knocked over banks in the surrounding countryside with almost monotonous regularity.

At a police convention in Memphis, Tennessee in 1926, more than 300 revolvers, submachine guns, shotguns and rifles used by the Licavoli gang went on display. These weapons had been confiscated by police over the course of pursuing the gang, but unfortunately, for the law, anyway, the gang members were never caught.

Pete Licavoli. (*Left*)
Yonnie Licavoli. (*Right*)
(*Windsor Star*)

Detroit for the Licavolis appeared more welcoming. Liquor was far more lucrative than bank robbing. Payoffs were easily arranged and the risks were few. Most outside gangs learned early to stay clear of the city because the famed Purples had tight control of the action. They had managed to secure rule over the downriver booze business, and instead of handling the task of hauling the cargoes across the river, they had set into motion a network of rumrunners from other gangs to handle the passage of booze across the border. One of those conspiring gangs was the Little Jewish Navy. Others included Canadian links to the Purples in Sandwich, Windsor and Belle River.

The Purples had also muscled their way into the blind pig industry in Detroit and regularly exacted protection money from the owners. They had also created the Art Novelty Company to handle the booze traffic across the U.S. The shipments coming to Detroit from Canada were repackaged under false labels, then hauled

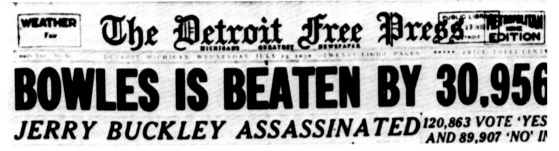

WEATHER

The Detroit Free Press

DETROIT MICHIGAN WEDNESDAY JULY 24 1930 — TWENTY EIGHT PAGES •••••• PRICE THREE CENTS

BOWLES IS BEATEN BY 30,956
JERRY BUCKLEY ASSASSINATED
120,863 VOTE 'YES AND 89,907 'NO' IN

Bulletin: Jerry Buckley assassinated.

(Detroit Free Press)

by train or truck to St. Louis, Toledo, New York and Chicago. Throughout Prohibition, Al Capone was the Purples' main customer. Thousands of cases of the expensive Canadian whiskey Old Log Cabin were shipped to him. It was one of these shipments that, when hijacked by the Bugs Moran Gang in Chicago, led to the St. Valentine's Day Massacre in 1929. Thus the Licavolis had to face up to formidable foes if they wanted to secure a piece of the rumrunning action in Detroit. They would have to face the Purples head-on. The two gangs eventually fought for dominance in Detroit during Prohibition, resulting in several open wars and slayings.

Several other murders have been linked to the Licavoli brothers and their gang, but due to lack of evidence, the courts failed to prosecute. The most infamous of these was the slaying of Milford Jones, an acknowledged gunman from St. Louis, at the popular Stork Club in Detroit in 1932. Pete Licavoli and another hoodlum, Joe Massie, rushed into the club and riddled Jones with bullets. Neither Licavoli nor Massie were ever brought to trial, because witnesses either fled the state or disappeared.

Another time, both Pete and Yonnie were wanted for the murder of Jerry Buckley, a muck-

Jerry Buckley.

(Detroit Free Press)

raking radio commentator in Detroit, but miraculously avoided convictions.

Buckley, an admired broadcaster in the Twenties, was also widely praised for his good deeds on behalf of the needy in the city. One *Border Cities Star* reporter observed that "he wouldn't have an enemy in the world." But one September night in 1930, not long after Cammarata and Yonnie were released from

Kingston Penitentiary in Canada, Buckley was shot to death. He had been sitting in the lobby of the LaSalle Hotel in Detroit. Cammarata, recently released from prison, was believed to have driven the gunmen's getaway car, but no one could prove it.

Later, a story circulated that a gangland defence fund of $25,000, raised on Cammarata's and Licavoli's behalf for the earlier Canadian conviction, had been misappropriated by their Detroit counsel at the time – the same Jerry Buckley.

Buckley, it was rumoured, had loaned $20,000 to someone to buy a house in Riverside, Ontario (now incorporated into Windsor). Buckley, according to Essex County Registry Office records held a mortgage on the home.

The Licavoli gang had been swift to retaliate because Buckley had allegedly cheated them.

Buckley's involvement with the Licavolis wasn't known to the general public, but he did appear in the Essex County Court House in the fall of 1927 to act as the Detroit counsel for Yonnie Licavoli and Frank Cammarata. The case centred on the seizure of a loaded .38 calibre handgun in a side pocket of a car owned by Cammarata. The car had been parked in a lot outside the Prince Edward Hotel, in Windsor.

But upon a search of Rooms 501 and 502 of the hotel, the police uncovered another loaded .38 under the pillow in Licavoli's room.

According to a newspaper report, "this was an embarrassing turn of events for a couple of torpedoes from St. Louis who had adopted

Detroit as their playground, and although under the suspicion of several police departments had beaten all the raps. Now they were in collision with the Criminal Code of Canada, with no prospect of a fix in sight."

Buckley's involvement wasn't mentioned until three years later when he was shot. During those years, Licavoli and Cammarata patiently waited out their time behind bars in Kingston.

But the trial was among the most dramatic from the rumrunning days. James H. Clark, appointed Canadian counsel for the two hoodlums, argued vehemently that the police had planted the gun in the defendant's car. Furthermore, he insisted the possession of a handgun wasn't anything sinister, since the two were recognized rumrunners, and in that line of employment such hardware was standard equipment.

Justice Wright, unable to restrain himself, interrupted Clark to ask, "What necessity is there in this country of Canada for having guns of that nature? There has been a suggestion that these men had them for the purpose of rumrunning. That is carried out on the Detroit River, not in the rooms of a hotel.

"Has the day come in this country when it is necessary for any person to have in his or her possession weapons of that nature?"

The Crown Attorney, C. W. Bell, on the other hand, maintained that the two were not actually rumrunners at all, but hired gunmen from Detroit. Their purpose in Windsor was merely an extension of their mission in the U.S.

The smooth-talking Licavoli struggled to persuade the court to believe he wasn't a gunman

at all, but an ordinary, hardworking rumrunner. He insisted he had nothing to do with the Detroit mobsters and explained that he and Frank Cammarata had been smuggling liquor across the border that night. When they had finished, they dropped into the Madrid Club for "some fun." They remained there till 3:00 A.M., and at this point decided to check into the Prince Edward. But no sooner had they bed down than the police busted down their doors and arrested them.

The two were convicted for "possession of offensive weapons for a purpose dangerous to the public." They were sent to Kingston for three years.

Jerry Buckley, the man who shouted against the gangsters. One night in a Detroit hotel, the vociferous enemy of the mob was shot and killed. X marks the spot. Buckley's attacks were most effective by radio. (*Windsor Star*)

Acknowledgements

The genesis of this book grew out of a commission from the University of Windsor's Drama Department in the late 1970s. I was asked to write a play for its graduating class. That production, *The Fighting Parson,* was performed in Windsor, but also at the Bathurst Street Theatre in Toronto. The research that went into writing that drama, which is really the story of Rev. J. O. L. Spracklin, the gun-toting Methodist minister who shoots a tavern owner, led to this book. When *The Rumrunners: A Prohibition Scrapbook* was first published in 1980, the following helped me compile the stories and pictures that went into that edition. These included Frances Curry, formerly of the Windsor Star Library, the Windsor Public Library, the Detroit Public Library, the Public Archives of Canada and the Public Archives of Ontario, the Southwestern Regional Library of the University of Western Ontario, the Windsor Police Department, the United Church of Canada archives, the Ontario Historical Society, the Leddy Library staff at the University of Windsor, Larry Kulisek of the University of Windsor History Department, the Hiram Walker Museum, John Marsh of the Amherstburg *Echo,* Elton Plant, Jack Geller, the Sandwich United Church, Paul Vasey, Les Trumble and family, the Vuicic family, the Spracklin family, the University of Windsor Drama Department, the *Detroit Free Press,* the *Detroit News,* Jim Cornett, Jack Kent, Gerald Hallowell, James Reaney, Frank Rasky, David Lawrence Jr., former executive editor of the *Detroit Free Press,* and of course, all the rumrunners and people interviewed in this book.

Permissions were given by the following: Walter Goodchild for the priceless photographs of rumrunners on the ice; Bill Johnson for his drawings of the Chappell House and Edgewater Thomas Inn, the Vuicic family for photographs of the Rendezvous Tavern; Peter Frank of Gale Research in Detroit for area maps; the *Detroit News* and the *Free Press* for photographs including those of the Purple Gang and the Jerry Buckley murder; the Windsor Police Department for the photograph of the blind pig in Sandwich, Ontario; the Public Archives of Ontario for the photographs of the Elk Lake blind pigs, and the photographs of William E. Raney; the *Windsor Star* for many of those wonderful period photographs; Allied Artists for the picture of the movie about the Purple Gang, and by Danielle Kaltz of the *Detroit News.*

Permissions to quote passages from articles were given by the following: the *Detroit News, Maclean's Magazine,* the *Windsor Star,* the *Detroit Free Press, Today Magazine,* the Windsor Separate School Board, the *Toronto Star,* Tom Paré of *Walkerville Times,* Ron Scott and CBE Radio, Gayle Holman and *Windsor This Month,* the *Woodstock Sentinel-Review* and *Modern Mechanix.*

Help in preparing many of the photographs in this book was provided by the late *Windsor Star* photographers Stan Andrews and Walter Jackson. Other assistance came from Kyle MacMullin and Rod Rieser. Bill Marentette graciously provided images and stories related to the history of breweries, especially those of the Riverside Brewery.

Special thanks goes to Jim Venney, publisher of The Windsor Star for permission to use some of its material. Chris Edwards and Elaine Weeks of Walkerville Publishing also provided many of the photographs in this book along with some of the stories. University of Windsor students Jasmine Elliott, Amber Pinsonneault and others helped out in typing and organizing much of the manuscript before it was handed over to Biblioasis. Of course, without the prodding of Dan Wells, publisher of Biblioasis, I might never have taken up the task of reissuing this book. I must also acknowledge the meticulous work of Dennis Priebe in designing this book, and also Karl Parakenings for his inspired cover.

Bibliographical sources for this book included the following: *Prohibition in Ontario,* by Gerald Hallowell, *Nostalgia, Spotlight on the Twenties* by Michael Anglo, *Prohibition, The Era of Excess* by Andrew Sinclair, *Playboy's Illustrated History of Organized Crime* by Richard Hammer, *Mobsters & Rumrunners of Canada: Crossing The Line* by Gord Steinke, *Outlaws of the Lakes: Bootlegging & Smuggling* by Edward Butts, and *Booze Boats and Billions: Smuggling Liquid Gold* by C. W. Hunt.

Every effort has been made to secure permission for photographs and drawings reproduced in this book from the rightful copyright holders. We regret any inadvertent omission.

Index

About the Author

Marty Gervais is an award winning journalist, photographer, poet, playwright, historian, editor and teacher.

In 1998, he won the prestigious Toronto's Harbourfront Festival Prize for his contributions to Canadian letters and to emerging writers. In 1996, he was awarded the Milton Acorn People's Poetry Award for his book, *Tearing Into A Summer Day*. He has twice won the City of Windsor Mayor's Award for literature, and has been the recipient of nearly two dozen Ontario Newspaper Awards for journalism.

Gervais has also published a book titled, *Seeds In The Wilderness*, a book of essays that stemmed from interviews he conducted with such notable religious leaders as Mother Theresa, Bishop Desd Tutu, Hans Kung and Terry Waite. Previous to this, he published another book *Voices That Thunder* that brings together both his photographs and stories of a Catholic mission in Peru.

In 2007, Gervais went to Iraq and came back with award winning stories about life in that country in the midst of war. In 2008, he traveled to Bosnia to cover the world championship in women's boxing.

Biblioasis published *My Town: Faces of Windsor*, a collection of columns that appeared in *The Windsor Star*.

DONNA GERVAIS